PHOTOGRAPHIC
MEMORY

For Peggy, Christopher, and Colleen

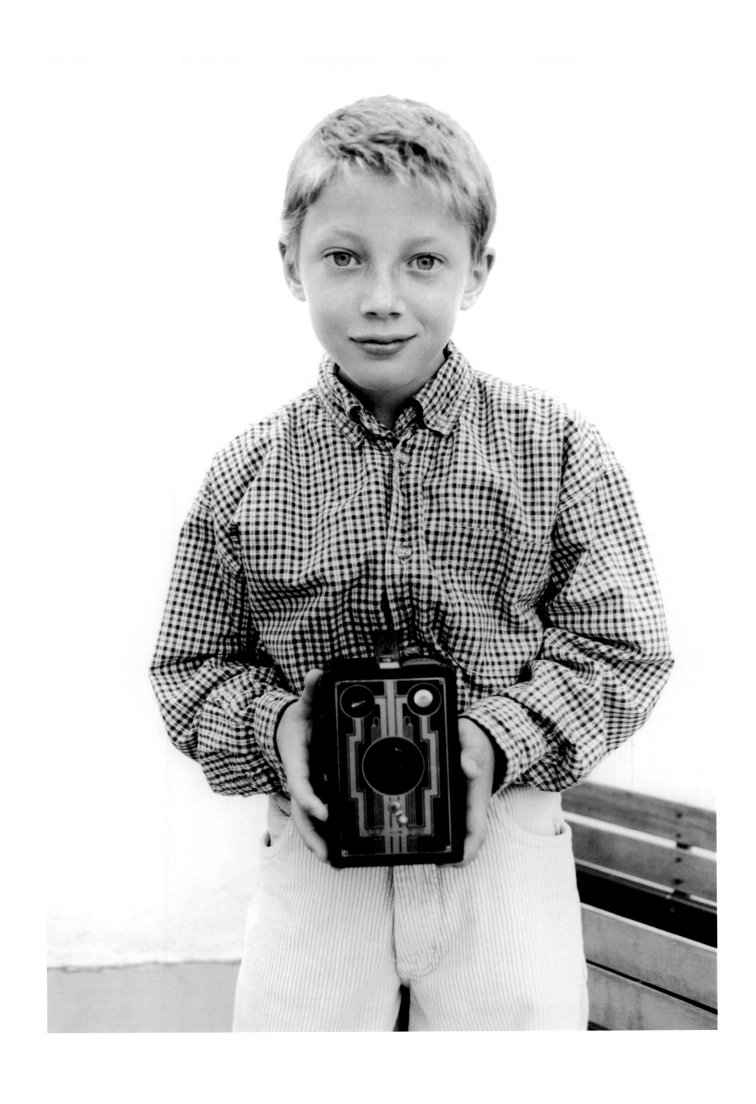

PHOTO
MEMO

WILLIAM CLAXTON

GRAPHIC

INTRODUCTION BY
GRAYDON CARTER

pH powerHouse Books
New York, NY

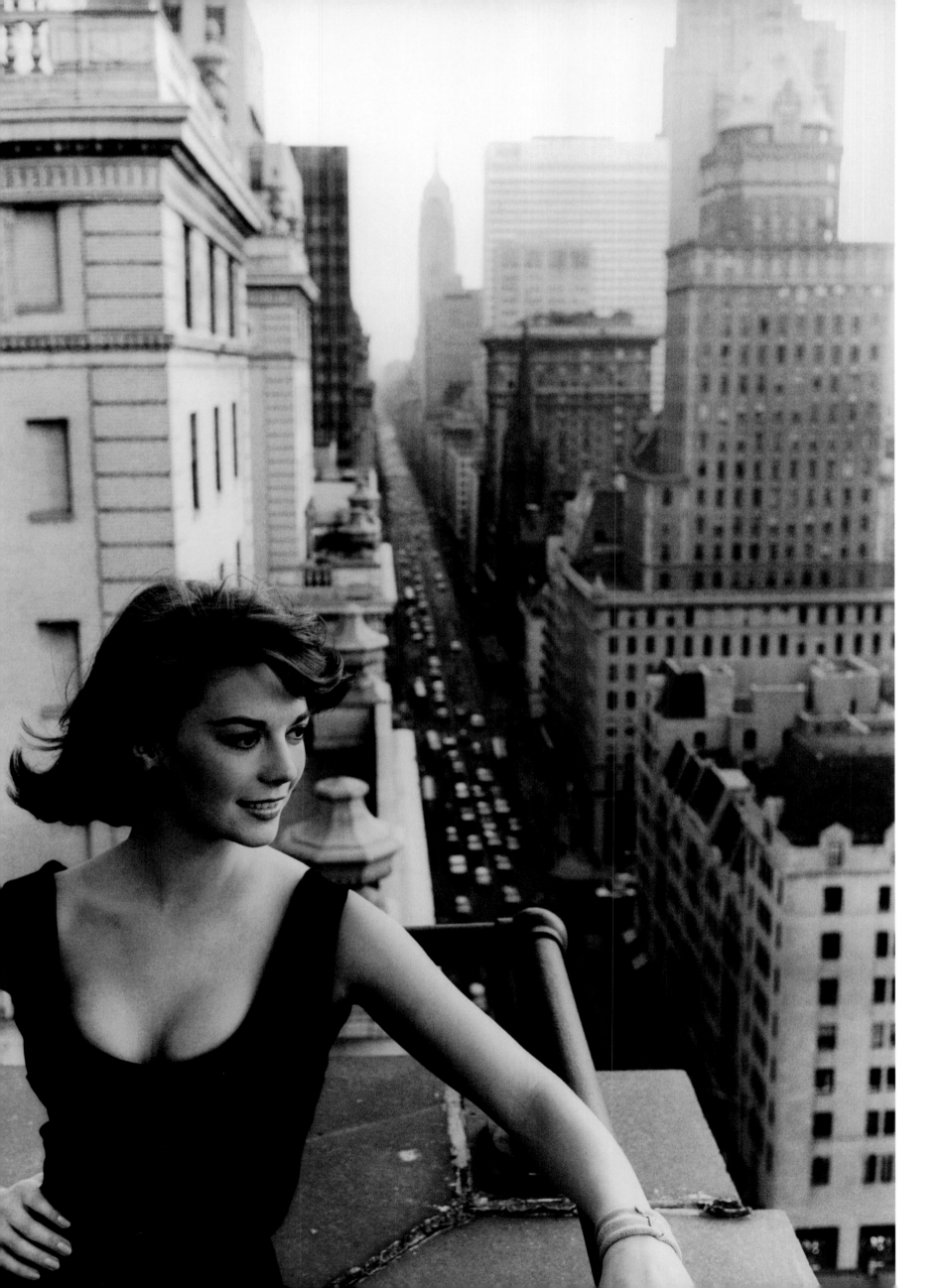

INTRODUCTION

by Graydon Carter

The William Claxton of legend is an artist who will be forever linked with his singular photographs of jazz giants taken in the moneyed, sunny exuberance of postwar Southern California. Charlie Parker, Chet Baker, Billie Holiday, Duke Ellington, Dizzy Gillespie, Joe Williams—baby, he shot them all, and his portraits are jazz standards in themselves.

But Claxton—born in Pasadena, schooled at UCLA, rooted in Beverly Hills—has long been a West Coast fixture on other fronts as well, most notably in the intersecting spheres of film, fashion, and the arts. And although he made a living shooting for *Life, Look, Vogue,* and *Harper's Bazaar,* this new book, *Photographic Memory,* has the comfy intimacy and weekend pace of an extended-family album. It is Claxton's personal view of his California neighbors over the course of more than half a century. Most of the images are fresh indeed: few have ever seen the printed page. And the best of them were taken during that lost adolescence (mid-'50s to mid-'60s) when Hollywood—downwind of the Beat scene, hepped up on jazz—was bristling with new ideals and young, electric talent.

Turn to any spread of this book and you are struck by Claxton's sense of freedom and ease; his pictures, almost without exception, are lithe and full of life. The gang is all here: Marilyn Monroe, Robert Redford, Henry Miller, Shirley MacLaine, Terry Southern, Joan Baez, Hoagy Carmichael, Sidney Poitier, Christopher Isherwood, Marlon Brando, Sal Mineo, Lenny Bruce, Robert Mitchum, and Billy Wilder, among others. And this being a Bill Claxton book, you've also got cameos by Steve McQueen, Chet Baker, Claxton's wife Peggy Moffitt, and Rudi Gernreich, the designer she modeled for.

Claxton's intent seems not to glamorize but to linger, long and inquisitively, with a mind as open and forgiving as his aperture. Sheer likability is one of his assets. Look, anyone who could win the trust of McQueen is a charmer not to be trifled with. Even at age seventy-five, he's a tall, relaxed drink of a fellow. His hair is full and gray and curly, and he dresses like a prep-school headmaster. Safe. You feel safe around him.

Put him behind a camera and it's as if his lens were fitted with a filter that makes every man come away a shade more handsome, every woman more alluring. Claxton's Ursula Andress, entangled in tall grasses, has rarely looked more genuine, spirited, and maybe even attainable. Hedonists in the making (Baker, Dennis Hopper, and Truman Capote, shot between 1955 and 1957) appear mere innocents in Claxton's pictures, each touched by fame's first blush. A waif-like Mia Farrow looks barely legal, and with good reason. The blonde with the freckles, photographed in 1961 on the grounds of the Beverly Hills Hotel, had just turned sixteen.

Claxton's Hollywood is certainly glamorous, but it also has a relaxed, unaffected coziness. In almost every picture, the images are the result of an encounter in which the subject and a gifted mischief-maker are in sly sync.

Claxton has an eye for the off-guard and unexpected. Here's Geraldine Page, between scenes in a Lillian Hellman play, idly sucking a lollipop. There's photographer Lee Friedlander as a hip Chevalier in a cocked boater. And look at Judy Garland, miraculously transfigured in the course of two exposures—aided by a few pills, and a couple of hits from a bottle of Liebfraumilch—from a dressing-room wreck into a footlight dynamo.

Amid all this freshness, true magic is inevitable. And here Claxton manages to present classic images of Hollywood luminaries. Marlene Dietrich in white tie and black top hat, eyes lost in the stars. Frank Sinatra, looking insanely debonair, popping out of a harp case. Natalie Wood, on a windswept balcony, the city tamed by her commanding gaze. And on. And on.

Open your senses to William Claxton's world. Each picture in *Photographic Memory* seems to have been made with the cool, breezy ease of a Paul Desmond solo. "Photography," as William Claxton once observed, "is jazz for the eye."

New York City
June 2002

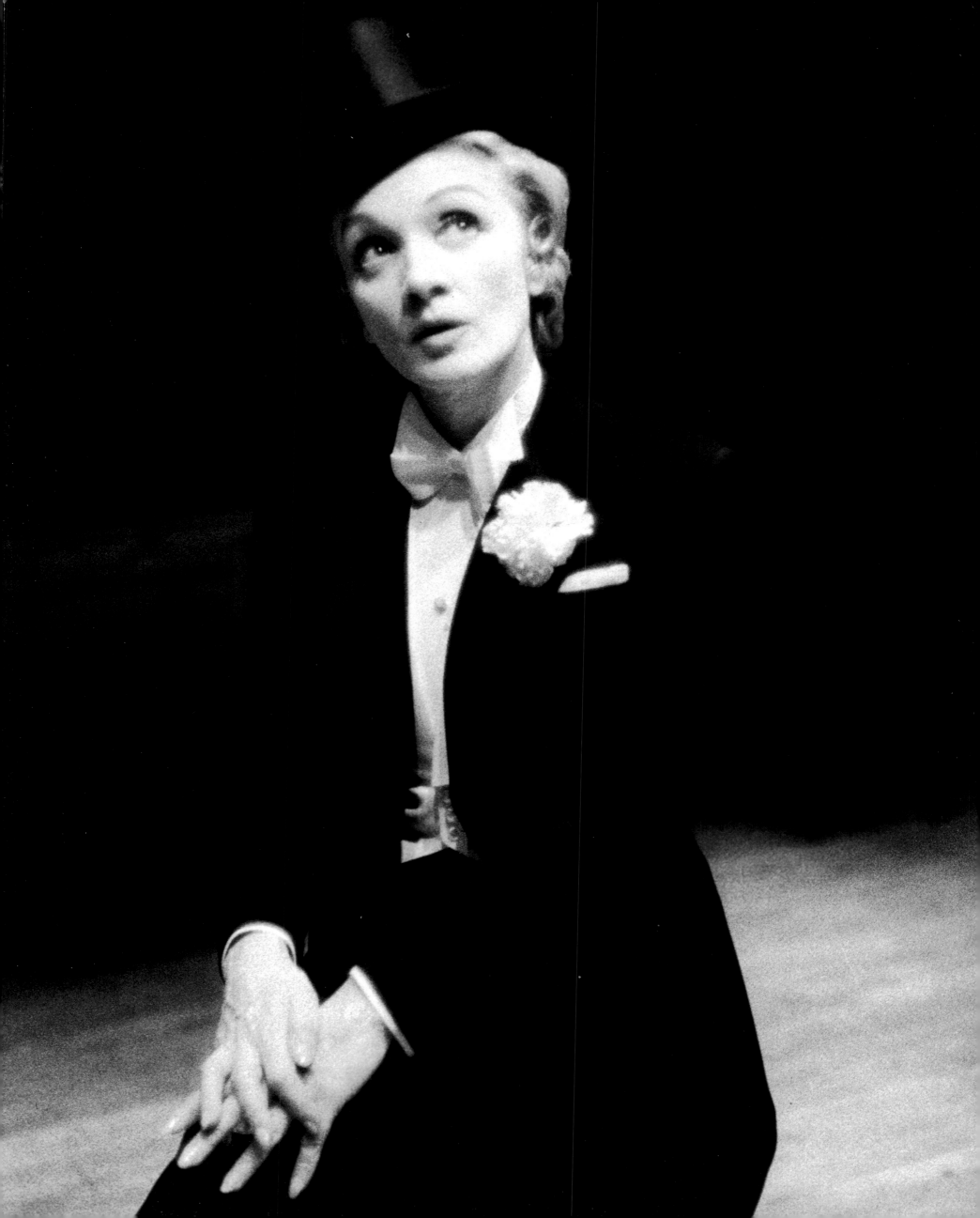

MARLENE DIETRICH

Las Vegas, 1955. That spring, I had an assignment from Columbia Records to photograph Marlene Dietrich in Las Vegas, where she was performing at the Sands Hotel. It was all quite sensational, if just for the fact she was appearing onstage in a "nude evening gown" designed by Jean Louis — all jewels and netting worn tightly over her naked body. Our meeting was scheduled for 6:00 p.m. in her dressing room backstage. I walked down the hallway looking for the door. On my way, I passed a room in which an elderly woman sat. She looked very much like my grandmother, who had come from St. Petersburg. I stopped in my tracks. This can't be. Was that Marlene Dietrich? I slowly approached the dressing room door. "Come in," she said. "You must be the photographer, yes?"

There sat a small, thin lady with fine and delicate features and just a wisp of hair on her head, just like my grandmother. She smiled and invited me in. "Put away that camera; come sit down next to me. Hannah," she said to her assistant, "please bring our young photographer-friend a cup of tea." I sat down next to her dressing table; she sat facing her mirror, hardly looking at me. "Now, my dear. You see this?" She pulled on the loose skin below her chin and shook it. "We don't want to see this, understand? You sit there and enjoy your tea, and I will explain how I like to be photographed. I have a great deal of experience, and believe me, I know this face." She tugged at her cheeks, still not looking at me, looking only at the mirror, and began to apply her makeup meticulously, layer upon layer—eyelashes, rouges, powders of various shades, all the while explaining to me how the light strikes her face, how it hits her cheekbones and reflects back to the camera or to the audience. Her eyes never left the image in the mirror. After about an hour, she snapped her fingers and beckoned her assistant. The assistant came in with a blond wig and helped Ms. Dietrich place it carefully on her head. They fussed with it a bit. Finally, she turned and faced me directly. She looked stunning. "Now," she said, "you may take out your camera."

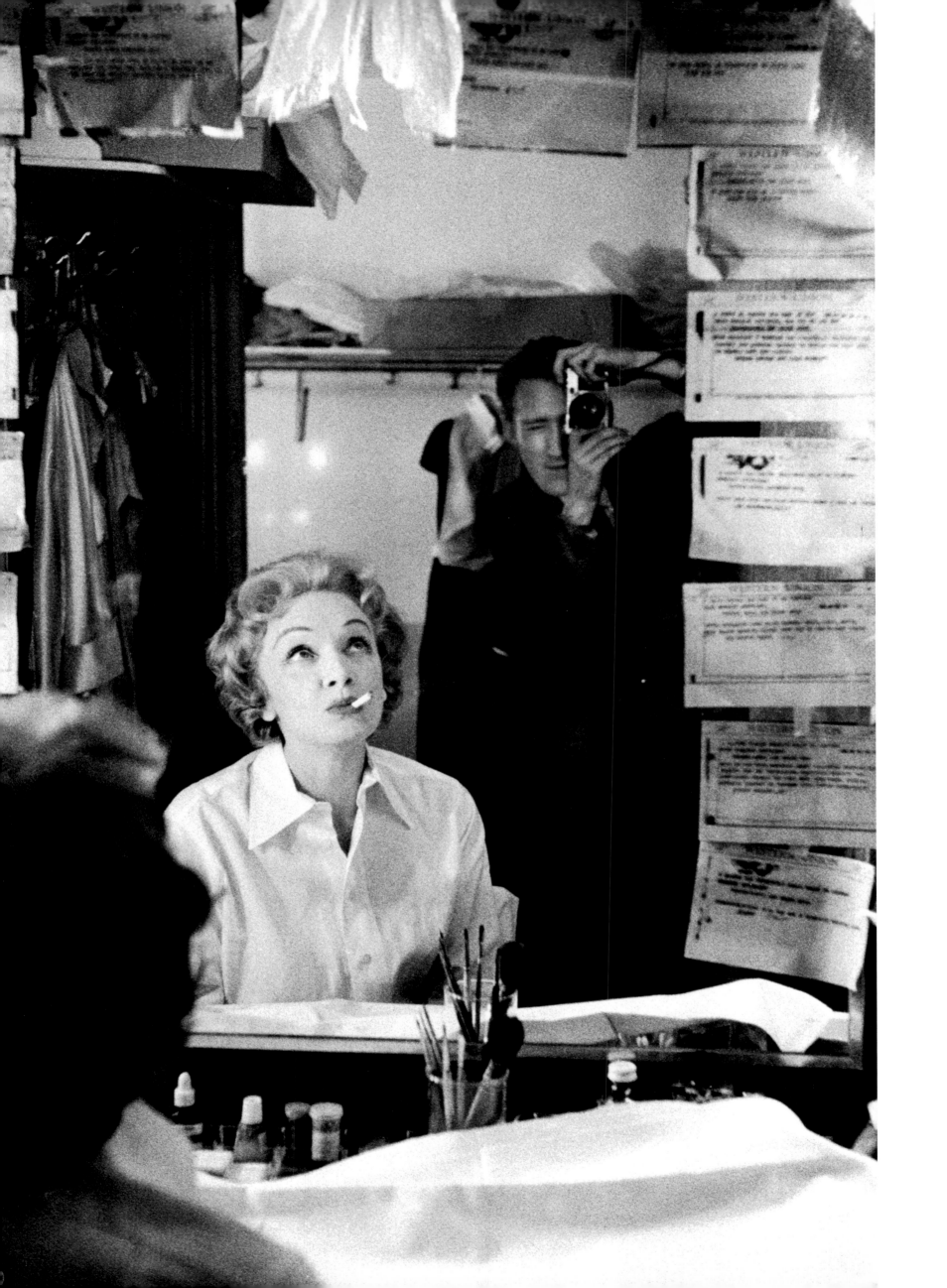

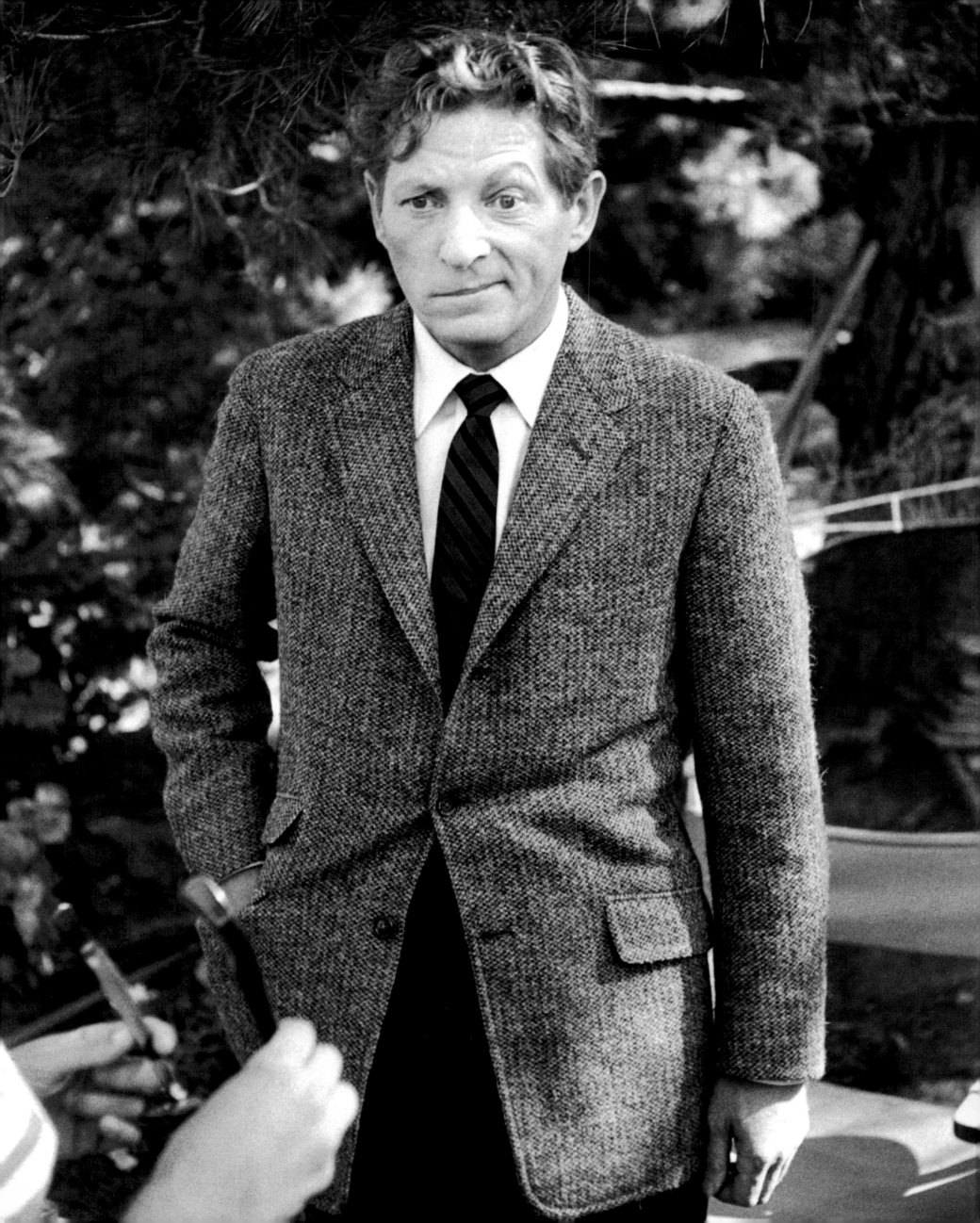

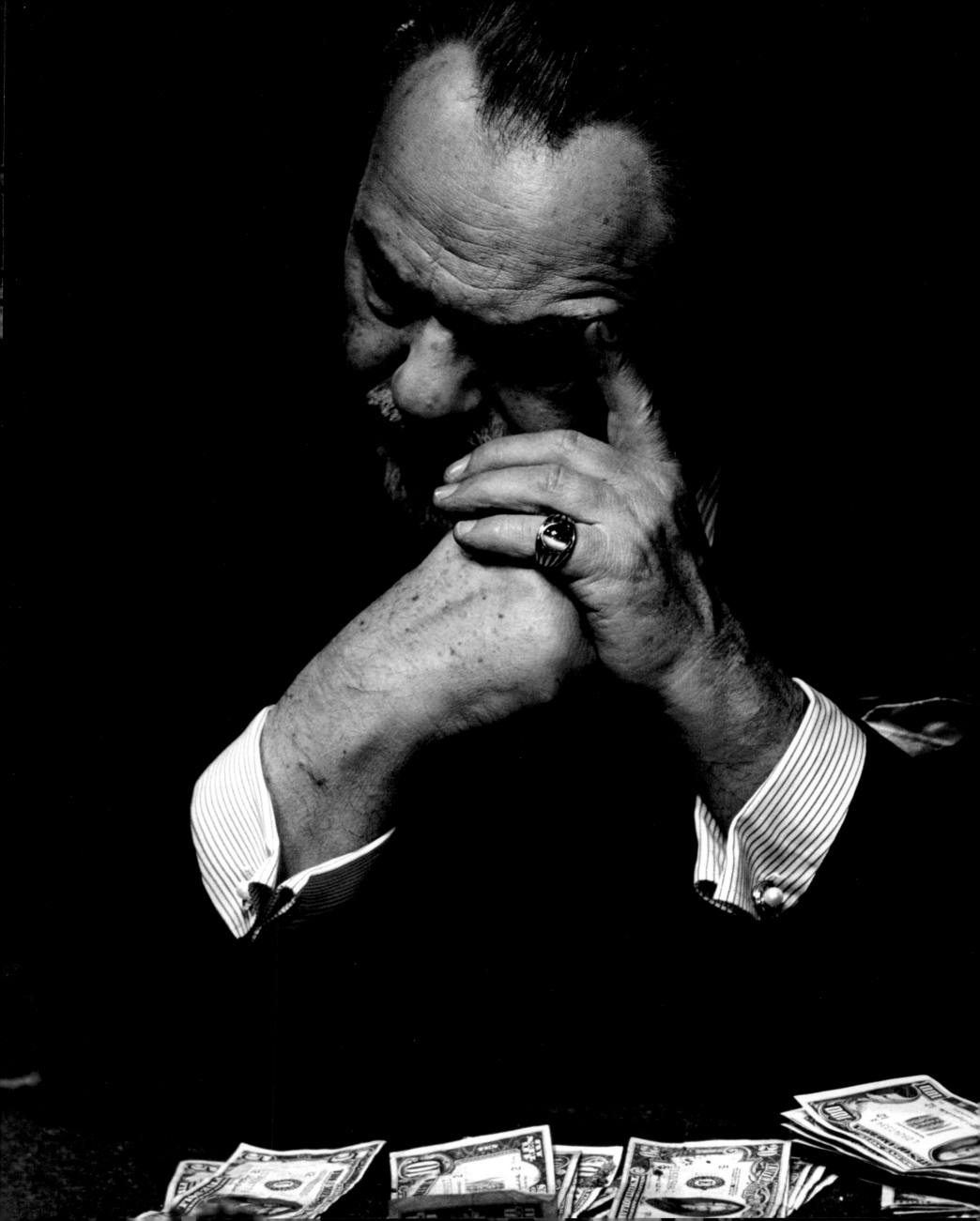

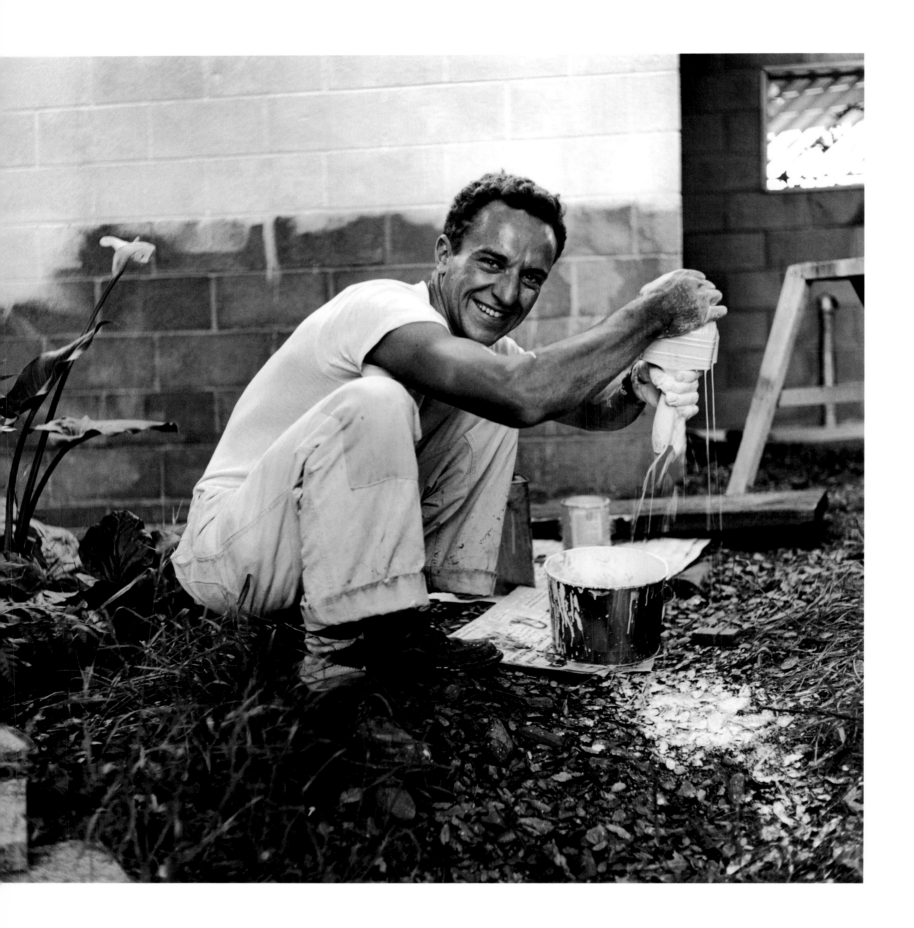

RICHARD LANG

La Crescenta, California, 1952. Richard and I met when we were teenagers. He was seriously into photography. I had always loved the art, but knew little about how to perform it well. Dick was a born scientist. He was a near genius at math, physics, and chemistry. We would spend a lot of time together during summer vacations. Besides photography projects with me, Dick always had a construction under way, whether it was to build a brick wall around his mother's garden or to undertake the digging of a swimming pool. There wasn't anything that he couldn't build. He was husky, strong, and thrived on hard work. After dinner, Dick would relax, lying back on the couch listening to records or watching television. Often his mother Ruth would call out, "Rich, make us some fudge!" or "How about a chocolate cake!" Dick would happily leap up from the couch, go into the kitchen and whip up something great that the whole family would enjoy.

Being the scientist that he was, he taught me all the technical ins and outs of the chemistry of photography, and the physics of lenses. He was a tough teacher. I had to learn the process properly. He wouldn't let me slide by on any aspect of the craft. On summer vacations, we had a neighborhood photo business, shooting weddings, parties, and portraits. We built a state-of-the-art darkroom. Actually, Dick did most of the construction. We developed film and made prints into the early hours of the morning while listening to our favorite big bands like Duke Ellington, Glenn Miller, and Tommy Dorsey.

Although I was studying hard at UCLA, my real love was shooting pictures and then printing them. The darkroom virtually became my den for introspection, my sanctuary from the Sturm und Drang of everyday life. Not only was it a place to ponder, but the payoff was handmade, tangible photographic prints that I was proud to show to my family and friends.

I will always be grateful to Dick for teaching me my art and craft. He went on to become a successful building contractor creating luxury homes in the beautiful country around Sequoia National Forest in central California.

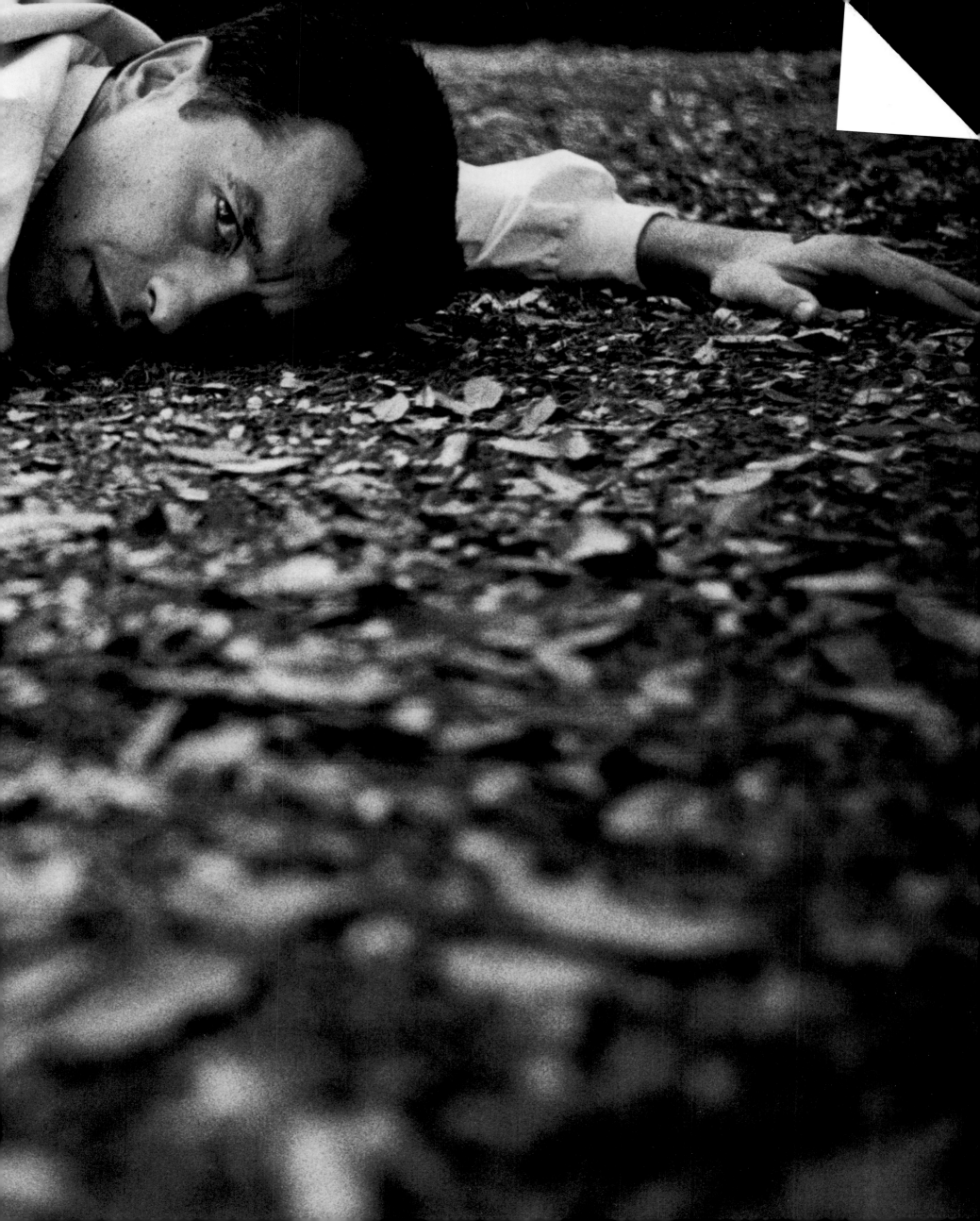

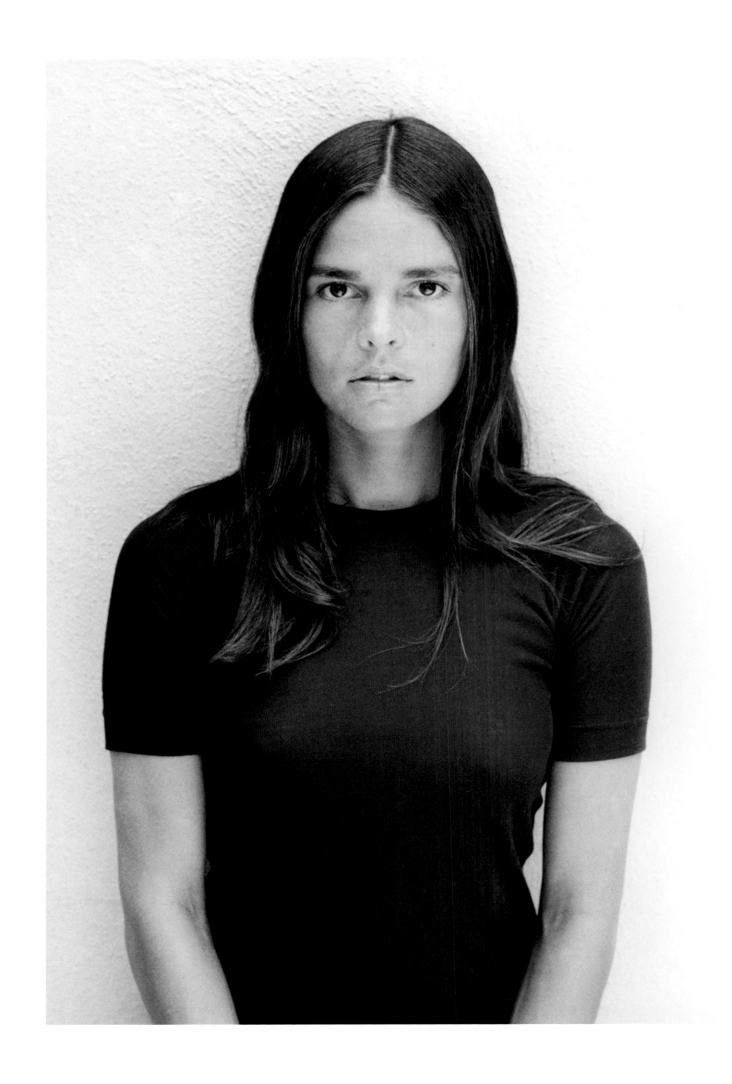

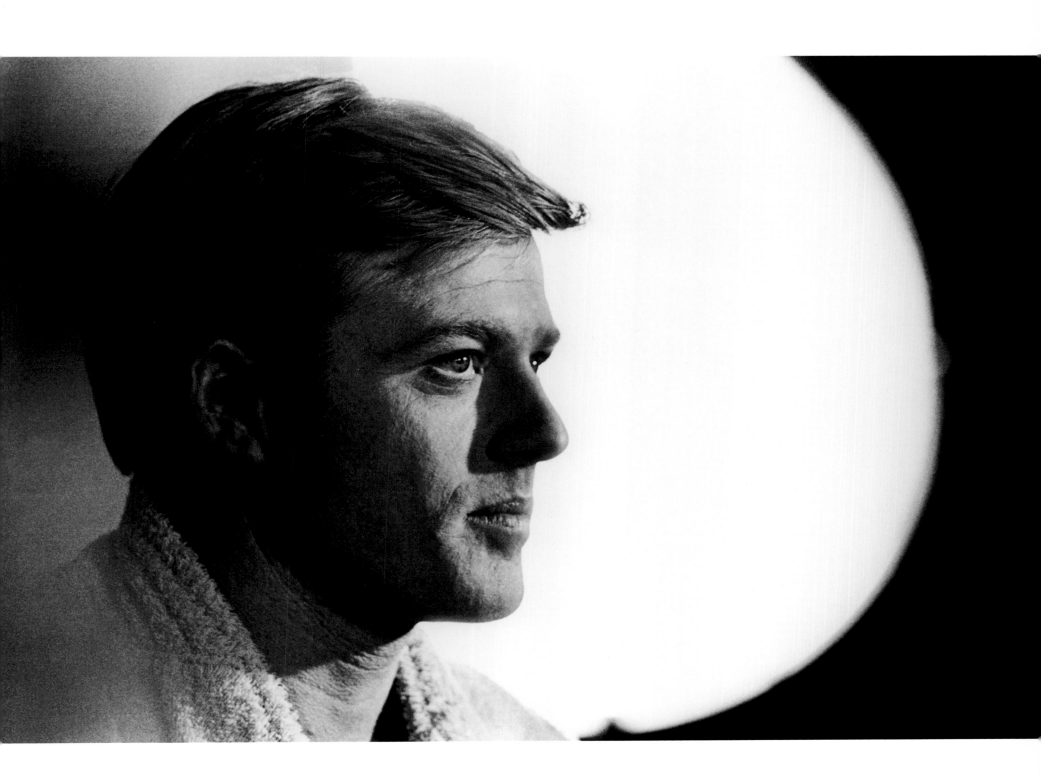

Laguna Beach, 1956. I was invited to see a performance by the Lester Horton Dancers at a small theater in Hollywood. Although Carmen de Lavallade was the star of the small, creative company, it was a young and spirited dancer named Lelia Goldoni who caught my eye. She moved across the stage with such freshness and confidence that she really seemed to take it over completely.

We met and had a lot of fun together—I was always photographing Lelia; her unusual countenance adorned many a record cover that I shot, both classical and jazz. In spite of the fact that she could look like Italian aristocracy, especially in profile, her riotous laughter and young-girl behavior were disarming. She would surprise me, and everyone else for that matter, with her funny antics.

Shortly after my father died, I would frequently drive my mother to her various appointments. One day while driving in Hollywood, I was telling her about this fabulous dancer I was seeing. She listened politely with that no-girl-will-be-good-enough-for-my-son look, when all of a sudden I saw Lelia across the street. She was walking her exotic Afghan hound, Rasputin, and wearing an outrageously sexy outfit. I said to my mother, "Oh my God, that's Lelia!" As we got closer, my dear mother had a fit, "Why is she smoking a pipe?" It was true; Lelia was smoking a large man's pipe. That was Lelia—you never knew what she would do next. I have not seen her smoke a pipe since. And my mother, like Queen Victoria, "was not amused."

LELIA GOLDONI

Lelia was to star with Ben Carruthers in John Cassavetes's innovative, all-improvised movie *Shadows*. That opened many doors for her, and she began to appear in many films. She moved to London during the "swinging London" period, as I did. I ran into her one day; she had not changed. She was delightful and funny. She invited me to lunch at a large and beautiful house where she was living in the Belgravia section of London.

Her butler served us drinks. I couldn't help noticing that he was very much the proper English butler, with a strong, resonant, and deep voice.

Lelia was the prefect hostess, and we had a wonderful time reminiscing. The time came for me to leave, and her excellent butler helped me with my topcoat. He showed me out the door, inquiring dutifully if he might call a taxi for me.

About two years later, my wife Peggy and I were invited to a screening of a new film called *Joanna*. Suddenly there appeared on the screen an actor with a magnificent voice. "My god!" I said to Peggy, "That's Lelia's butler!" The actor's name was Donald Sutherland.

Once again, Lelia amazed me.

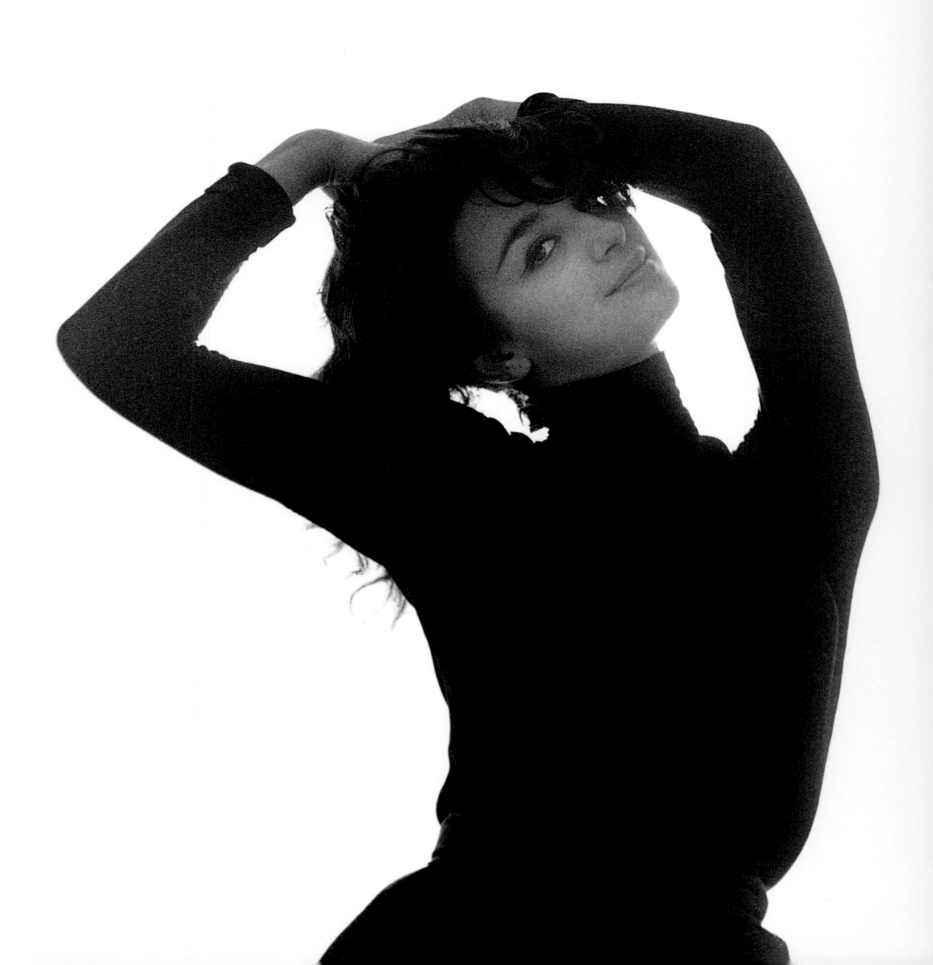

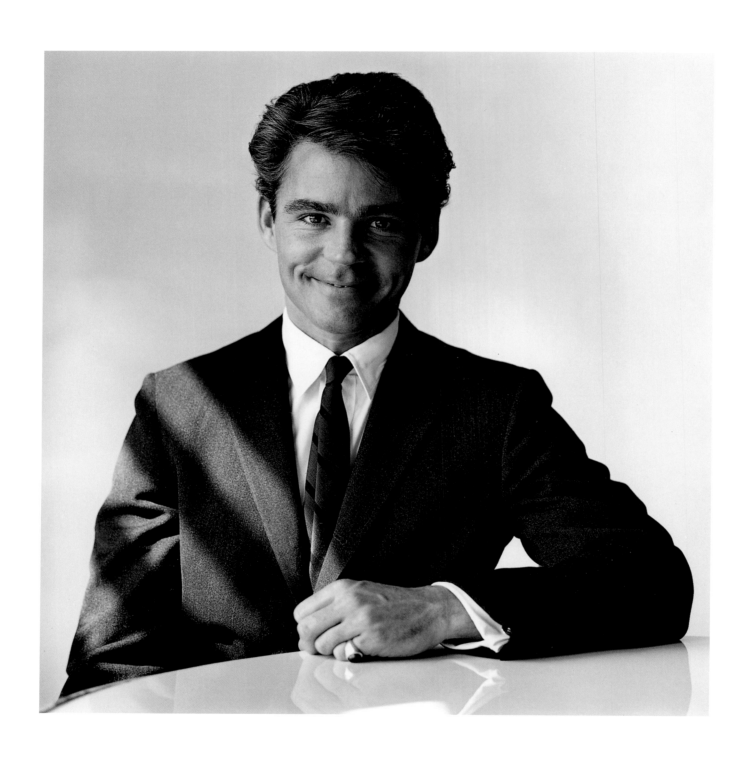

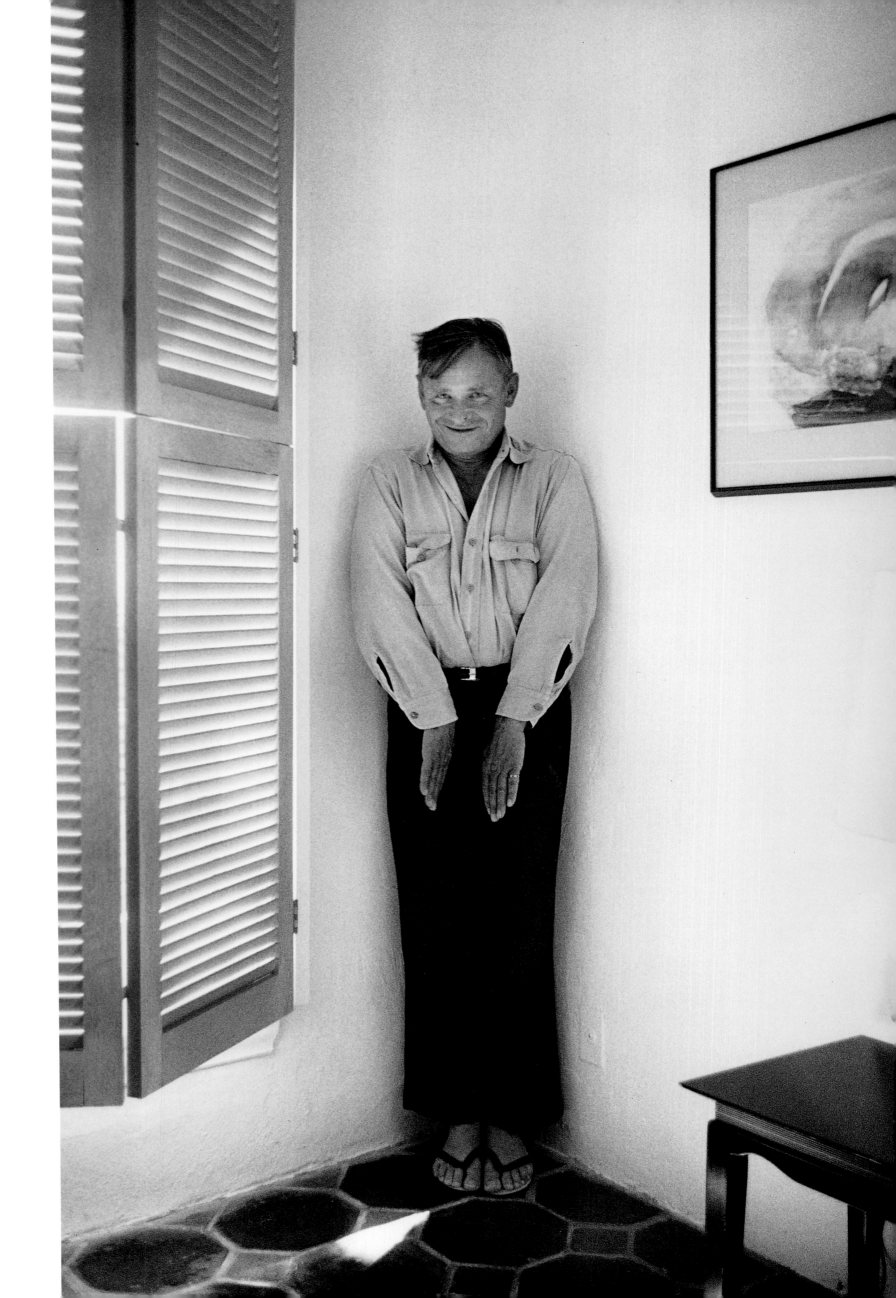

New York City, 1969. In the winter of 1957, I knocked on the front door of an upstairs Spanish duplex in what is now West Hollywood. The door opened suddenly, and a beautiful black-haired, pale-faced girl stood there. "You must be William Claxton. I love your photographs," she said as she rushed out past me leaving. That's how I met the young actress, Peggy Moffitt. What a great girl—she actually likes my work! I thought; not bad for starters.

She returned fairly quickly to the apartment of our mutual friend, actor Tom Pittman. I had asked him to be in a photo story that I was shooting about a young Los Angeles couple going around to popular coffeehouses and hip clubs. Peggy, Tom, and I went out about town while I shot them in various locations. The three of us had so much fun together that we were actually better than *Jules et Jim*. What was to be a one-day shoot went on for the entire weekend.

Peggy and I instantly hit it off. After a few weeks of seeing each other, we grew closer and closer. We shared many passions. Peggy was extremely bright, funny, and sophisticated beyond her twenty years. I had never met anyone quite like her. I was falling in love and not knowing it.

Peggy had great style not only in the way she dressed, but in everything she did. The simple things became small productions. She had that knack. For instance, late one night after the theater, I mentioned that I was hungry. "We can take care of that right now," Peggy replied. She drove me to the lush gardens of the Los Angeles County Museum in her chic black '55 Thunderbird, where she produced a chilled bottle of vintage champagne and a hearty supply of paté de fois gras and French bread. The moon was full that night. We turned on the car radio and danced around the garden in the moonlight.

PEGGY MOFFITT

Peggy learned very early how to make me laugh. One time we were driving down Wilshire Boulevard, and she began imitating a Hawaiian steel guitar accompanying a dreadful singer on the radio. She had me laughing so hard that I nearly wet my pants and had to pull the car over to recover. Her wit and her charm really turned me on.

Like a cloud over our heads, however, an unfortunate situation began to develop. Tom was feeling like the "third wheel," not an unusual problem when three people become close. Tom had always been unhappy about his work and about himself. His career and his life was becoming at times, in his eyes, unbearable. He broke off with us one night at a big Halloween party. It was late, and after drinking too much, he said sarcastically, "Why the hell don't you two get married?" He jumped into his specially-built Porsche and roared off, disappearing into the night, never to return.

The police did not find the demolished Porsche with his body in it for nineteen days. We, of course, were devastated by the tragedy, but it also brought us closer together. I proposed to Peggy in February of 1959, and we were married in June in New York City.

Peggy had appeared in thirteen movies while she was very young, as a teenager, but she was not happy with the business end of the acting world. I suggested that she get into fashion modeling; she did, and became one of the most original fashion models in the world. Her work with avant-garde fashion designer Rudi Gernreich, coupled with the photographs we did together, produced some of the best fashion images of all time. This was especially true of the famous topless swimsuit photo that we made in 1964.

I think that the formula in the chemistry that has kept us together these forty-three years comes from a mixture of love and respect for one another. Peggy's enthusiasm for and insight into my work has made us great collaborators. I know for a fact that she is the best friend I shall ever have.

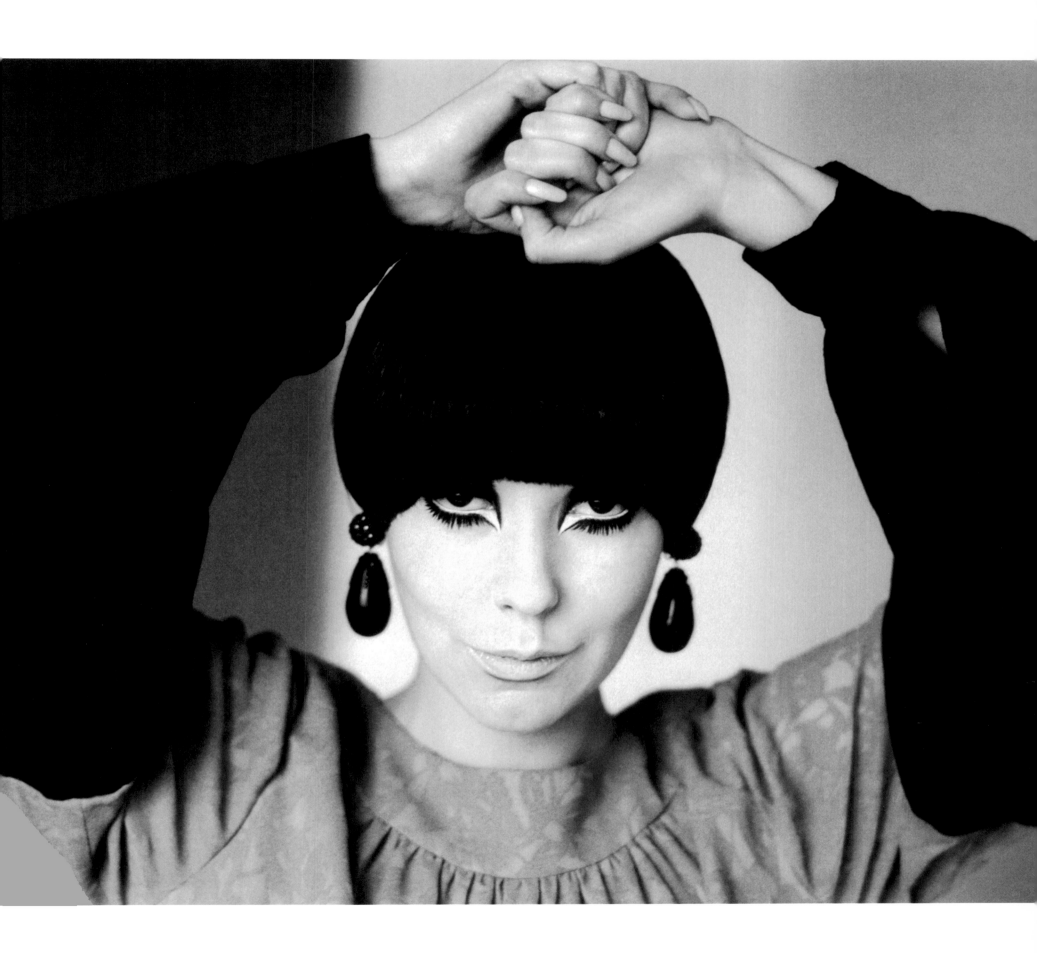

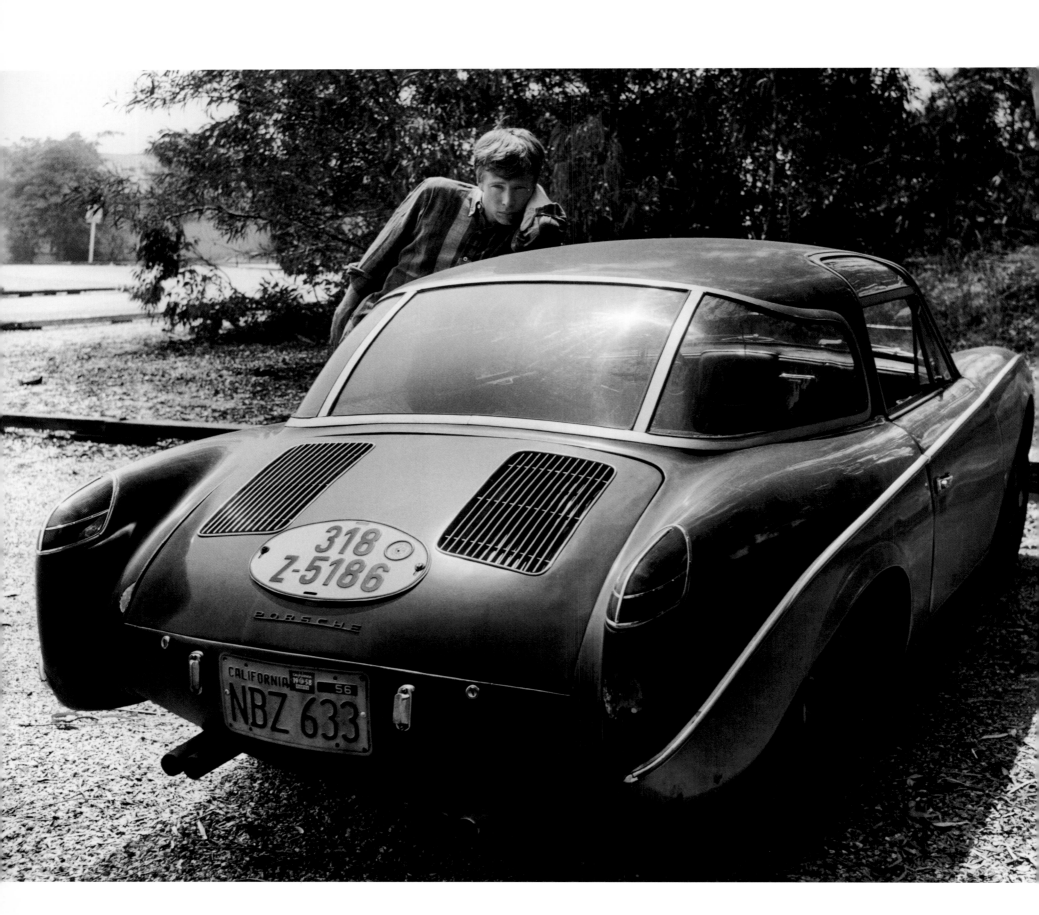

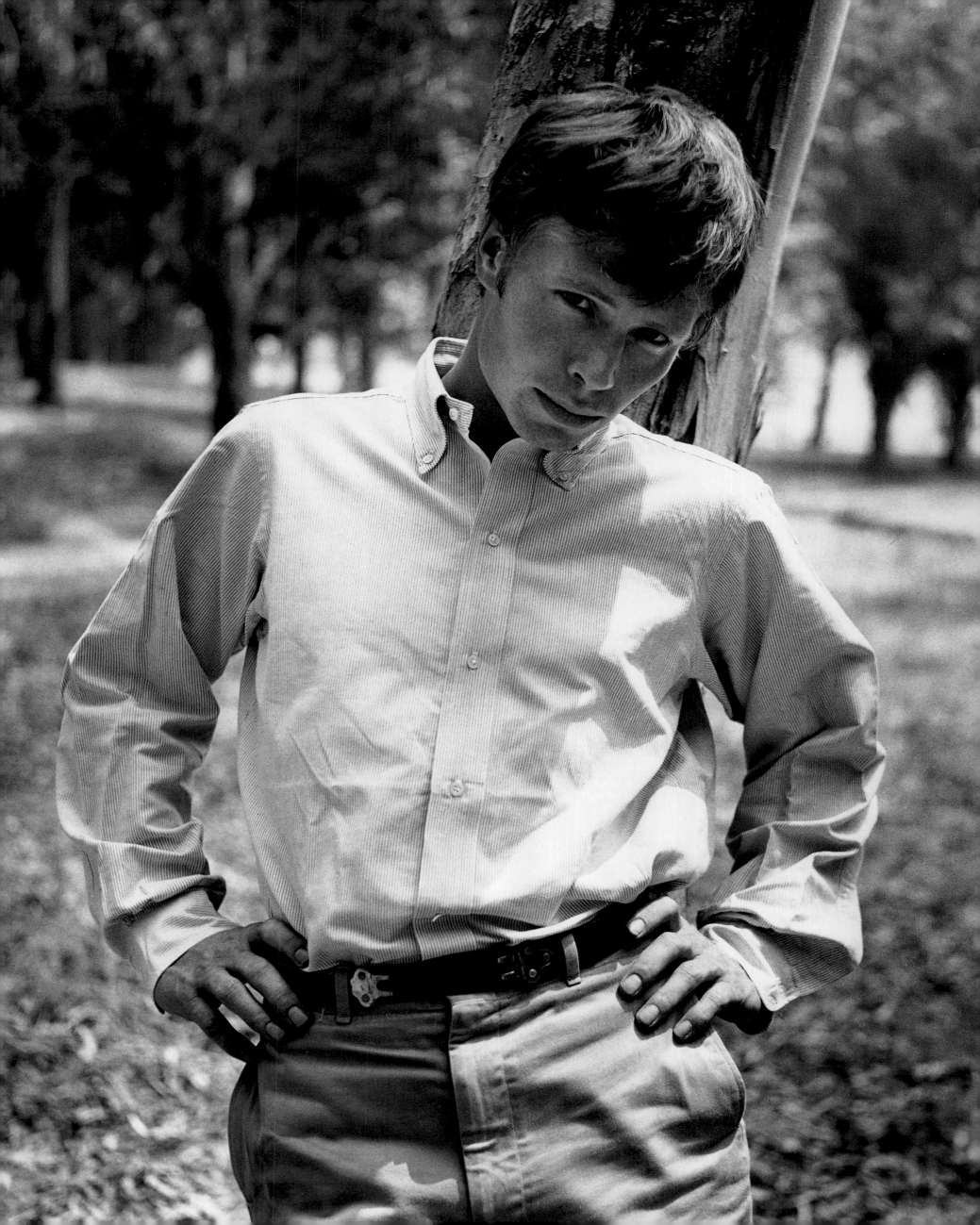

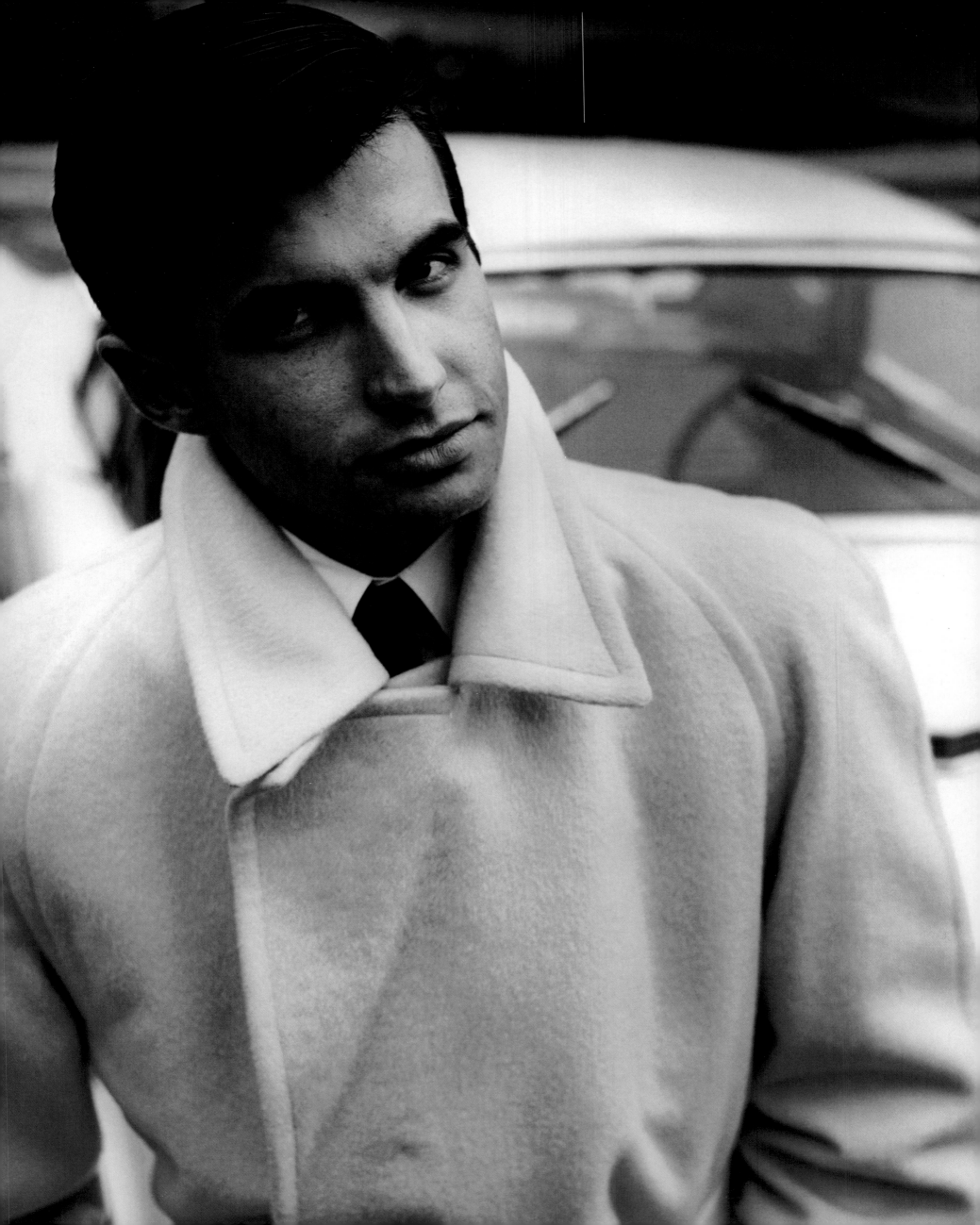

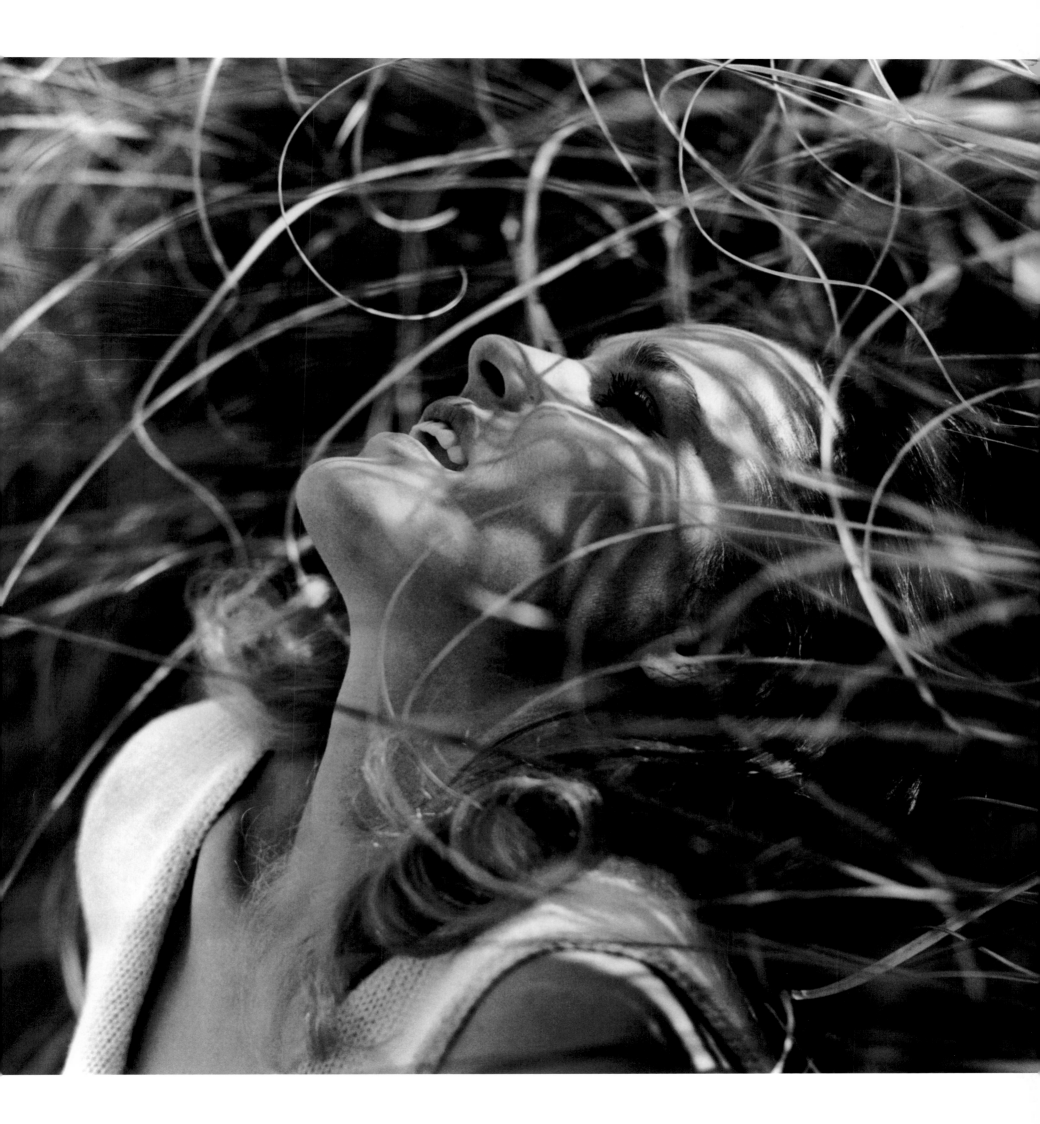

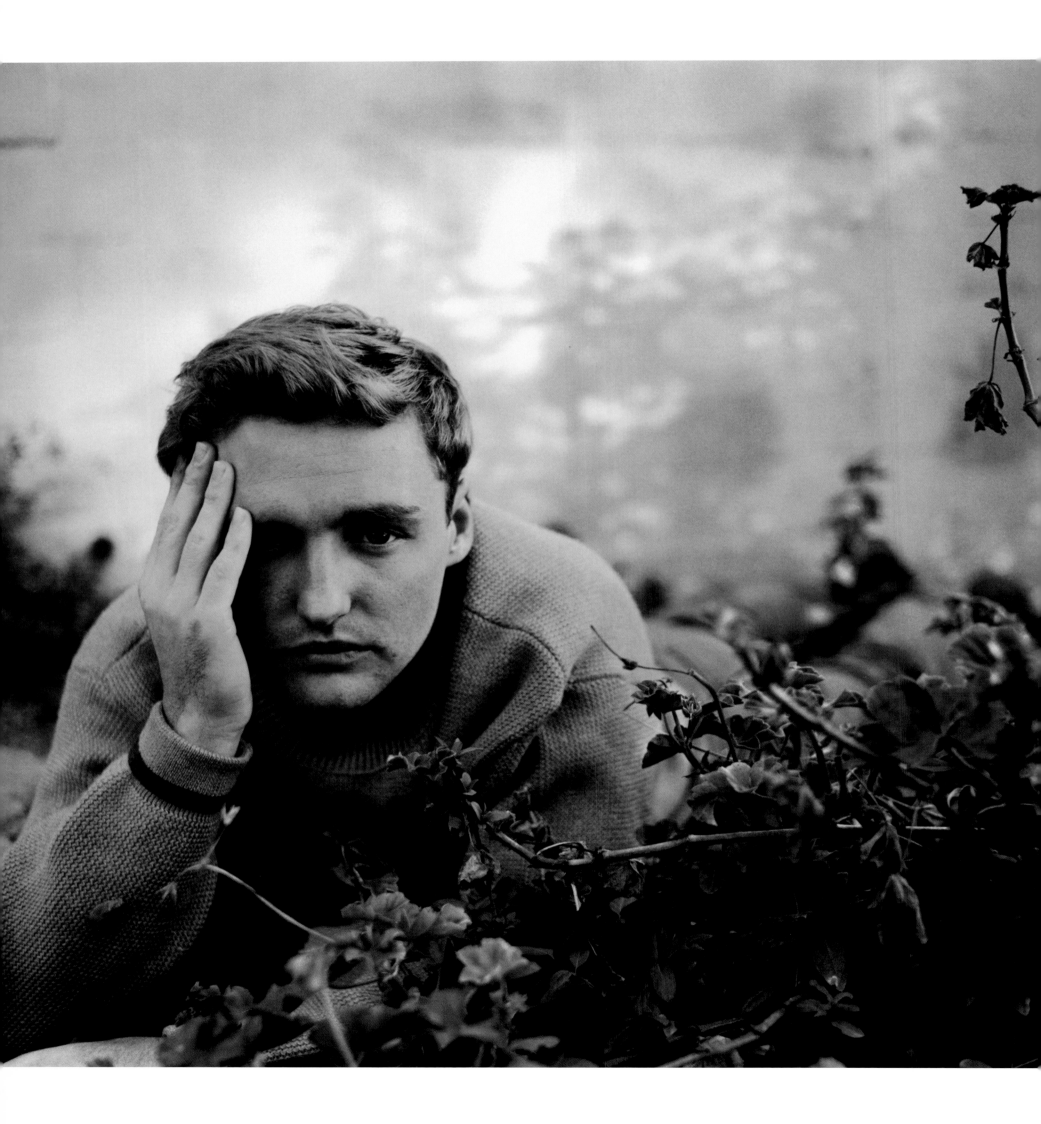

DENNIS HOPPER

Hollywood, 1955. I was driving west on Sunset Boulevard with the top down on my brand-new black Ford Skyline convertible, the first new car that I had ever owned. My photography business was finally beginning to take off.

As I approached a stop signal, a young man leaned into my car and asked me for a ride. I said, "Sure." It was a nicer, friendlier, and more trusting time back then, and it was not unusual to pick up a hitchhiker as a courteous gesture.

"Hi, I'm Dennis. I live right up the street," he said as he got into my car. I reasoned that he must live on or near Sunset, but wondered why he needed a ride just down the street. My passenger quickly shouted, "Turn right here on Kings Road and go up the hill." We drove up and up that damn hill for what seemed like forever. "Where am I taking us?" I inquired. He replied, "Oh, I live on top of the mountain, it's a great drive, and you can see all of L.A. from there."

As we pulled up to the hilltop house on Appian Way, he invited me in to see his apartment. "You'll dig my pad," he said. He told me that he was in two films, *Rebel Without a Cause* and *Giant.* I had not seen them yet, but I had heard a great deal about them. I was duly impressed. We talked about art and photography. He wanted to be a painter as well as an actor. I did not think much of his paintings, however, though we had a great time talking. I had my Rolleiflex with me, so I photographed him.

The next time I saw Dennis was about a year later. It was at Vincent Price's palatial home in the Holmby Hills section of West Los Angeles. I was working on a book about Vincent's extensive art collection. Vincent and I were discussing the project when his houseman interrupted us to say that Dennis Hopper was at the door. Vincent, who was one of the kindest and most sensitive people I had ever known, groaned, "Oh, Lord, Dennis again. He most likely wants me to critique one of his paintings. His work is dreadful, but do you mind? It will only take a few minutes."

Dennis came in with several paintings and displayed them around the room. Vincent tried not to cringe. He examined the paintings in detail and said, "Well, Dennis, you do show progress. Try working a little more on your colors and a bit more on your overall composition...shall we have some coffee?"

I told Vincent the story of how we met, which he found amusing, and said, "Only an actor would have the nerve to make such a bold request and talk you into bringing him to the top of the Hollywood Hills."

Dennis and I have remained good friends for many years, through his various wives, movies, art shows, crazy parties, and health problems. He has become a very good photographer. His images of the peace marches in the '60s are memorable. And he is still making bold requests of people and getting away with it.

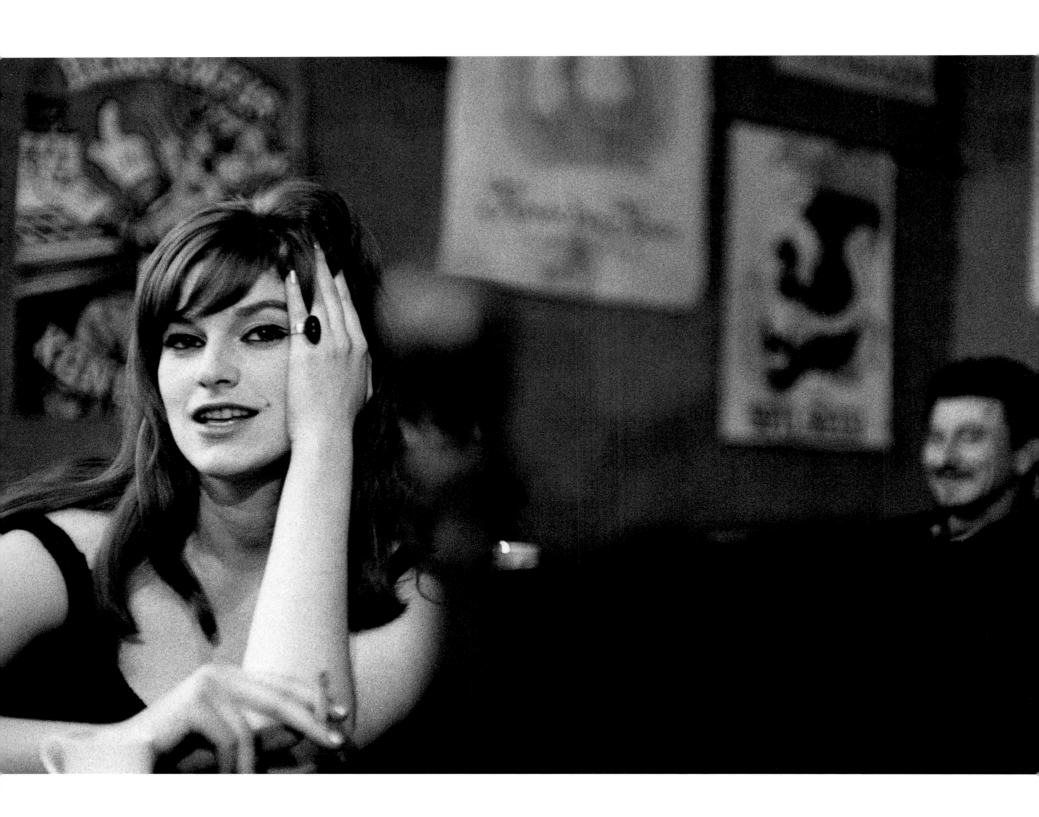

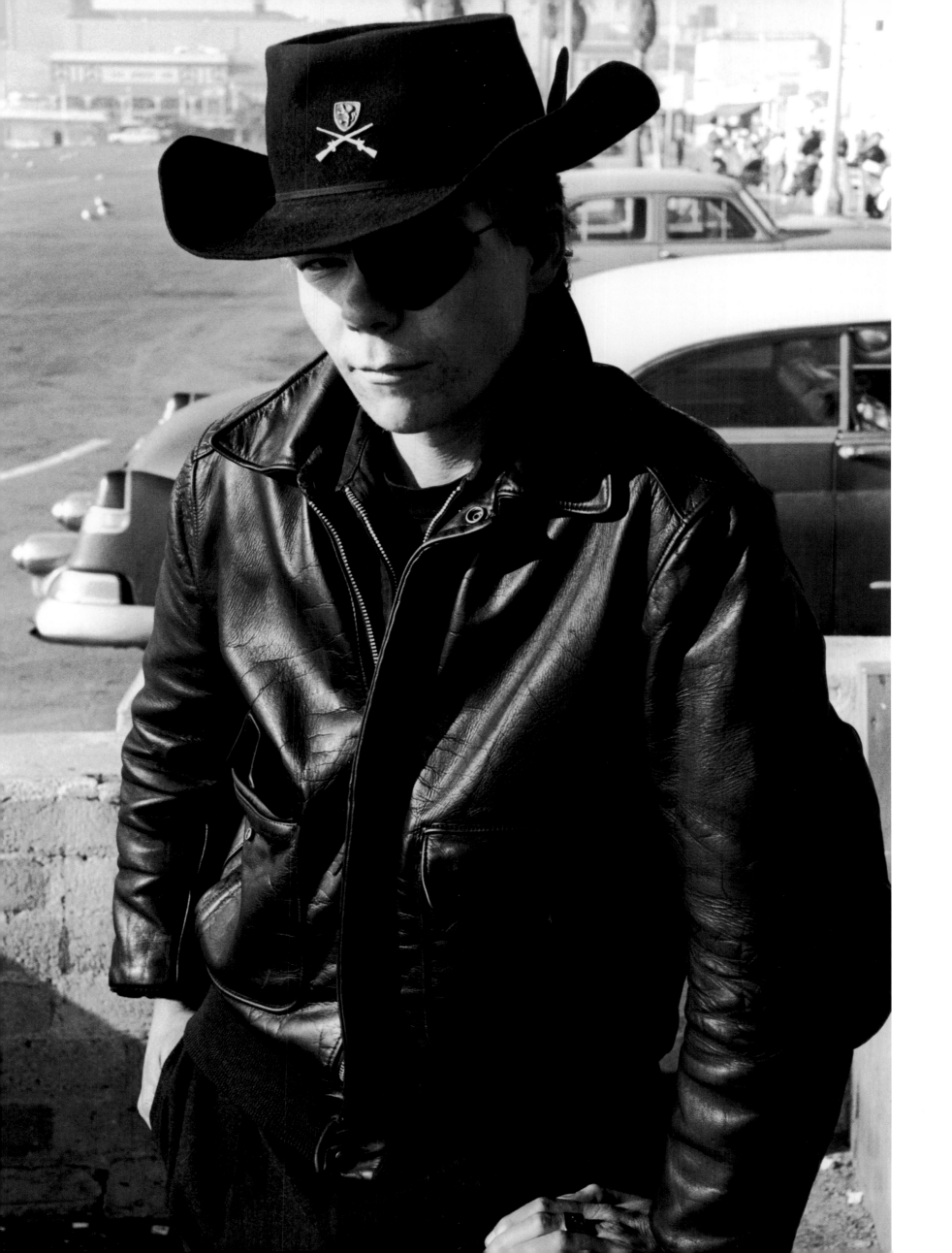

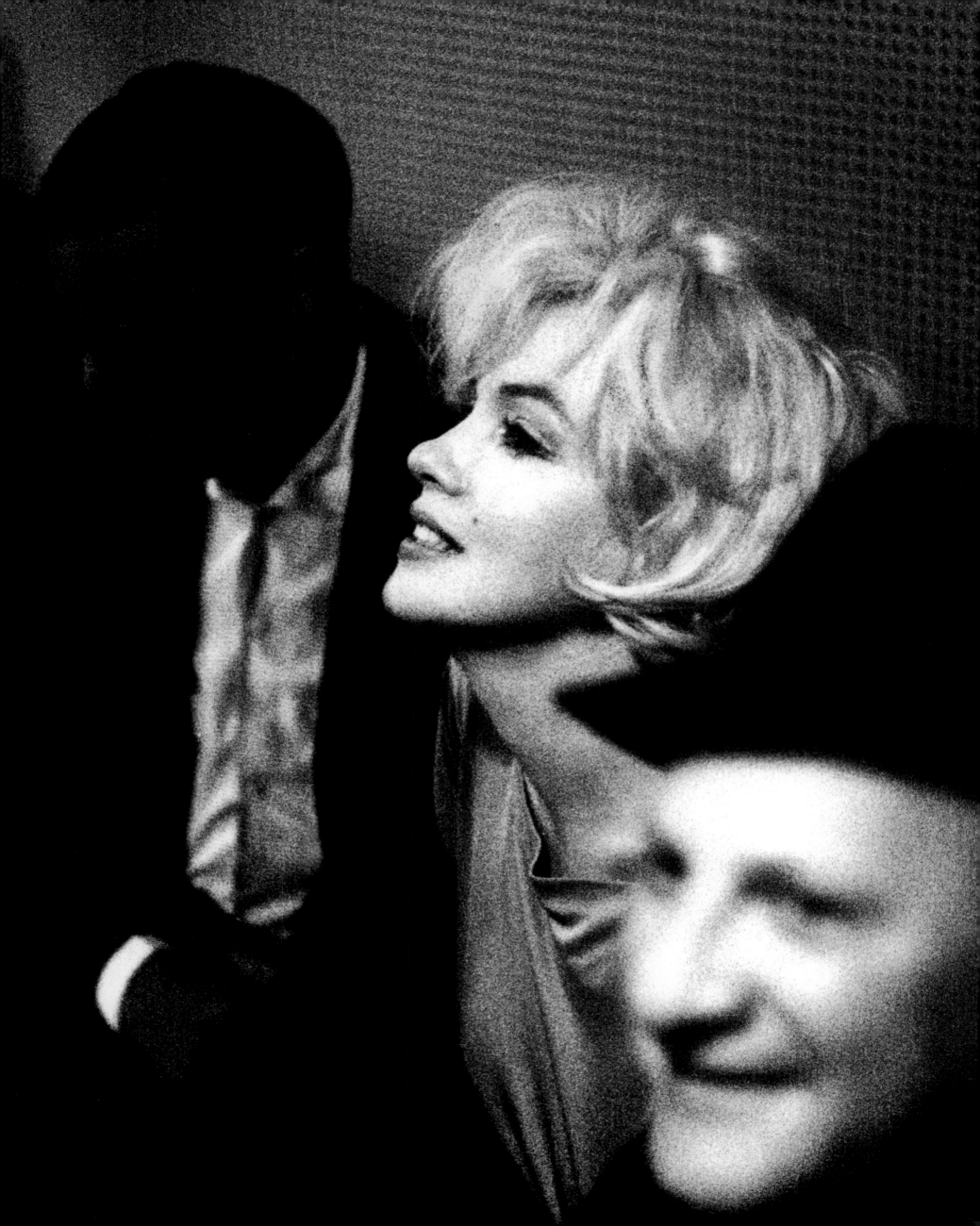

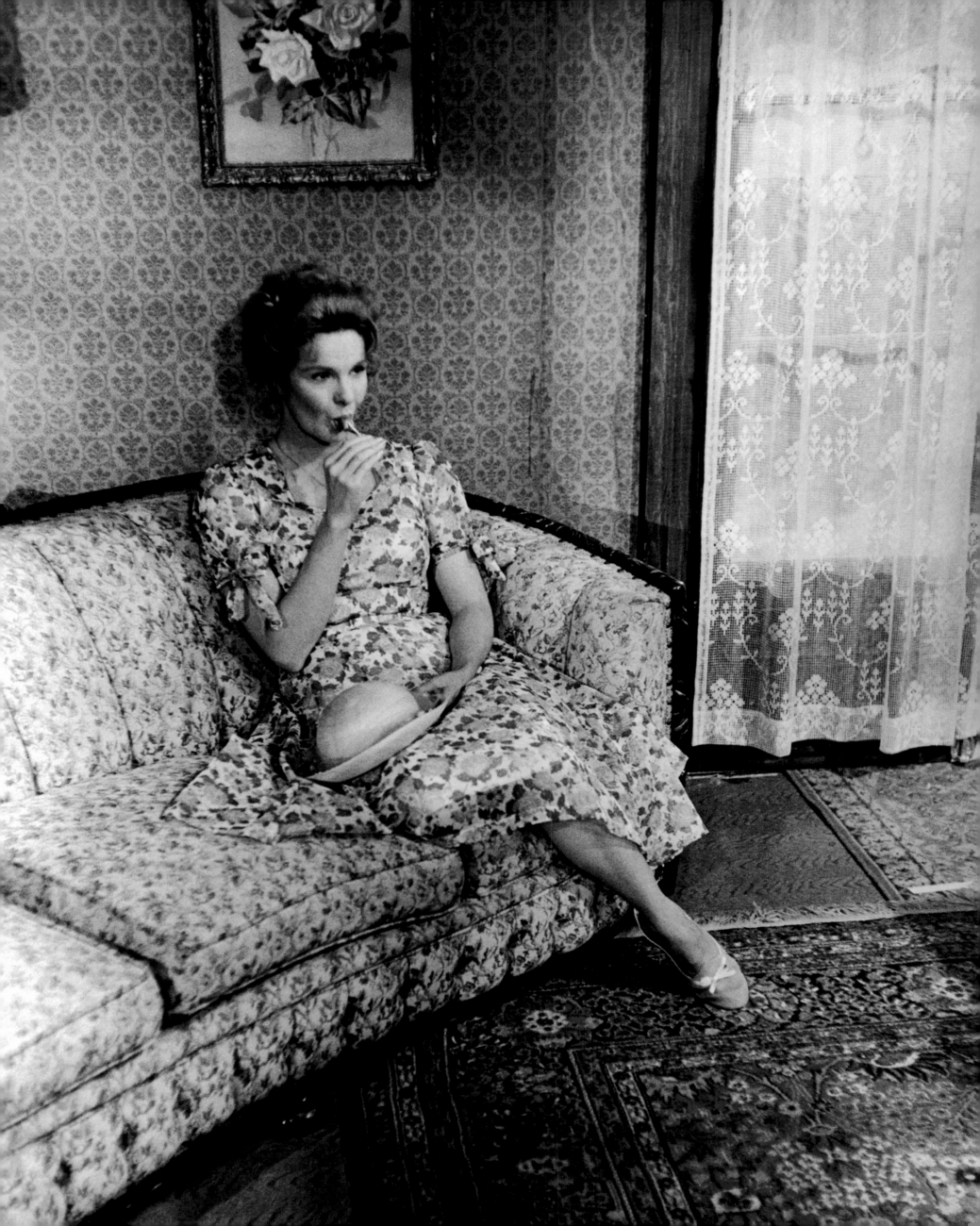

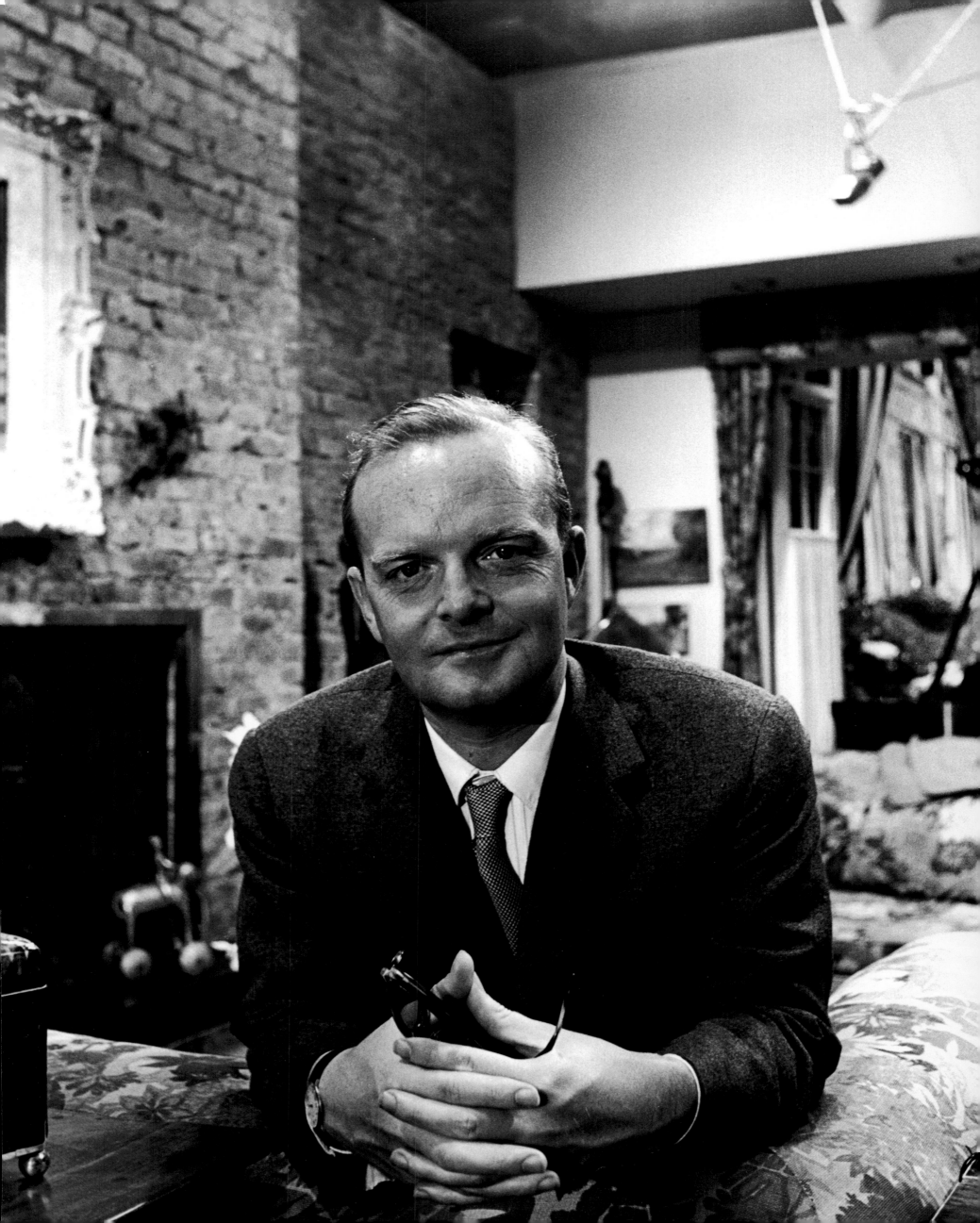

ALDOUS HUXLEY

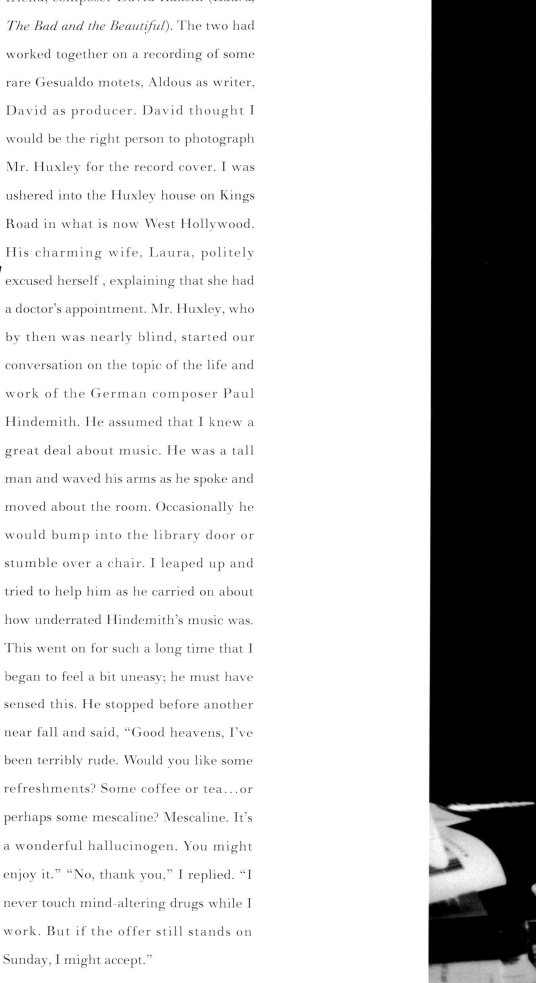

West Hollywood, 1957. I met Aldous Huxley in 1957 through a friend, composer David Raksin (*Laura, The Bad and the Beautiful*). The two had worked together on a recording of some rare Gesualdo motets, Aldous as writer, David as producer. David thought I would be the right person to photograph Mr. Huxley for the record cover. I was ushered into the Huxley house on Kings Road in what is now West Hollywood. His charming wife, Laura, politely excused herself , explaining that she had a doctor's appointment. Mr. Huxley, who by then was nearly blind, started our conversation on the topic of the life and work of the German composer Paul Hindemith. He assumed that I knew a great deal about music. He was a tall man and waved his arms as he spoke and moved about the room. Occasionally he would bump into the library door or stumble over a chair. I leaped up and tried to help him as he carried on about how underrated Hindemith's music was. This went on for such a long time that I began to feel a bit uneasy; he must have sensed this. He stopped before another near fall and said, "Good heavens, I've been terribly rude. Would you like some refreshments? Some coffee or tea…or perhaps some mescaline? Mescaline. It's a wonderful hallucinogen. You might enjoy it." "No, thank you," I replied. "I never touch mind-altering drugs while I work. But if the offer still stands on Sunday, I might accept."

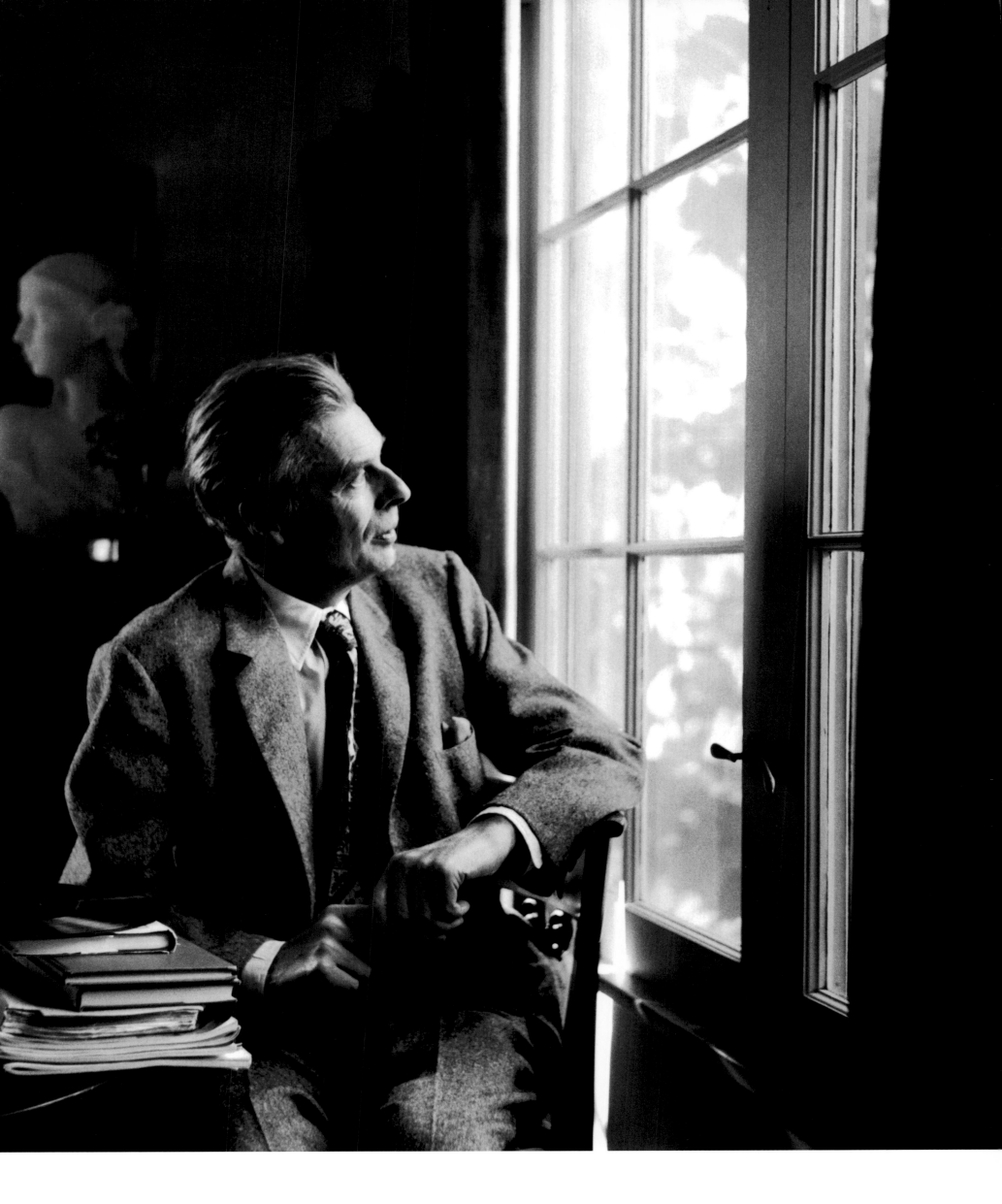

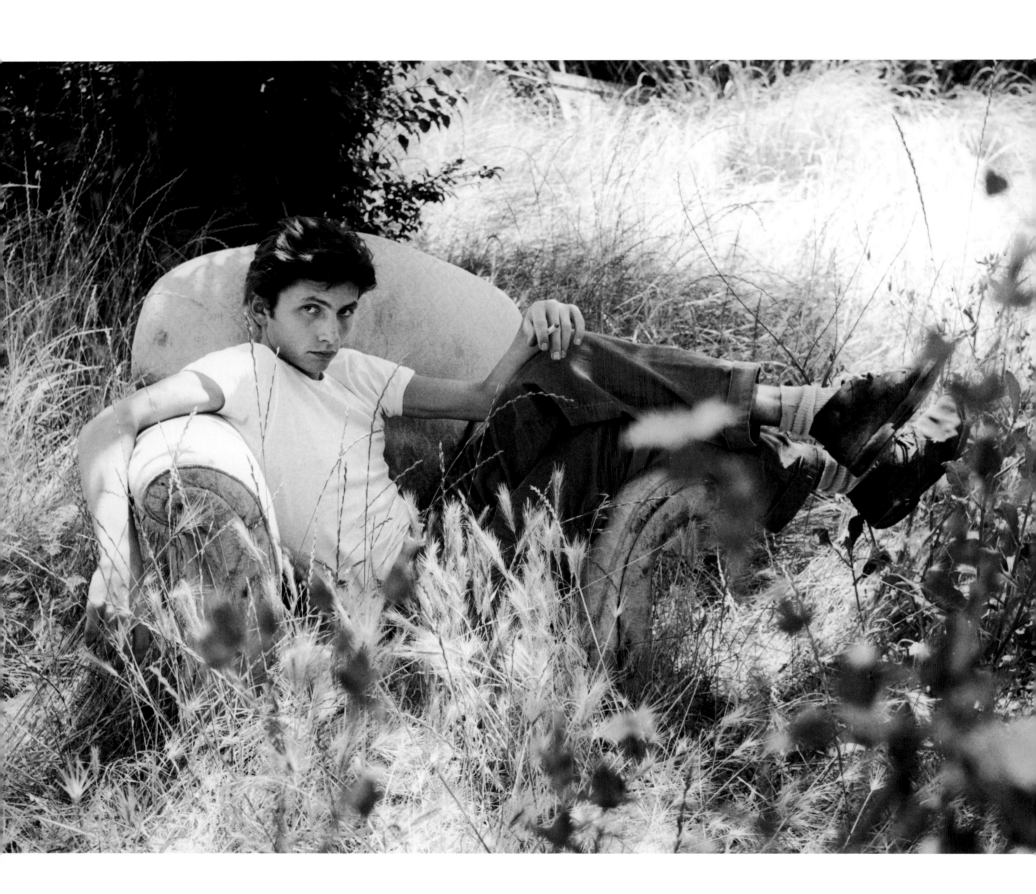

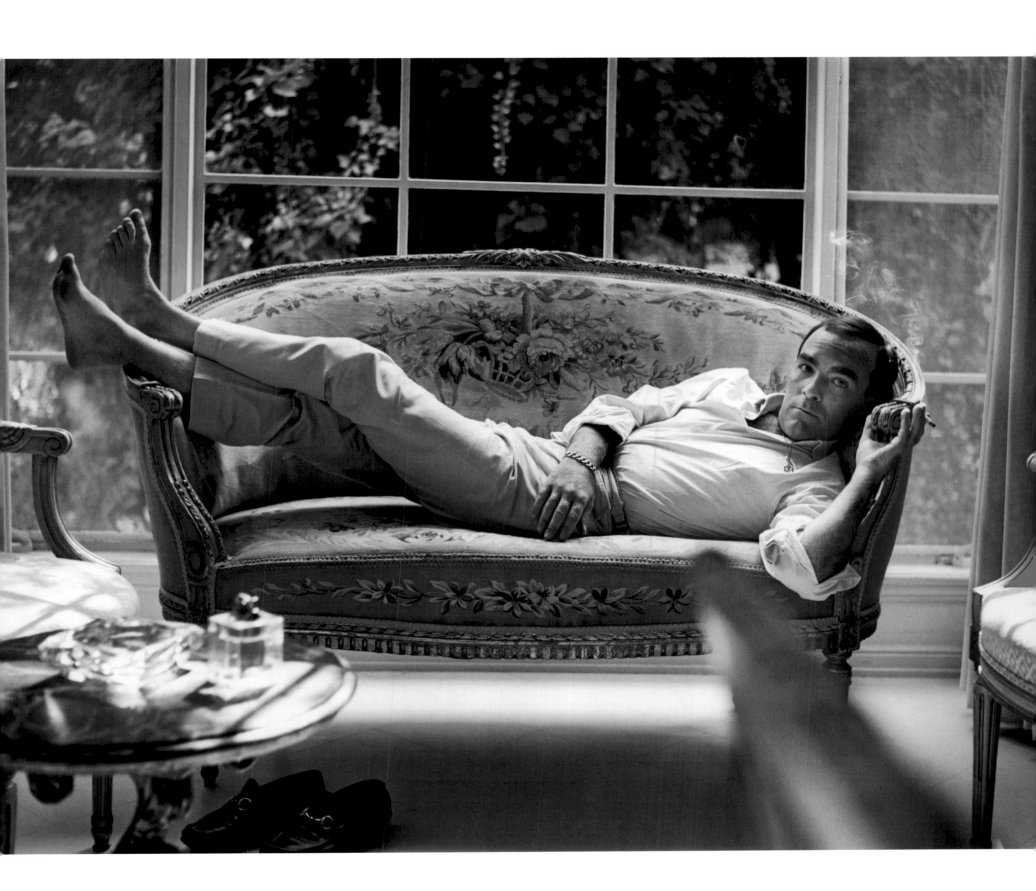

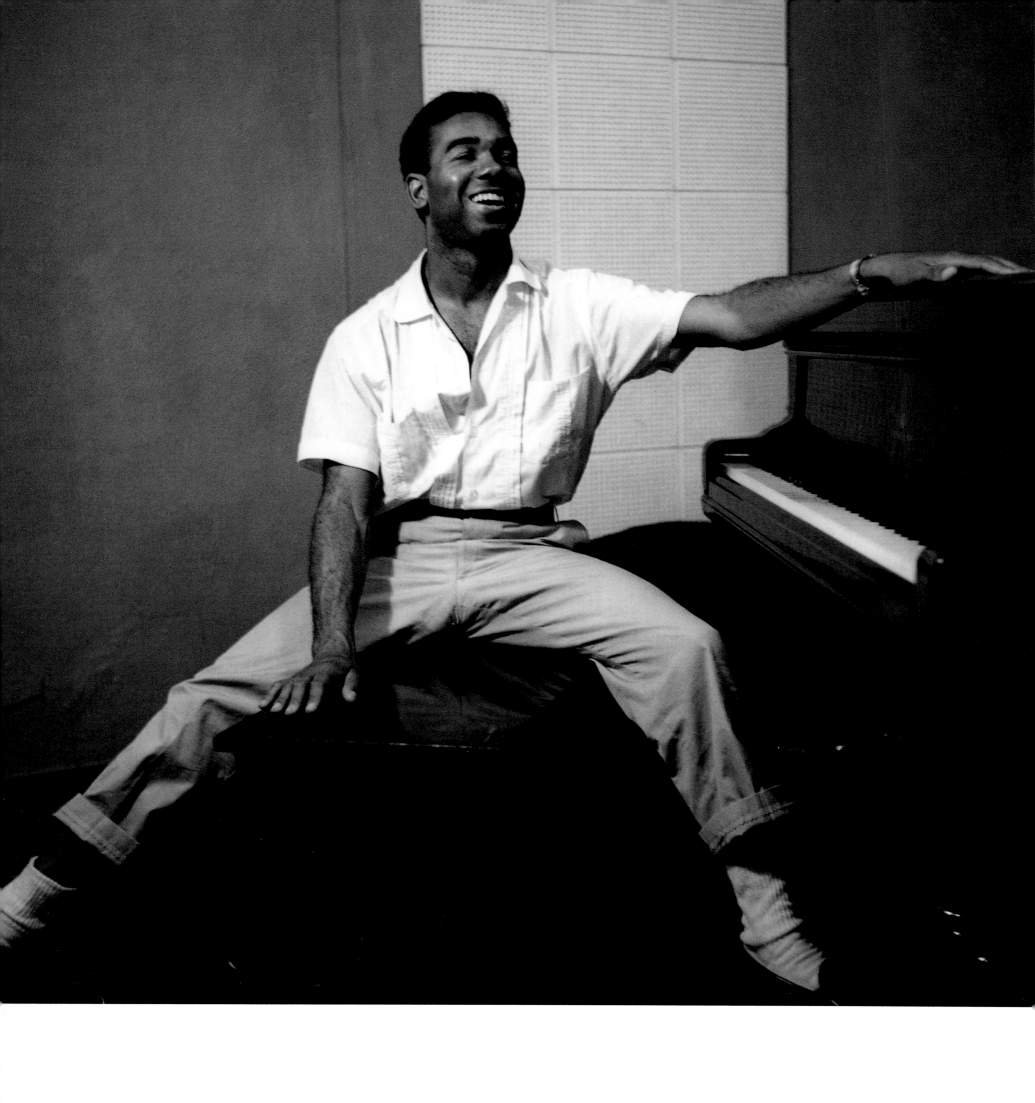

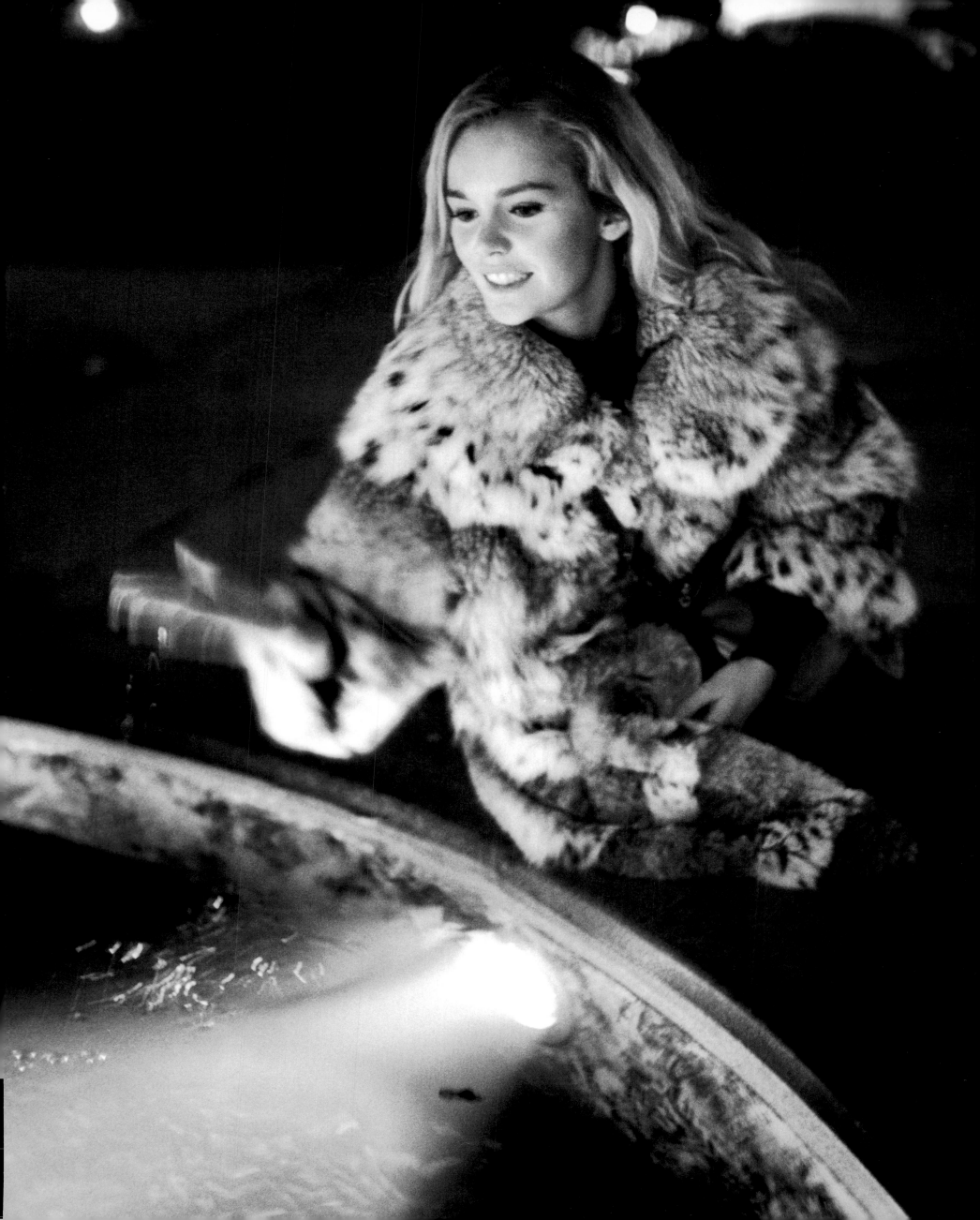

West Los Angeles, 1962. To be offered a job photographing for a cookbook was one of the furthest things from my mind in the fall of 1960. So, when the famous actor Vincent Price called me to say that he and his wife, Mary, had been commissioned to write a cookbook, I was not very excited. However, as we talked, I found out that this book was not going to be your average list of recipes, but was to cover the couple's gourmet cooking and entertaining, and was to be photographed against the fantastic background of their art collection in their spacious mansion. I could not resist the offer.

Our project began about a month before the Christmas season. We worked long hours with both Vincent and Mary cooking and art-directing each and every setup. They made a beautiful cheese soufflé and placed it on a rustic antique table with a small Rembrandt drawing in the background. We photographed a high tea of scones, jam, and thin watercress-and-cucumber sandwiches, with late afternoon light bathing a sensational Richard Diebenkorn painting serving as a backdrop. Finally we shot a large, bright, shiny black and orange Clyfford Still oil that reflected the candlelight of a sumptuous "New Year's eve supper."

About halfway through the night, Vincent would crack open a bottle of champagne or brandy, and shortly after that repast, he would sing German lieder in his most theatrical voice. After an evening's shoot was complete, and when we were sure that we had captured the gourmet beauty on film, we would start gorging ourselves at two or three in the morning. Sometimes, however, these magnificent concoctions were inedible, having been propped up by plaster of Paris or plastic glues

VINCENT PRICE

and glazed over with mineral oil to give them a shine. We used all the tricks of food photography.

During one break, Vincent asked me if my bride and I had any special Christmas plans. I grumbled, "No, I was never very happy at Christmas time and I'd just as soon forget about the entire holiday," even though I knew that it was Peggy's favorite holiday. She grew up having a big tree to decorate. There was endless gift-wrapping behind closed doors in preparation for the festive event. I went on sadly that I didn't think that we would have a tree this year. Perhaps we would spend Christmas at her family's house. Whereupon, Mary and Vincent howled in unison, "Bah humbug! Mr. Claxton. Shame on you!"

A few days later, there was a knock on the front door of our apartment. There stood the Prices' houseman with two enormous stacks of boxes. They were as tall as he was, and they contained Christmas ornaments of all kinds, colors, and sizes. There was a note attached from Vincent: "Bill, you had better get a twelve-foot tree for Peggy to decorate, or Santa Claus will never forgive you!"

Vincent's wit and generosity had no limit. He could always be counted on for making any occasion, no matter how small, a wonderful and stylish event.

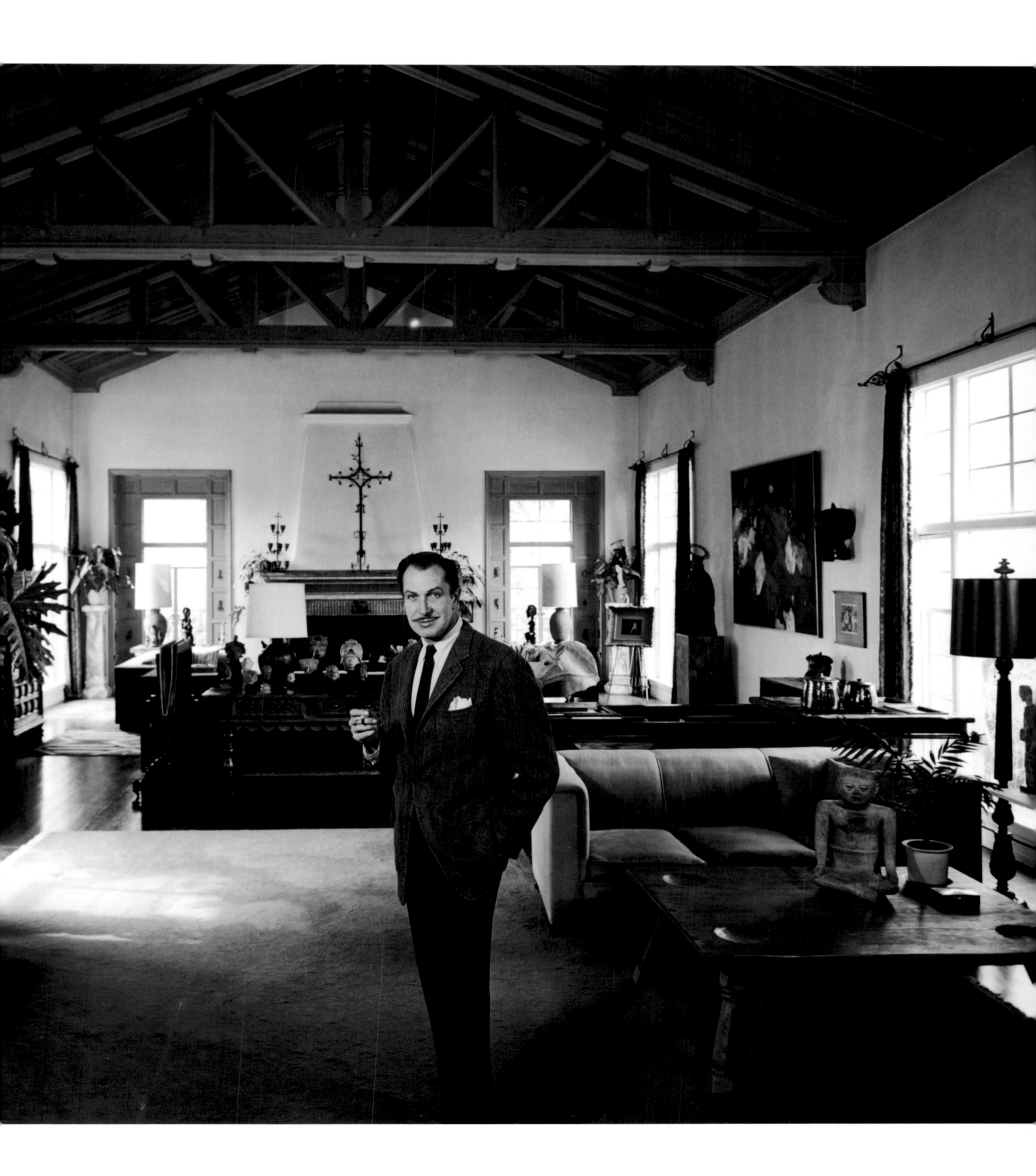

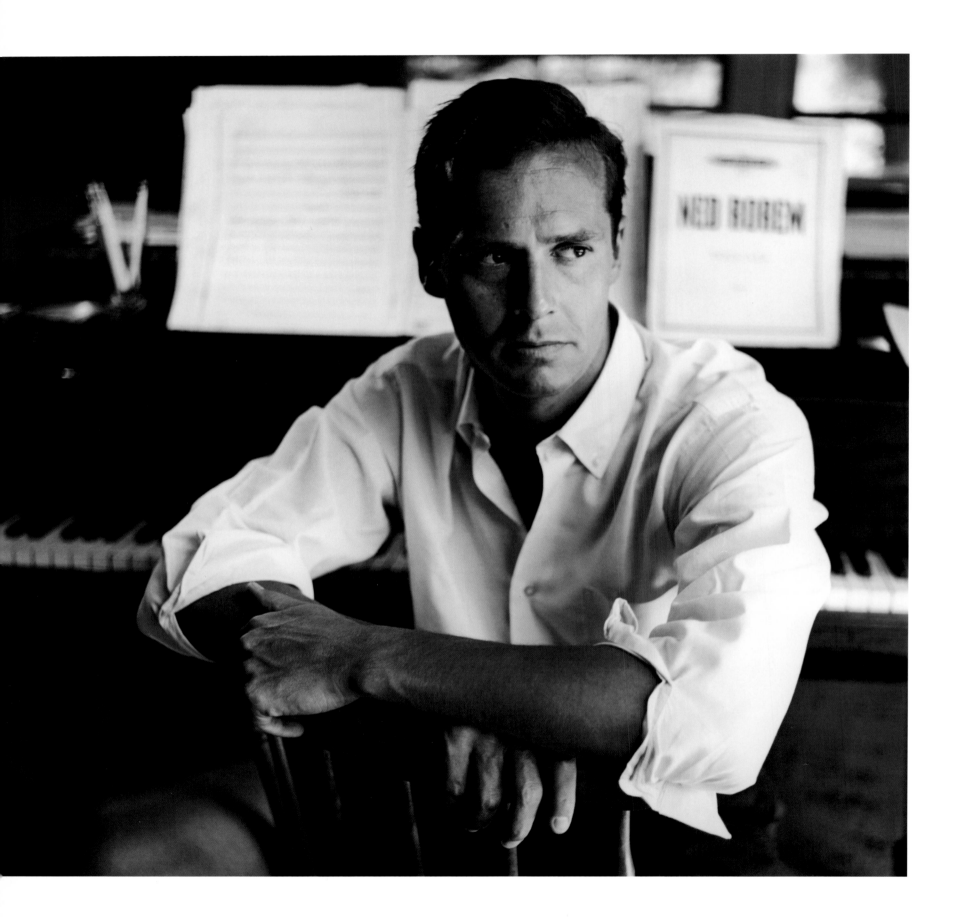

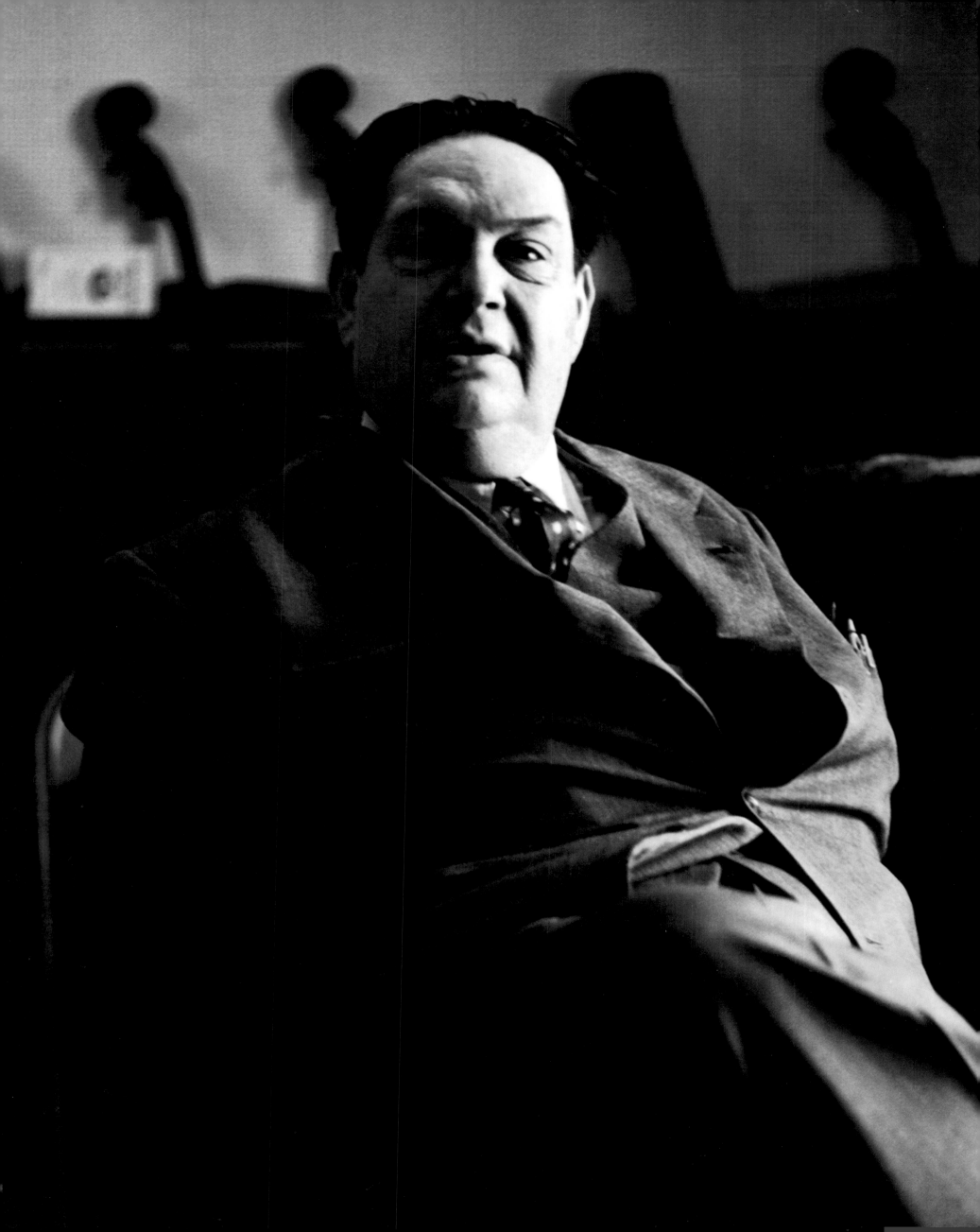

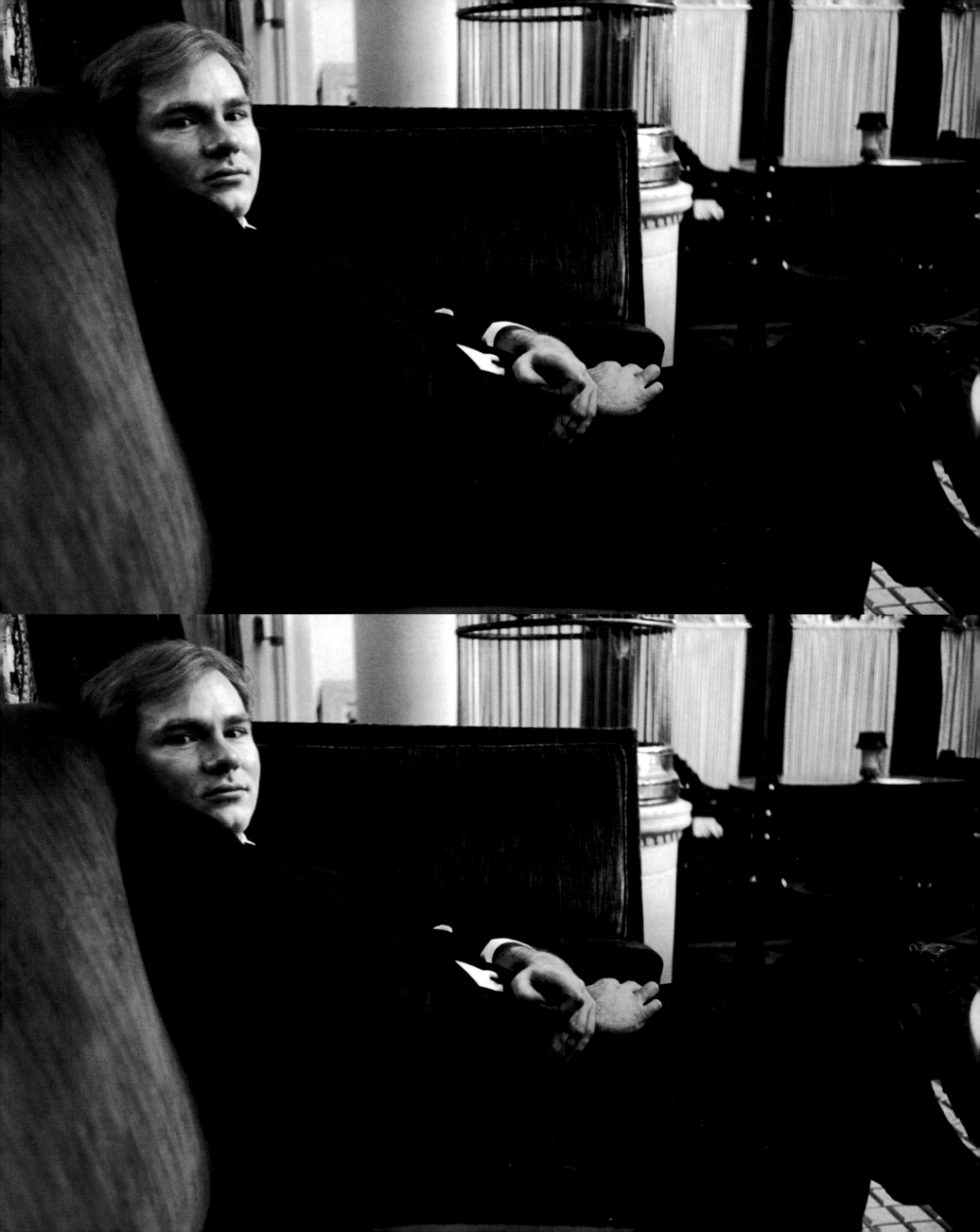

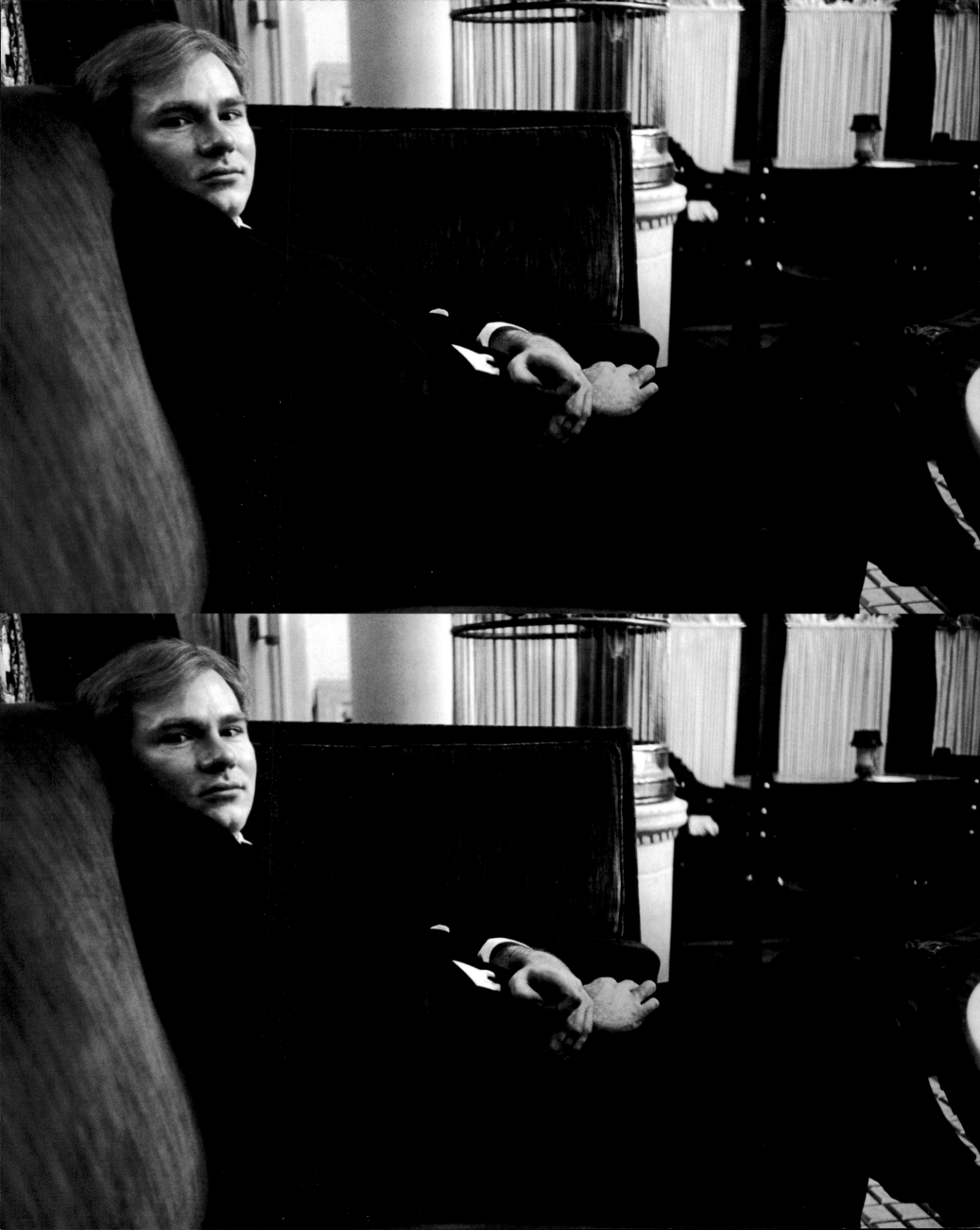

HENRY MILLER

Big Sur, 1955. Henry Miller's notorious book *Tropic of Cancer* had been banned in the United States after being published in 1934 in Paris. When I think back now, it was 1946 when copies of the book began to appear on some bookshelves or hidden in closets of the parents of my high school chums. One of my classmates borrowed his father's copy (without permission, of course), and during our lunch hour at school, we took turns reading aloud from this erotic, four-letter-word-laden book. Being young, we were all amazed that someone had actually written about these taboo subjects with such gusto.

Years later, in 1955, my friend Richard Bock and I made one of our many trips to Big Sur. It was one of the most beautiful areas of California. Through the years it had also become an artist's hideaway. One could find writers, painters, photographers, and sculptors from all over the world living there. These denizens of Big Sur would burrow themselves into little cabins tucked away amongst the rock and redwood trees overlooking the Pacific Ocean.

Richard had heard that Henry Miller lived in a certain canyon. So, we hiked up the mountain for what seemed like miles. We knocked on the front door of the first cabin that we came across. A pleasant-looking, balding, older gentleman opened the door. We greeted him and asked if he knew where the famous author Henry Miller lived. He replied that, yes, he did know, and that he was, indeed, Henry Miller.

He looked us over cautiously a couple of times, evidently decided that we were not a threat, and invited us in for coffee. We sat down at a large dining table that seemed to function as his desk. A beautiful young woman walked in and served coffee and cookies. Miller did not introduce her to us, but he did kiss her on the cheek as she left the room.

We talked about everything imaginable. He was a wonderful storyteller, and went on with long and detailed yarns about living his early years in Europe and his legal problems with not only *Tropic of Cancer* but with all of his books. I took pictures of him.

As the sun began to set, I began to worry about finding our way back down through the darkening canyon to where our car was parked on Highway 1. Miller walked us to the door, then down a long path. It seemed that he didn't want us to leave. We expressed that we had overstayed our visit, and that we had taken enough of his time. We had been very selfish in staying so long. He laughed, and said, "Nonsense, I'm the selfish one! I kept you here because I didn't really want to work. Writing is too difficult. It is a very lonely occupation. So, please, come again. You know where I live."

I never saw Miller again, but I often wondered who that beautiful woman was.

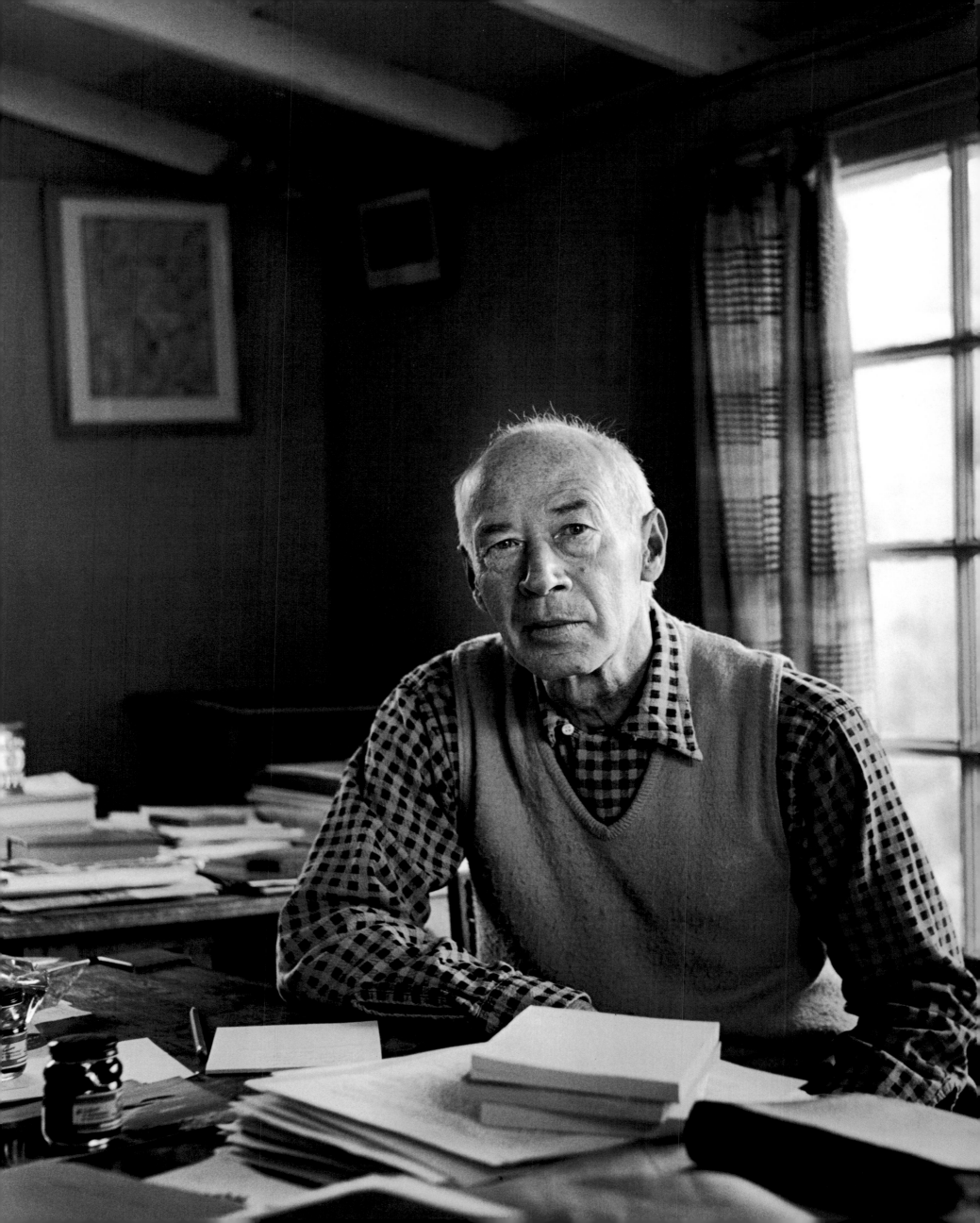

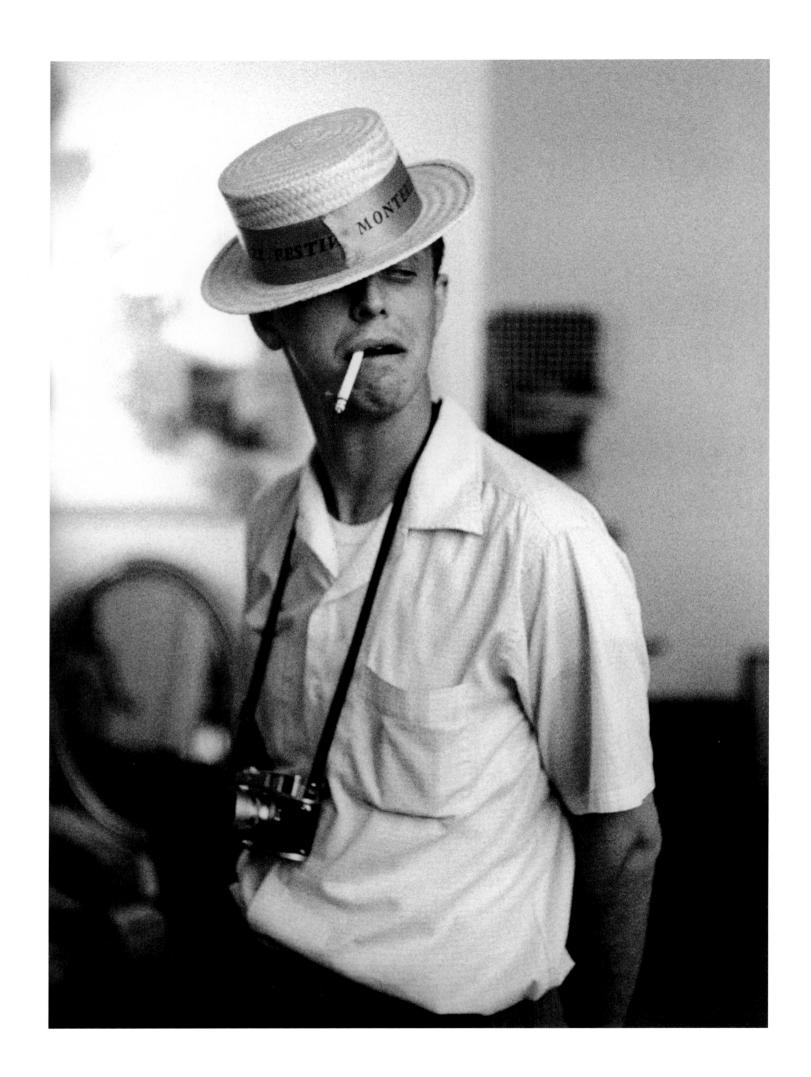

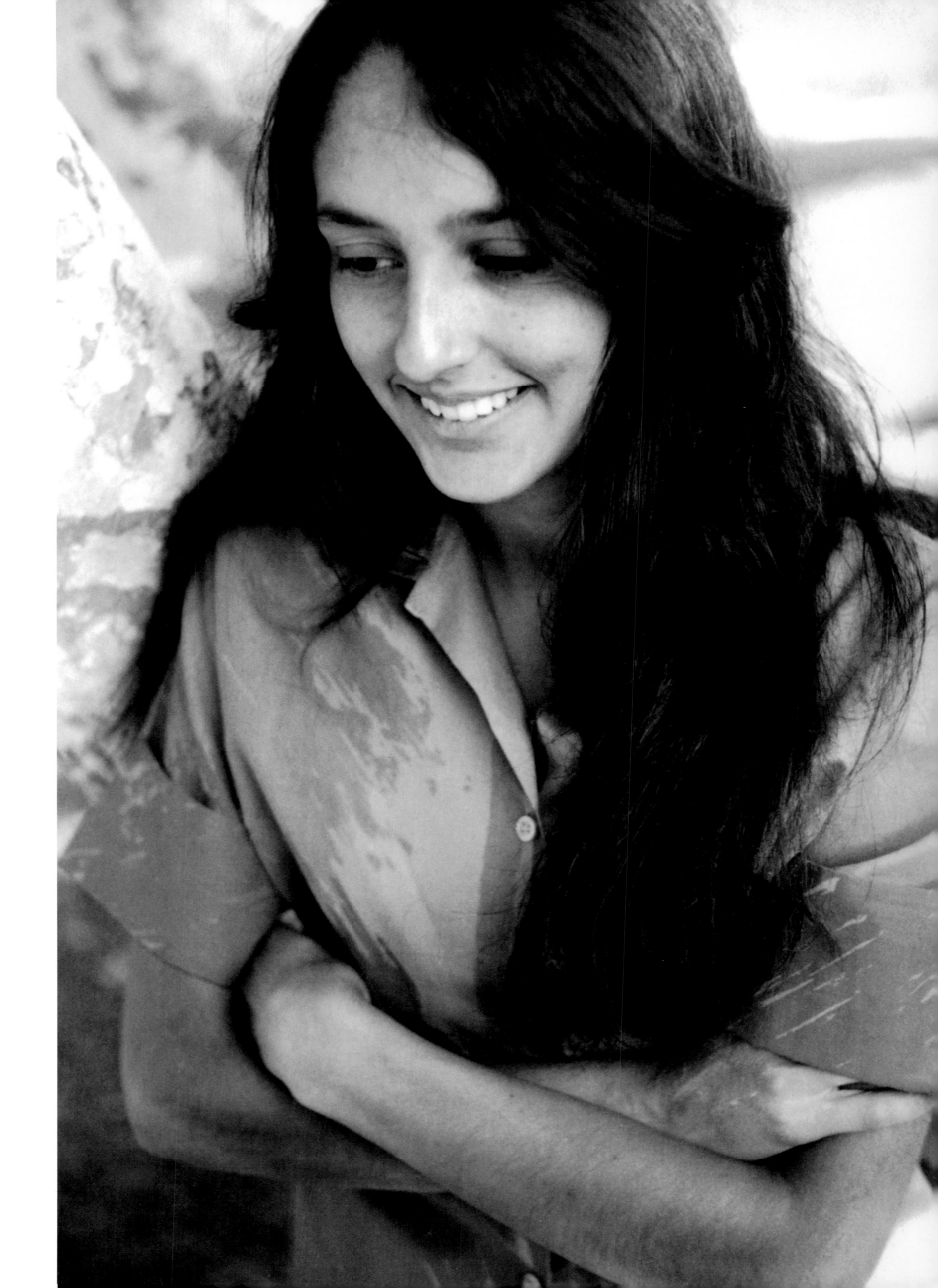

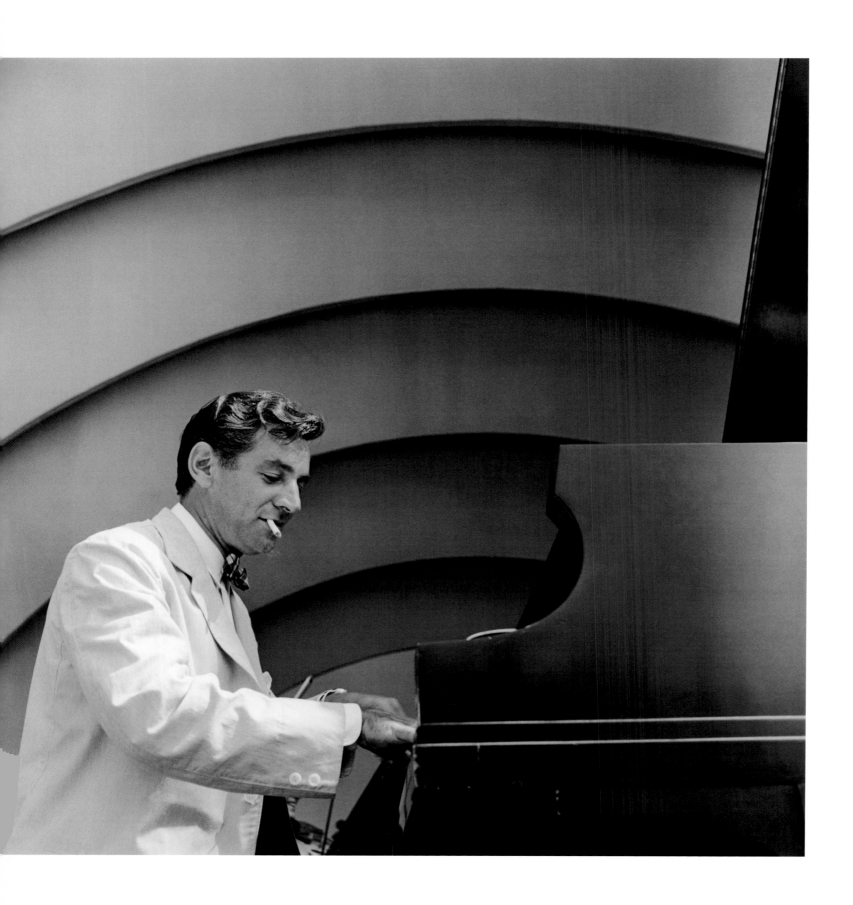

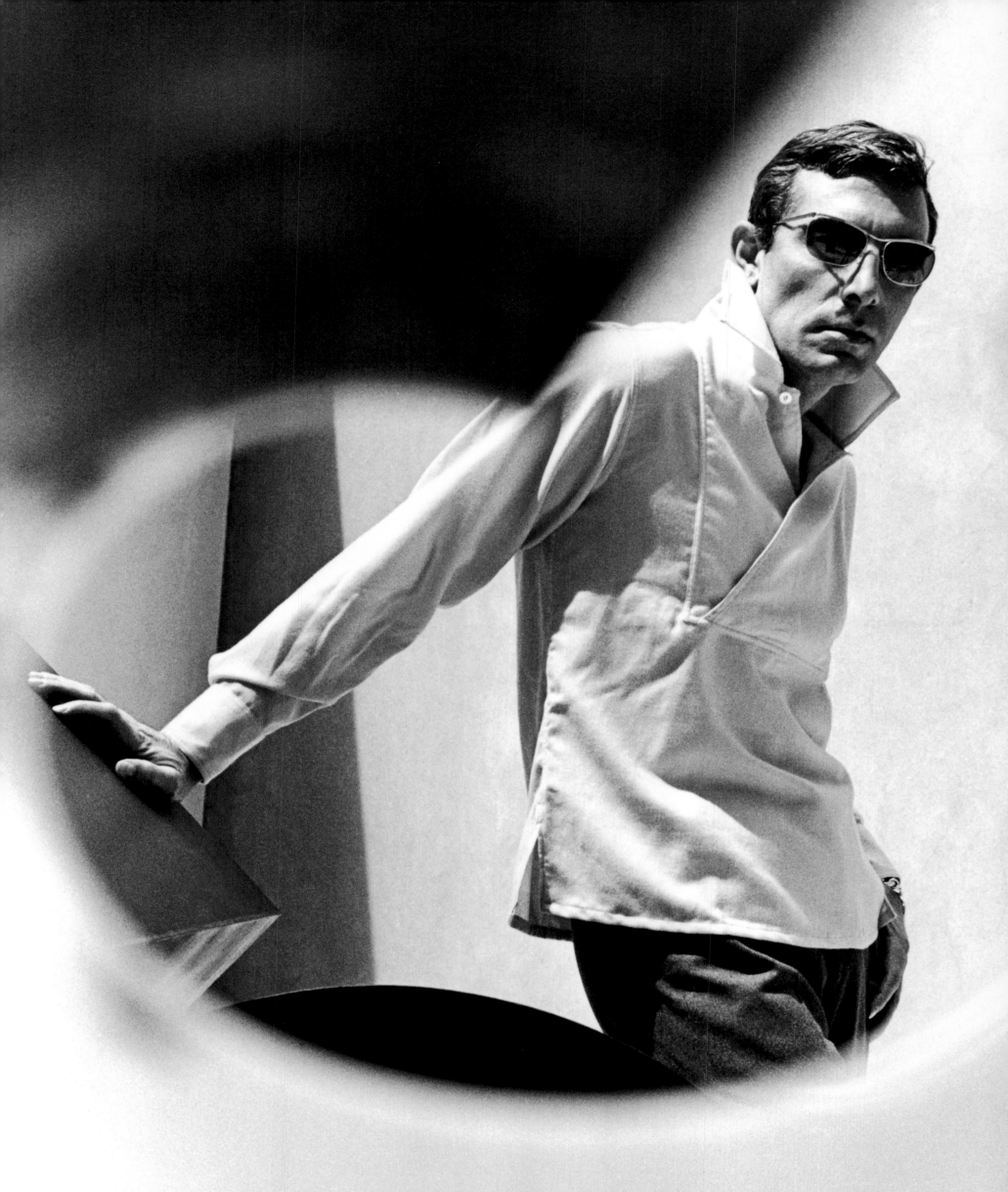

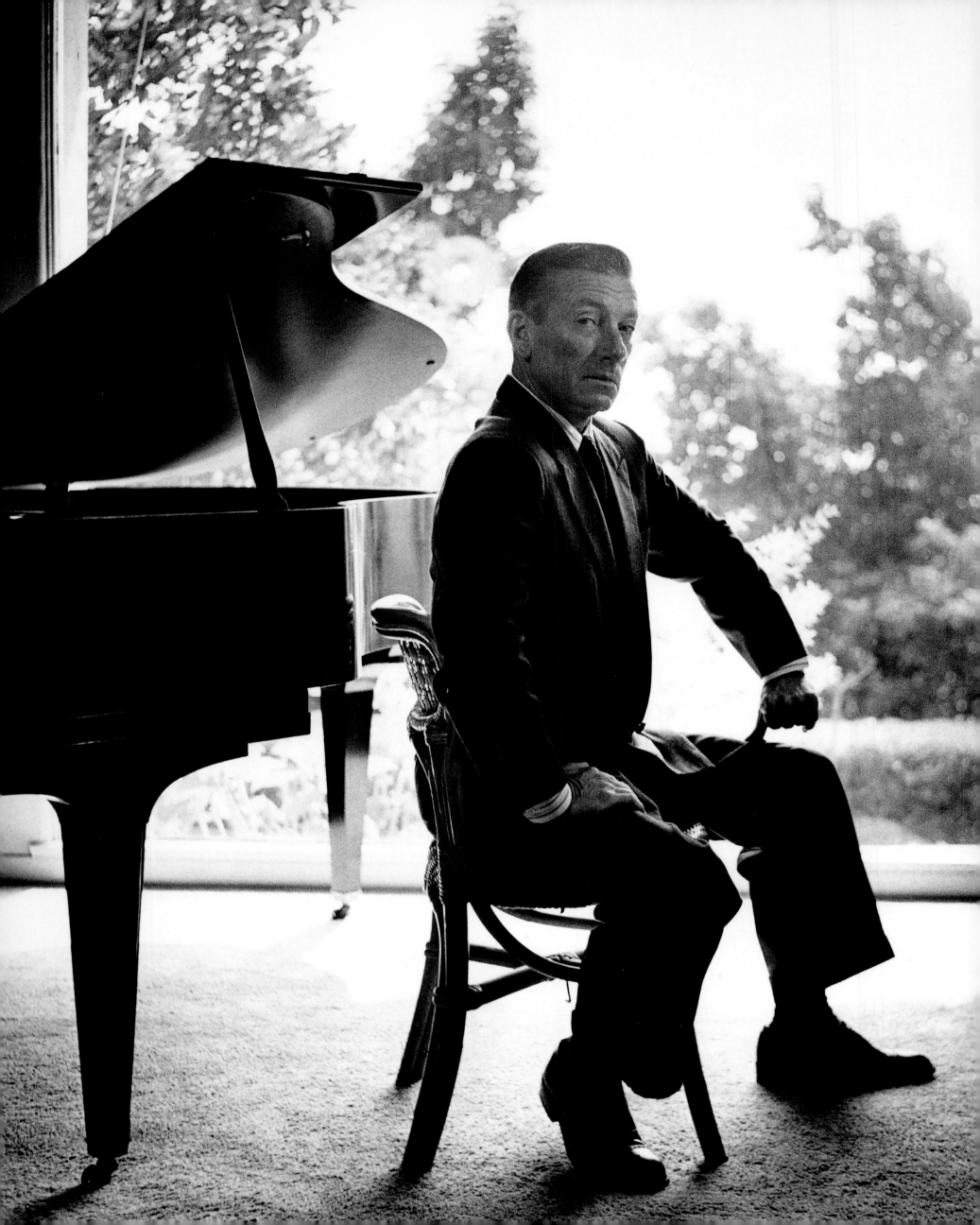

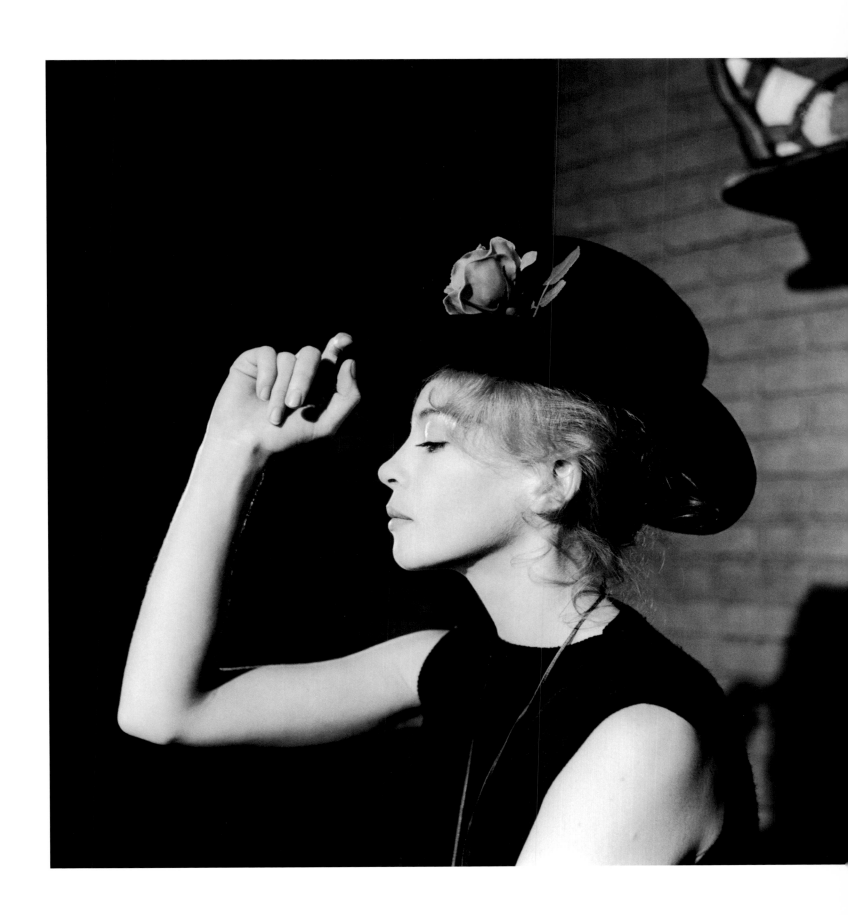

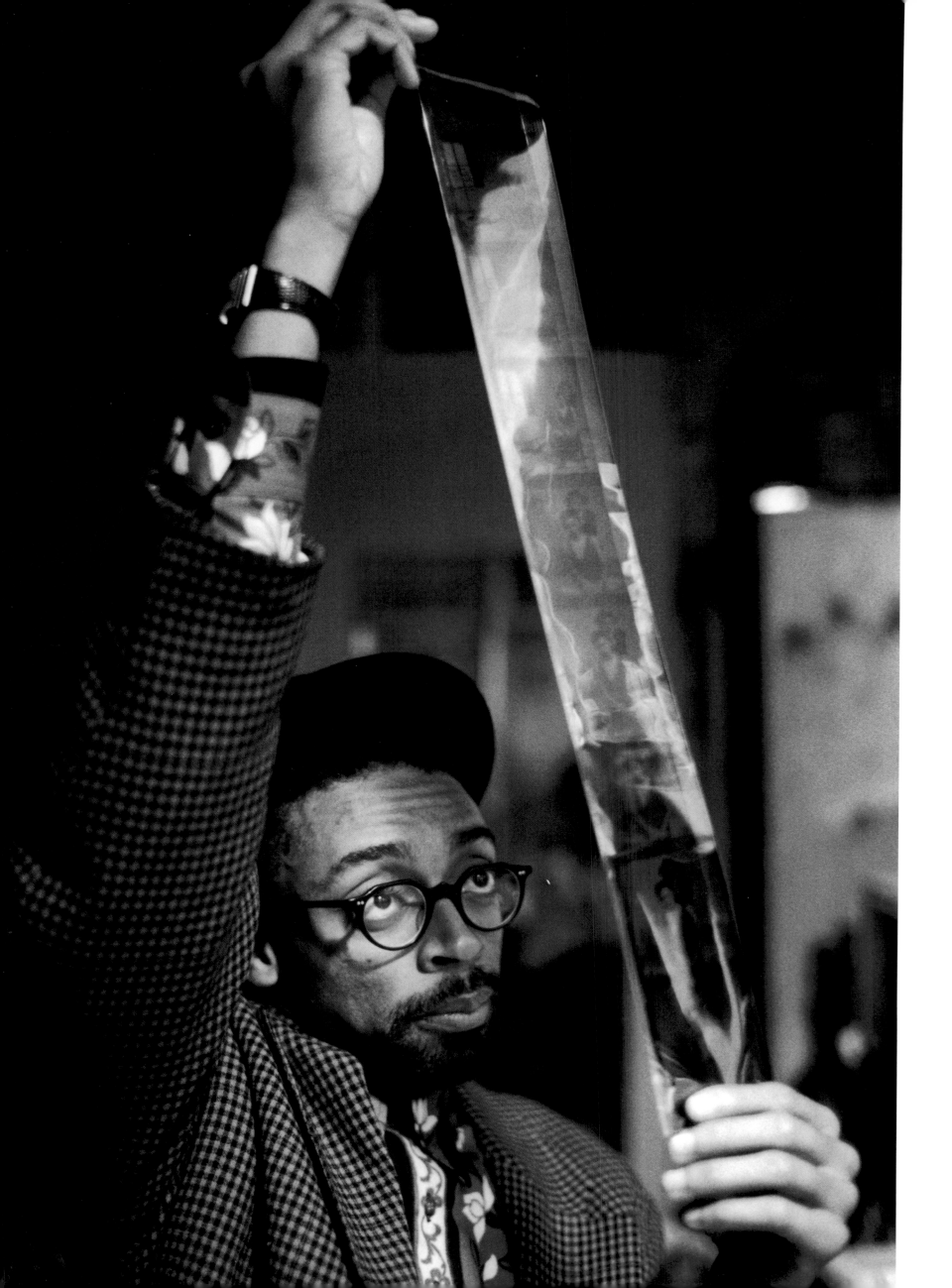

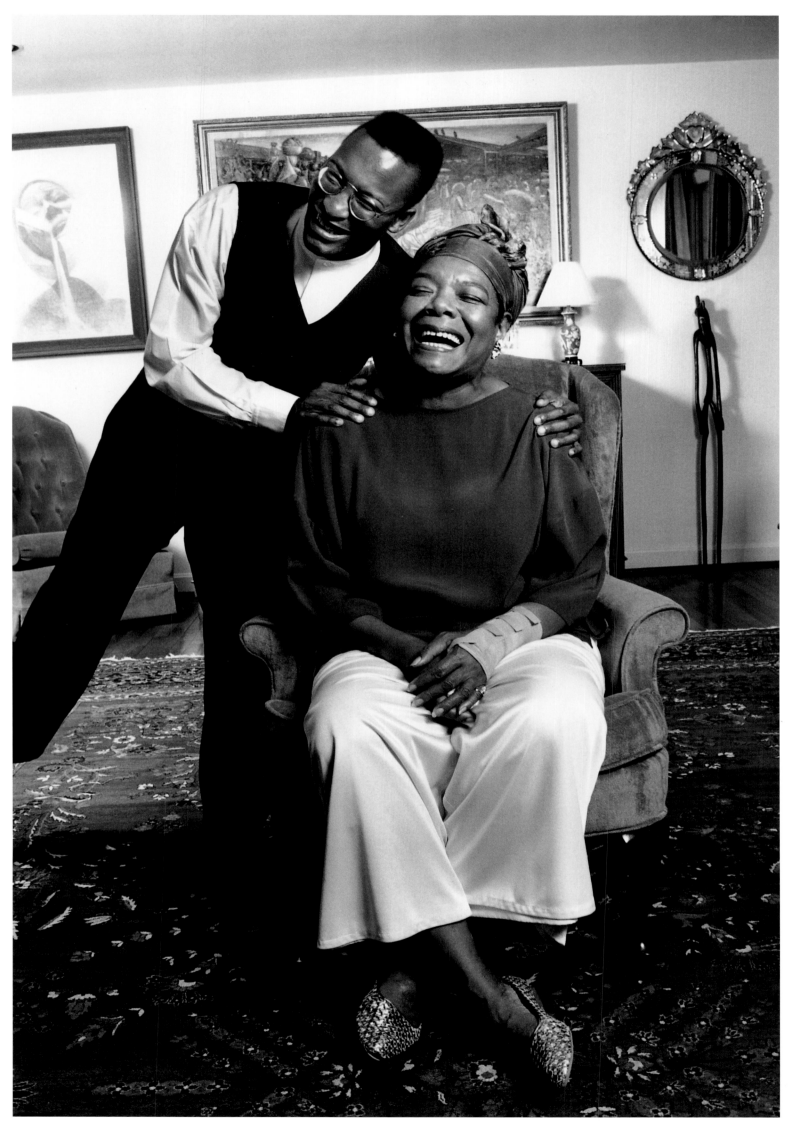

New York City, 1968. Wild colors; wonderful geometric designs; improbable combinations of fabrics and textures in motion; exposed flesh—these were the elements that I encountered when garments designed by Rudi Gernreich first appeared in the viewfinder of my camera. What a turn on it was for a photographer.

I first met Rudi in 1955, when I walked into his design studio at the Walter Bass offices in Beverly Hills. I had seen his sexy swimsuit designs in *Sports Illustrated*, and I wanted to borrow a few swimsuits for the models I was using for several jazz LP record covers.

Rudi was gracious and kind to this young and brazen photographer. The pictures I took that day turned out beautifully. Rudi invited me to a party shortly after that, and we became friends.

RUDI GERNREICH

A few years later, Peggy began to work for Rudi, first as his fitting model, then as a runway model in all of his shows. The three of us worked together through most of sixteen years of Gernreich collections. Peggy's unique and original modeling style added tremendously to the drama of his designs. Invariably we shot every collection against a seamless white background, thus emphasizing the beauty of the work.

In 1964 Rudi created the "topless swimsuit" design, and after much consideration, Peggy modeled the notorious swimsuit but for my photographs only. Rudi had made an important social statement about the freedom of women, and Peggy insisted that we keep it on that level. Needless to say, Rudi Gernreich then became known to the entire world as the "bad boy of fashion."

Rudi's work reflected his wit and appreciation of sensuality. He was a great designer and a very good friend. There never was and probably never will be a fashion designer as original as Rudi, and I was fortunate to catch a great deal of his creativity on film.

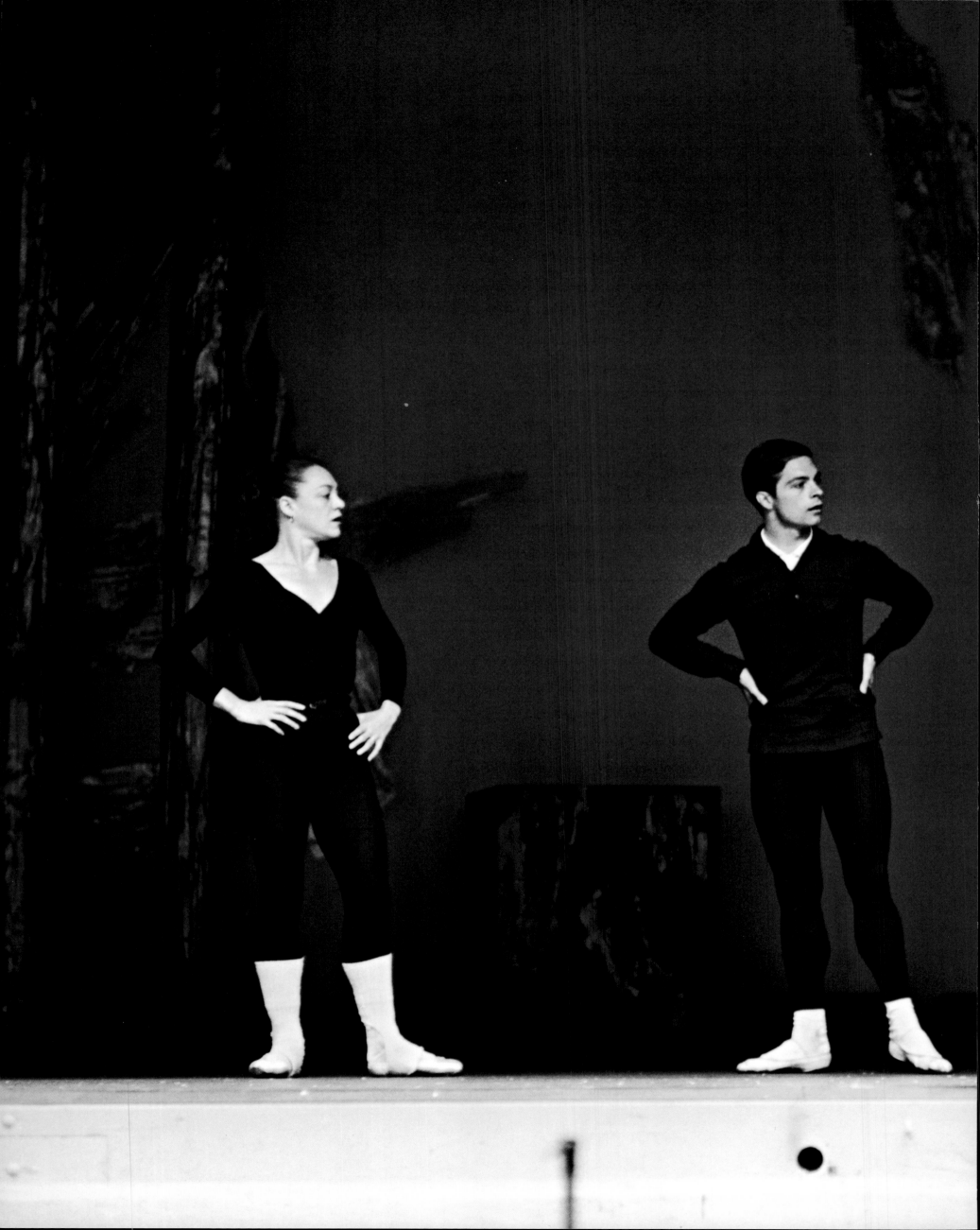

BARBRA STREISAND

New York City, 1964. Nicholas Haslam—a London-based interior decorator—was living in New York City, where he was the art director for Huntington Hartford's glossy magazine *Show*. When Nicky heard that I had photographed Barbra Streisand wearing Rudi Gernreich's designs, he asked to see them. We actually shot them for a small, new magazine called *Cinema*, but we allowed him to sneak a peek at them.

As far as I know, this photo session was the first fashion layout that Streisand had done. At our small studio in Manhattan, Peggy and Rudi had the clothing ready. We had the champagne chilling, and snacks were prepared. When our model arrived, she did not want champagne. She wanted Pepsi-Cola. Not a problem; I sent my assistant out to procure Pepsi.

She tried on some of the designs, and they were a beautiful fit. We picked one of pieces to shoot first. She dressed and stepped before the camera. She looked great, but was hesitant, explaining that she had never actually modeled before. So Peggy stood beside my camera, suggesting and acting out poses for Barbra to mimic. She began to have fun; with each garment, Peggy would strike a pose, or model a particular dress, and Barbra would copy it at first, and then add her own thing. We all had a lot of fun, and Barbra was brilliant; she was like a sponge.

Before saying goodbye, she asked if we would like to see her show, *Funny Girl*; it was her first Broadway starring role. We said, "Of course." She promised that we would have house seats reserved for us that night. Rudi, Peggy, and I arrived at the theater and were ushered to front-row seats. The overture played, and the musical began.

It was a wonderful show. Soon after it started, we realized that Barbra was cleverly incorporating into her role the actual fashion poses she had learned that afternoon at the photo shoot! We noticed too that the other performers were a bit startled and thrown by her new staging.

Afterwards, we went backstage to congratulate Barbra on her great performance. As we walked into her dressing room, we were met by Elliot Gould, her then husband, and a crowd of well-wishers. She looked up at us and began shouting excitedly, "Didja' see what I did? Didja' see?" We had indeed. She had been marvelous.

Nicky Haslam loved the pictures so much that he made them the cover story for *Show* magazine.

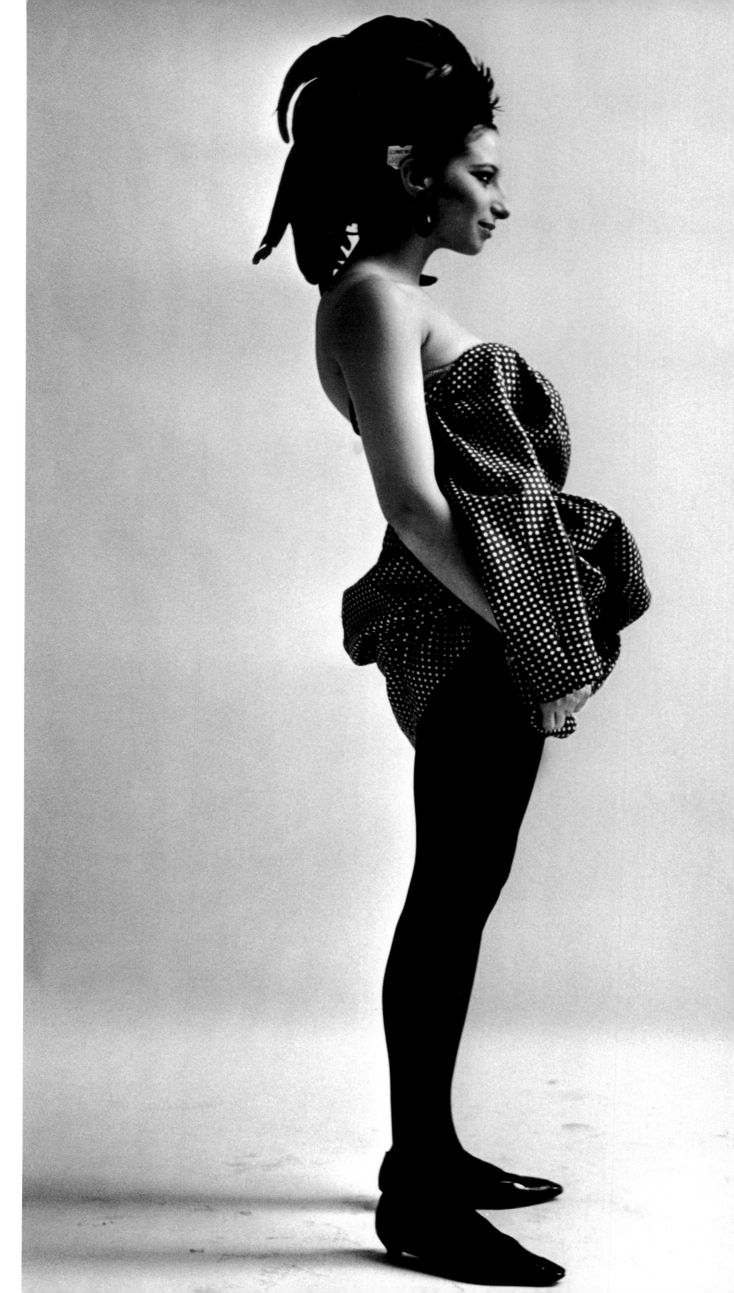

CAROL McCALLSON

New York City, 1949. Carol was my first "serious" girlfriend. We met at Glendale High School in Glendale, California. She was tall and had a bump on her nose. I was tall and skinny and had a bump on my nose. We were not included with the "in crowd." She was not the cheerleader type; and I was definitely not the football letterman type. We found that we had similar passions like music of all kinds, and movies. I would walk her home after school, and her mother would make us oatmeal cookies and milk while we listened to our 78-rpm records of Sarah Vaughan, Dizzy Gillespie, and Frank Sinatra.

In those days in our high school you were either a Bing Crosby fan or a Frank Sinatra fan. Carol and I were vehement Sinatra fans.

Every Thursday afternoon I would borrow my father's car to take Carol to the NBC Radio Studios at Sunset and Vine in Hollywood, where we would line up to get front-row seats for the broadcast. Sinatra would walk on stage for the live show with his first message: "This F.S. for O.G." His sponsor at the time was Old Gold cigarettes. Sinatra would look at Carol when he sang. It made me jealous. But I did enjoy his music. Years later, when I worked photographing Sinatra, I mentioned those days, and he said that he remembered us: "the skinny kids who were always in the front row."

During our senior year, Carol was discovered by a model agency and began appearing first in the *Los Angeles Times* fashion advertisements, then moving up to *Seventeen, McCall's, Charm,* and then to *Vogue* and *Harper's Bazaar.* Only at this point was she invited to join the elite girls' clique. Some of the guys in the male elite group liked jazz, so I made contact with them. They began inviting me to the "important" parties for the "important" guys and girls.

I graduated from UCLA and later became a photographer. Carol moved to New York and became a successful model. She married the photographer Francesco Scavullo, divorced him, and then remarried banker Bert Taylor. They went on to have a girl, Daisy, and lived in a beautiful apartment on Fifth Avenue overlooking Central Park.

In 1985, Carol died of breast cancer. During her last days, I sent her cards with photos of cats on them to try and cheer her up. I was told that Frank Sinatra sent flowers to her memorial service.

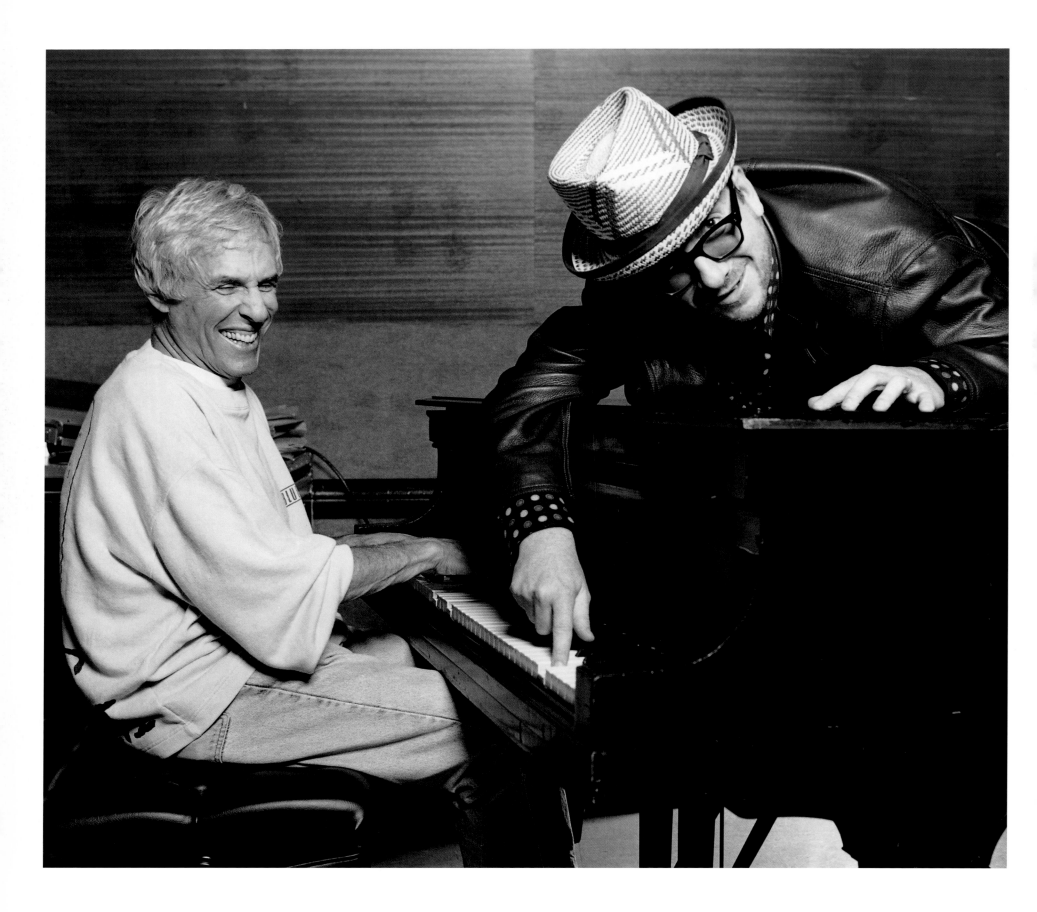

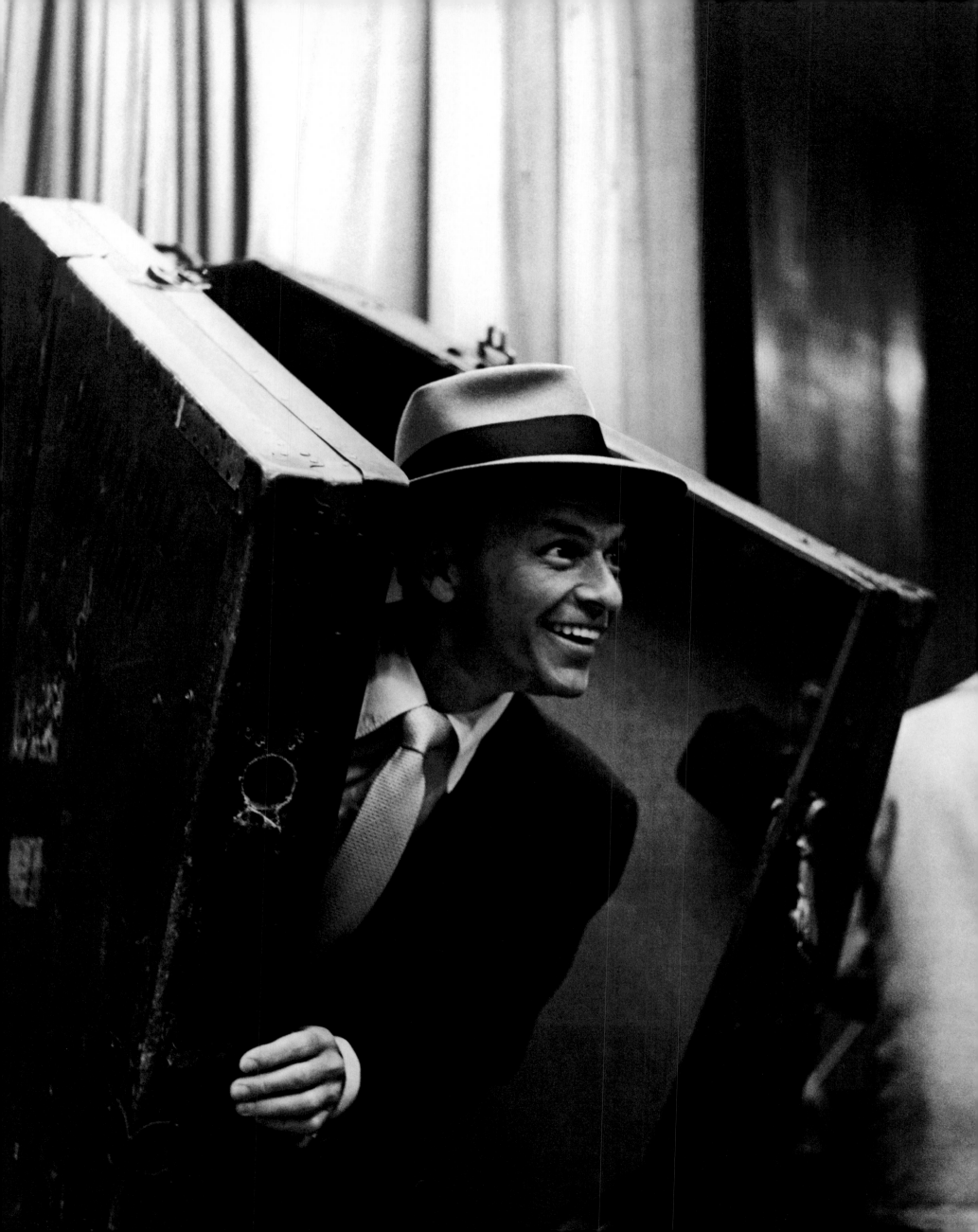

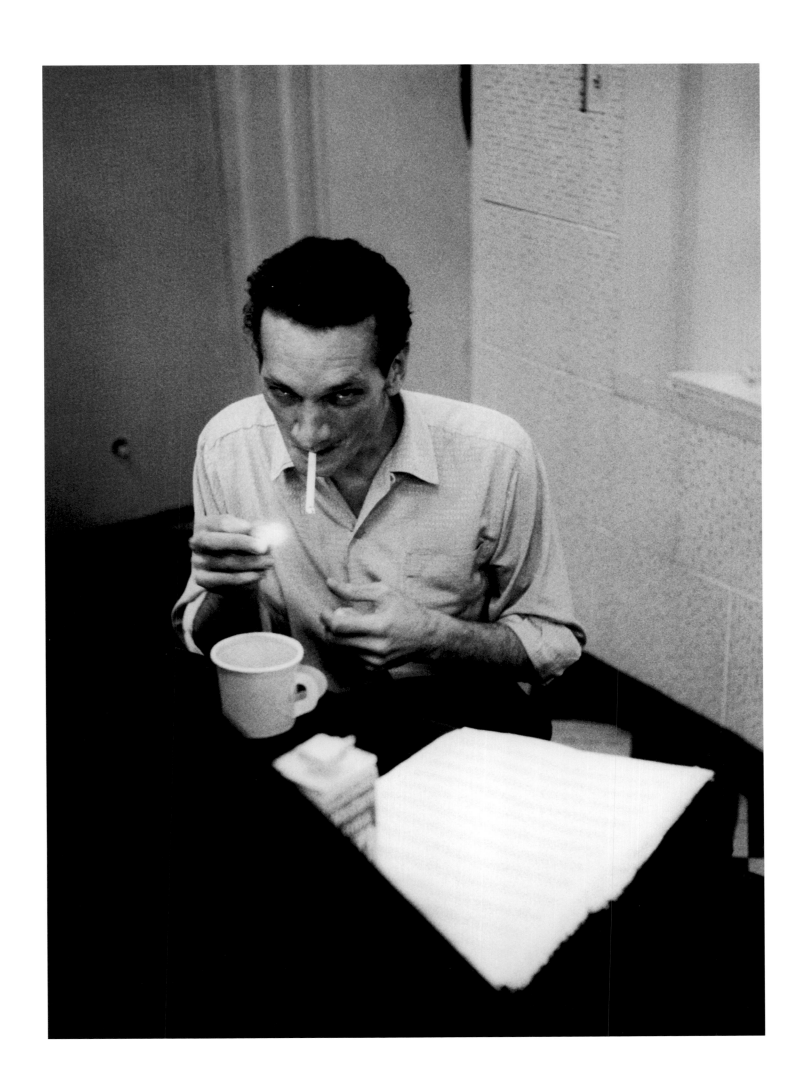

Ojai, California, 1971. The drive from Manhattan north to East Canaan, Connecticut, with my friend, author Terry Southern, could happen almost any time of the day or night. Terry would call me and say, "Clax, how about a whirl through the velvety white New England countryside? It is a veritable fairy land. We would accomplish a lot, because 'driving time is creative time.' How about it?"

Although I was not a writer, Terry loved bouncing ideas off me to hear my point of view, thus including me in his creative process. Terry liked to a collaborate. Much of his work—*Candy*, his screenplays for *Easy Rider* and *Dr. Strangelove*—was the result of a collaborative effort. His novels *The Magic Christian* and *Blue Movie* were his own creations.

He enjoyed my modest creative input, especially as we motored north toward his pre-Revolutionary farmhouse in Connecticut. As I would drive, Terry would have his yellow legal pad poised while taking nips from the silver flask that Ringo Starr (or was it Mick Jagger?) had given him. He was always almost ready to begin writing on whatever was his latest book or screenplay.

Barely an hour out of New York he would say, "Clax, time to stop for sustenance, 'creativity needs nurturing.' There's a quaint little inn at the next turn off." Once seated next to the blazing fireplace, drinks were immediately ordered. "If memory serves, a dry Rob Roy for you, sir, right?"

TERRY SOUTHERN

After lunch and many drinks later, we would resume our trip through the New England countryside, as I suggested ideas for his story and Terry made notes on his legal pad. Then, "Clax, time for a smart cocktail in this little hamlet that's coming up on the right, and perhaps a little 'Dex' just to keep us sharp and on our toes. Don't you agree?"

Upon arriving in the early evening at Blackberry River Farm, Terry's lady friend Gail and his young son Nile would greet us at the door. The smell of something wonderful like roast pheasant would drift across the threshold.

Settling down before a roaring fire in the library while Gail cooked, Terry would offer a cocktail and a joint. Once again we would settle down to some serious work. Then suddenly Terry would jump up, turning on the television, "Time for those grand guys, Huntley and Brinkley! We must stay on top of things." Terry would keep us roaring with laughter with his "inside" commentary on the news and his interpretation of the speeches of our leaders and politicians. "Come to dinner," Gail would call. Terry would say in a loud whisper, "How 'bout a small taste before our gourmet meal?"

The meal was wonderful, with a great deal of wine flowing. After dessert, a large snifter of brandy was in order. Then back to work in the library. But only after Terry would put on a record by Bird, or perhaps a side from the Beatles. Then, for a short while, we would all groove out singing and dancing.

Finally, Terry would call out, "Enough of this tomfoolery, we have some serious material to put down to paper. But first, how about a good ol' scotch mist?"

At about three or four a.m. I would awaken. With the fire smoldering in the fireplace, Terry would be wrapped in an ancient wool shawl watching an old movie. I'd bid goodnight and stagger upstairs to the guest room and collapse.

Sometime in mid-morning, I would go downstairs desperately hunting for a cold drink of fruit juice to put out the fire in my stomach. Terry would call out to me just as the sun was coloring the snow outside with orange light. "Clax, now dig this!" He would read from the manuscript of his work-in-progress. In this case it was from his novel *Blue Movie*: "The fan-fucking-tastic dyke, Khaki, would actually fall for this handsome, gay, red-neck, commie fag movie star…" He would read on and on and had me in hysterics. I would forget all about my headache. When he ceased reading, he would say, "And now my dear friend, considering the circumstances, I think that mimosas or perhaps tequila sunrises would be appropriate, don't you agree? You look as though you could use some good old vitamin C!"

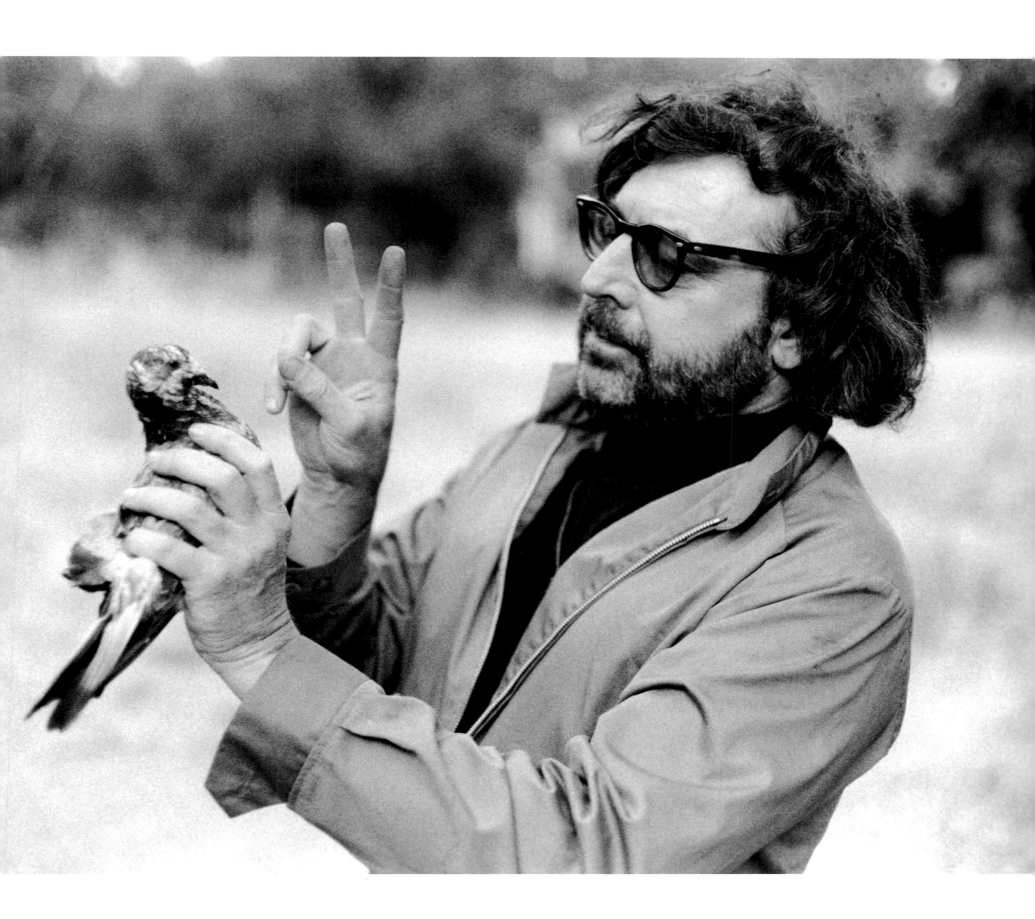

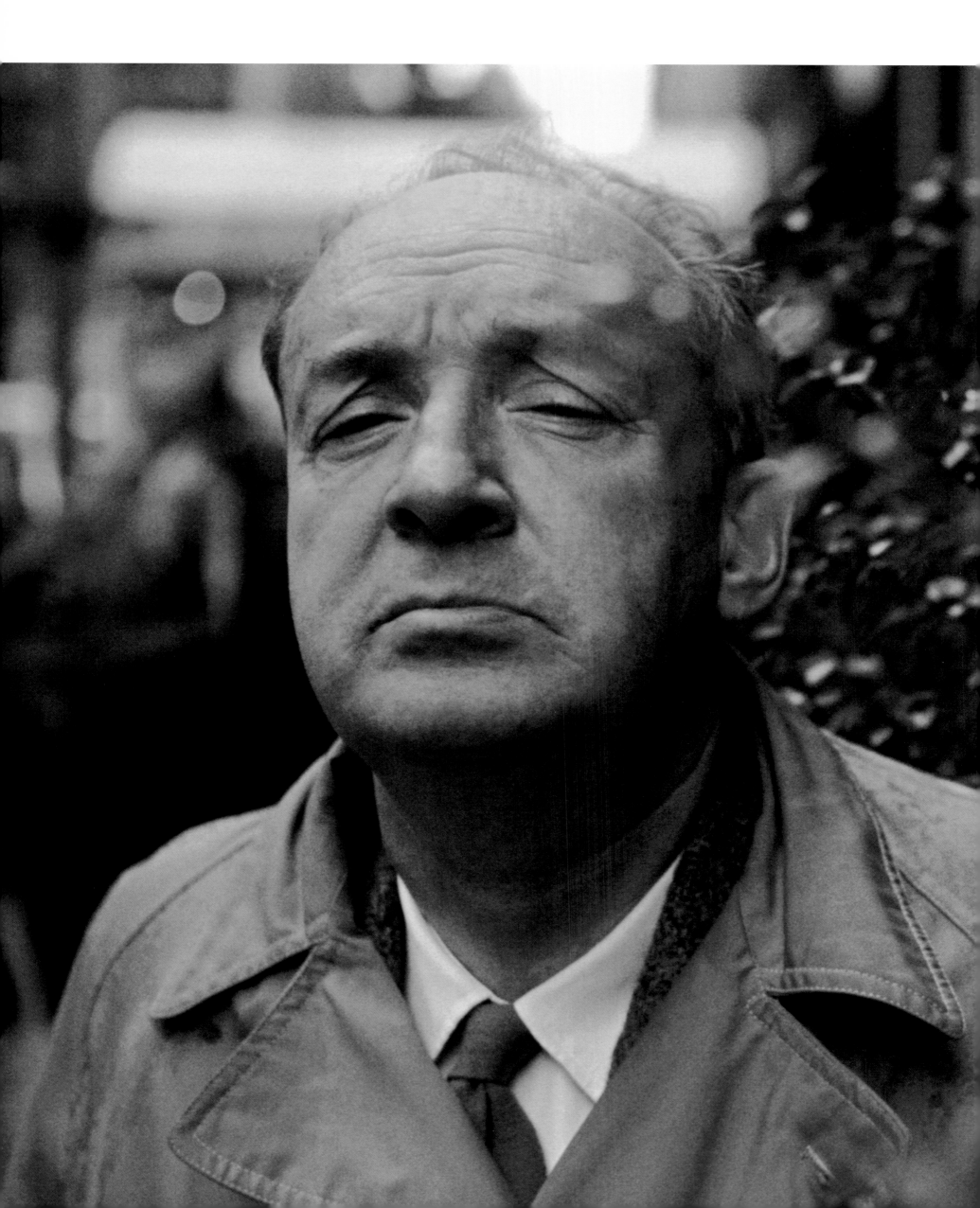

Beverly Hills, 1961. Former *Glamour* magazine editor Marguerite Lampkin and I did many picture stories together. She was great fun to work with and knew everybody in the world. One of the many new celebrities that she interviewed and I photographed was a very young Mia Farrow, who was then appearing in the television series *Peyton Place.*

Our photo session took place in the garden of the Beverly Hills Hotel, with Marguerite's luncheon interview to follow. Mia was adorable but shy and rather fey. She placed herself in the middle of a bed of flowers. The flowers complimented her pale, lovely complexion, and I told her so as I attempted to establish a rapport with this timid creature. She picked a flower and held it next to her cheek, making a very pretty picture. Then, to my astonishment, she began to eat the flower; then a second and a third. I began to worry, and begged her to stop eating the flowers, warning that they might be poisonous; they could make her ill or worse. She was not the least bit concerned, and replied she was "at one with flowers," and they knew her. "They are friendly

MIA FARROW

and delicious." My God, I thought, she's gone mad. Or is she just trying to be interesting? I could imagine the next day's tabloid headline: "Young Actress Succumbs to Deadly Flowers While Being Photographed for *Glamour* Magazine."

Fortunately, Marguerite arrived, and in her famous Southern accent apologized for being late, adding, "Now, doesn't everything look just fine?" She approached Mia and shook her hand politely.

Reservations had been made for a quiet corner of the Polo Lounge so the interview could be conducted. After being seated by the captain, our waiter arrived with the menus. Marguerite stated that she was "starved, no breakfast. Ah'm gonna have a great big salad." I began to ponder the menu, whereupon Mia said meekly, "No, thank you, I couldn't eat a thing." Marguerite exclaimed, "Oh my deah, ah think you've got a daisy petal right on your darlin' little chin."

Mia burped.

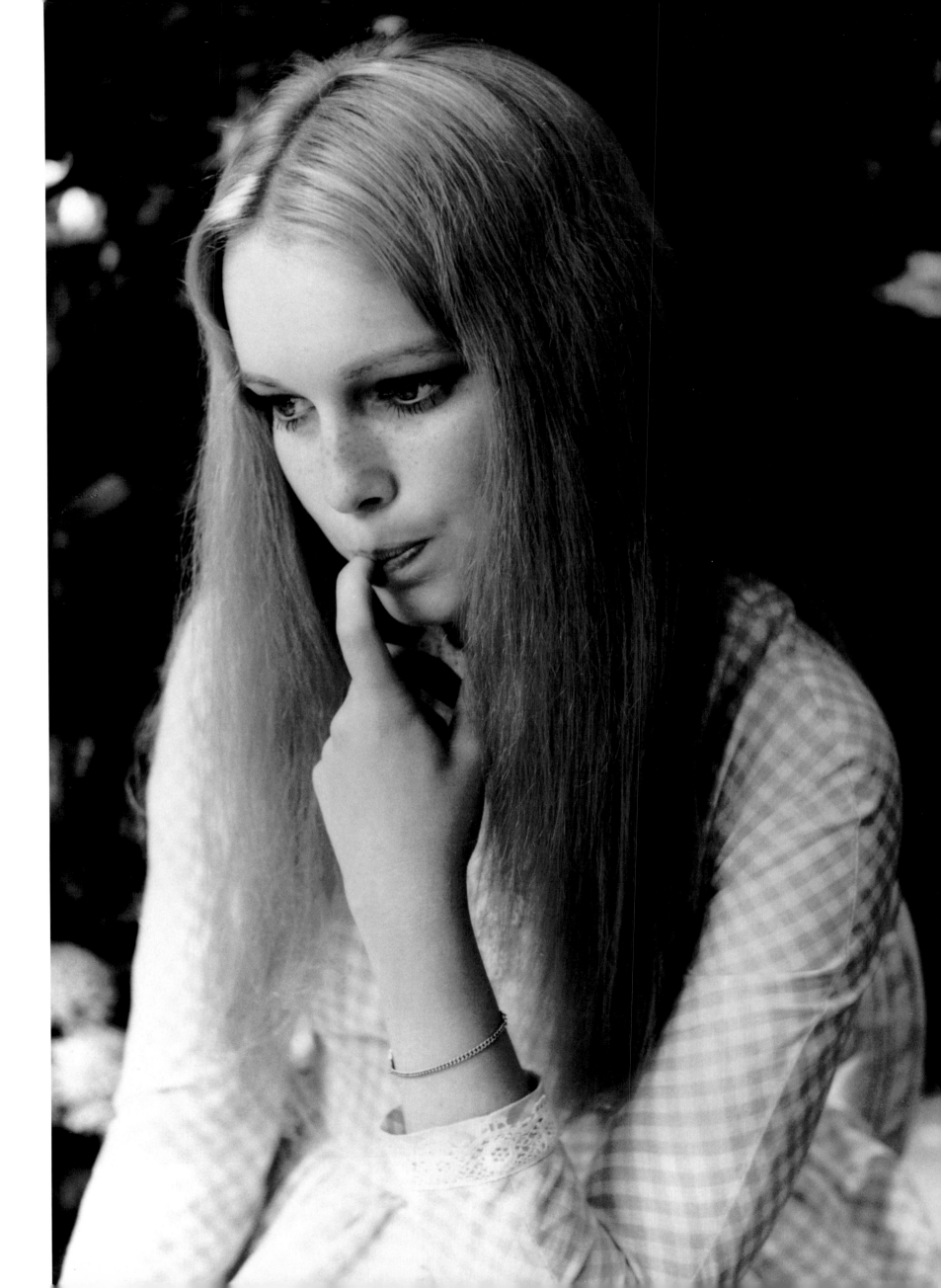

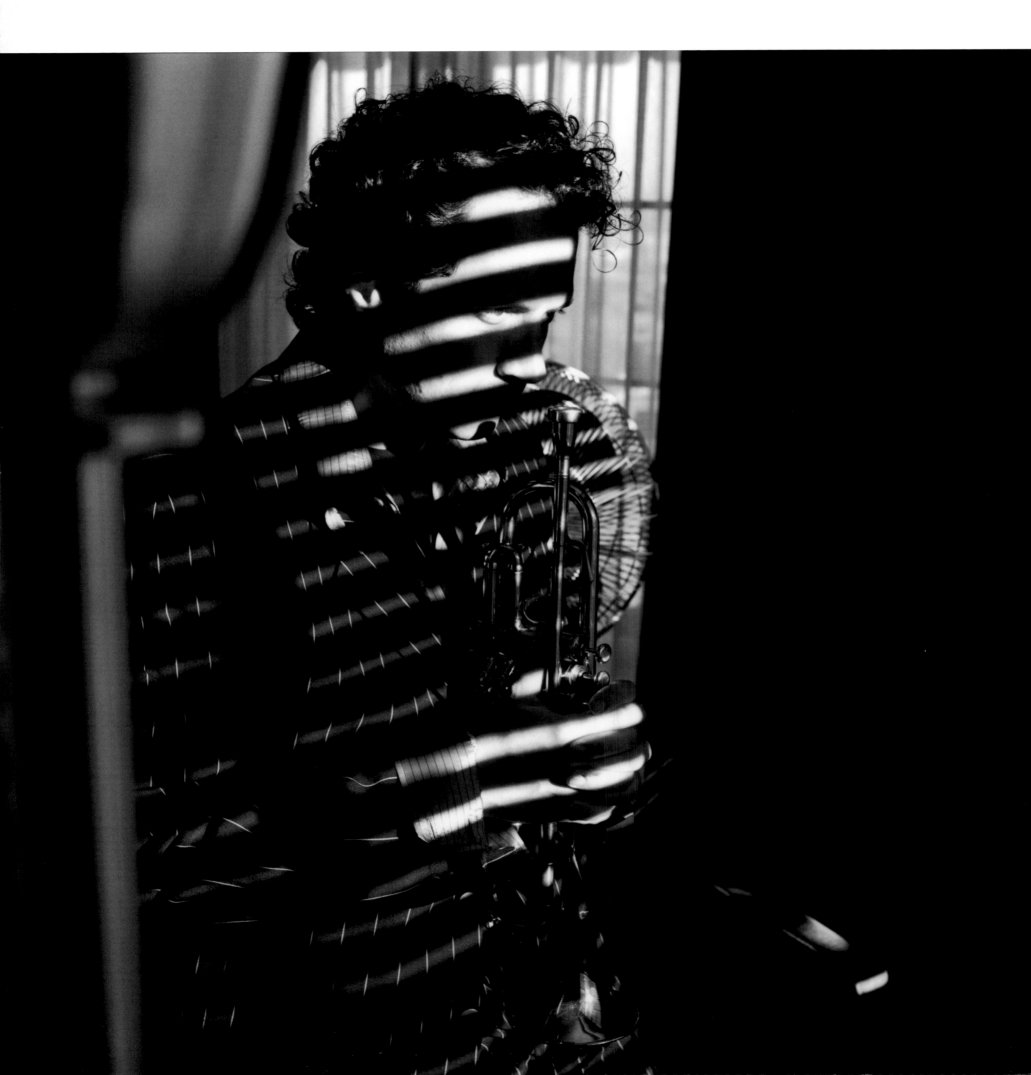

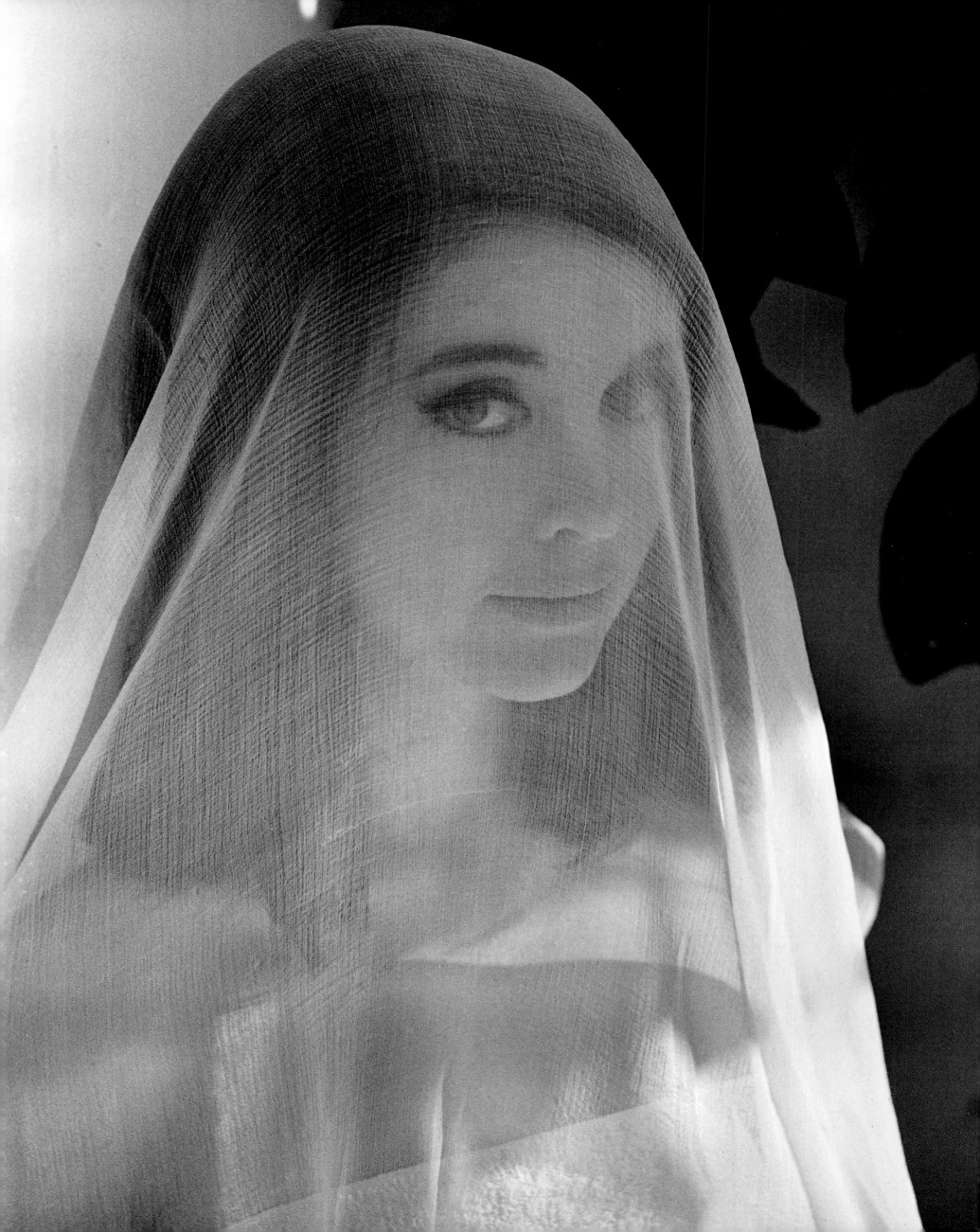

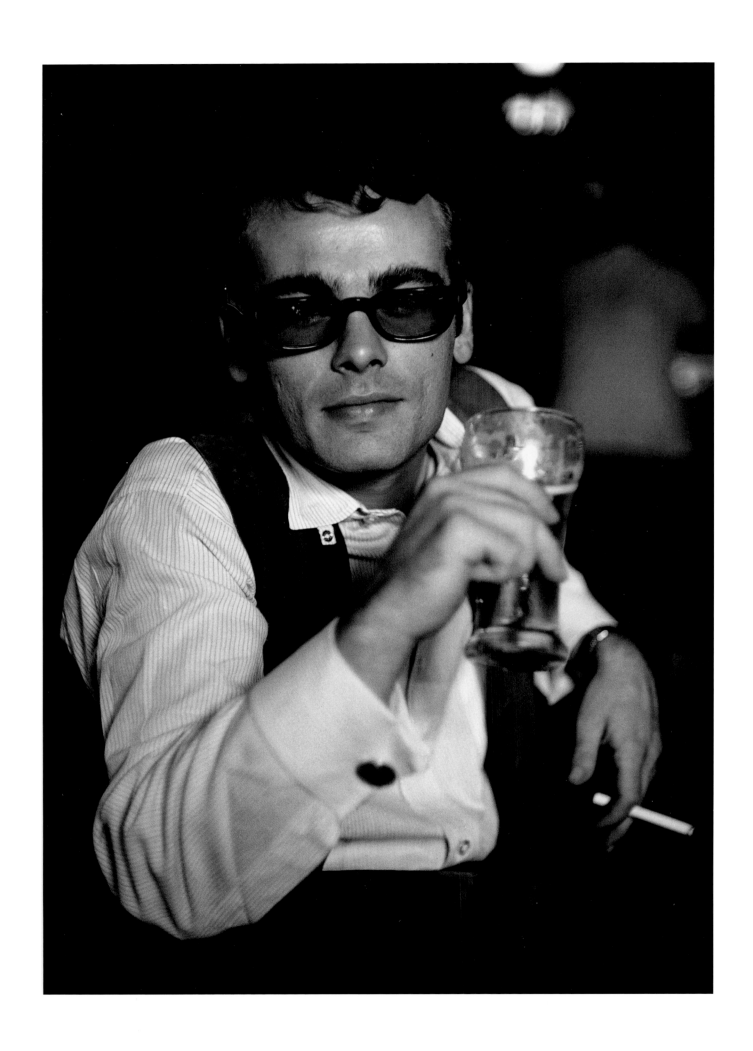

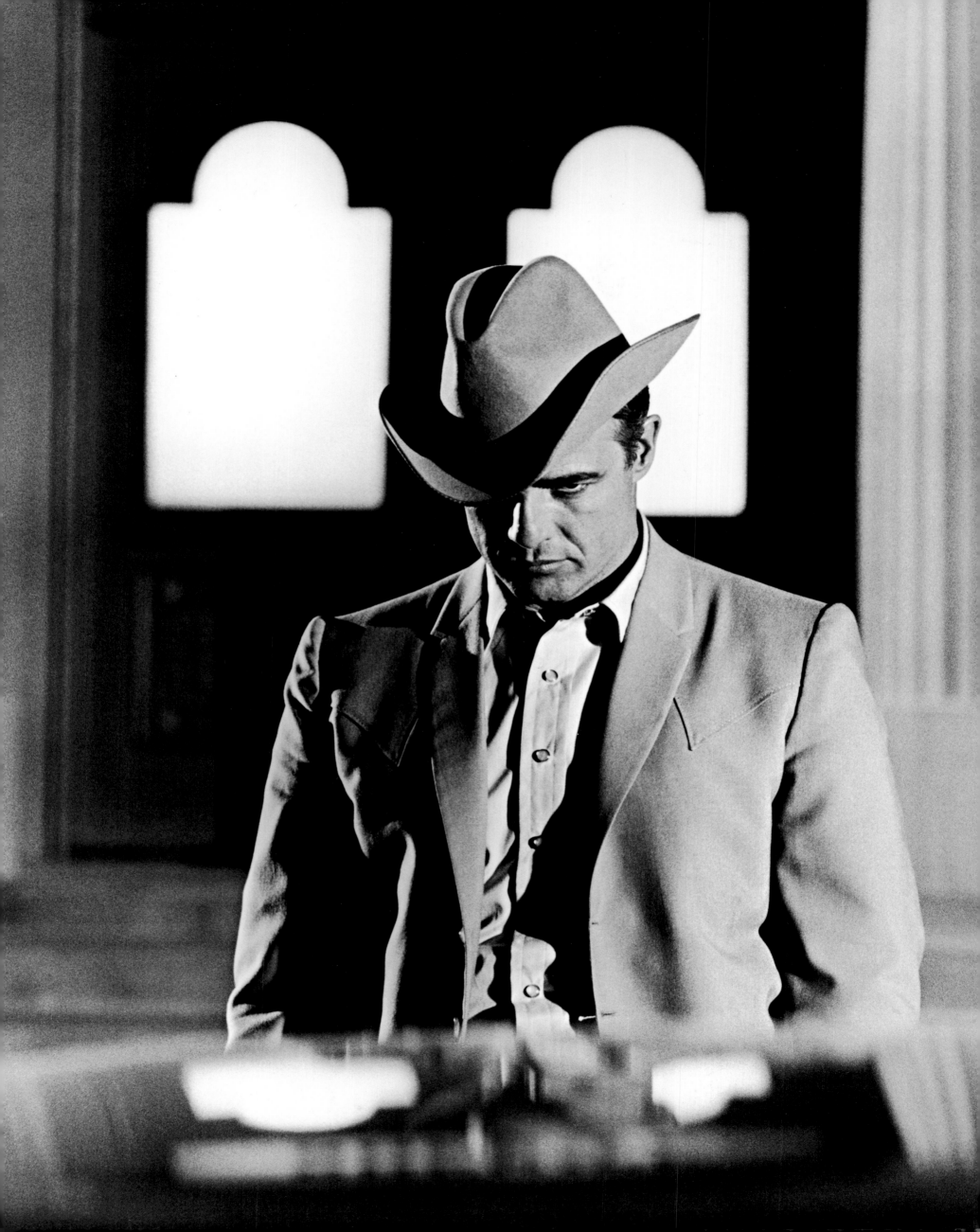

Hollywood, 1961. I had photographed Shirley MacLaine several times in the past, and we had become good friends. She was always a sweet, funny, charming gamine—very intelligent, razor-sharp, even downright bawdy at times.

In 1963, at the 20th Century Fox studio, J. Lee Thompson was directing Shirley and several leading men, including Paul Newman, Robert Mitchum, Dean Martin, and Gene

SHIRLEY MacLAINE

Kelly, in a sprawling comedy called *What a Way to Go!* I had an assignment from a major magazine to cover the making of the film, and due to the size of the production and the number of major stars in it, I had to be on the set for several weeks. One afternoon, the mood on the sound stage had become sullen, weighed down by a string of technical problems. Whenever shooting became difficult, the very nervous director had a habit of tearing strips of paper from the script and eating them. The cast and crew had almost grown accustomed to this peculiar habit. Shirley usually found some wonderful way to ease the tension with her great sense of humor, but the mood on that day was too much even for Shirley.

After the lunch break, the crew prepared for a love scene between Shirley and Robert Mitchum. It was a cramped set, with the camera operator and his crew and the director sitting practically on top of the two actors. I needed to get a close-up of the love scene, so I tried to wedge myself discreetly into the midst of this intimate little group. The rest of the crew knew enough to keep back from the action. When everything was ready, the tough assistant director shouted, "Quiet, goddamn it!" You could hear a pin drop.

Shirley and Mitchum were in a tight clinch. Their lips touched and parted and then touched again several times. It was a hot and steamy scene. This passionate kissing continued for quite a while. My camera was poised and focused while I waited for just the right moment to release the shutter.

Suddenly, Shirley opened her eyes wide and pulled back from Mitchum's wet lips. Her eyes locked on mine. Then she stared directly at my crotch and said very loudly, "Bill, you'd better have that thing lanced." Whereupon the director spit out a huge wad of paper and yelled, "Cut!" From then on, the mood was much lighter.

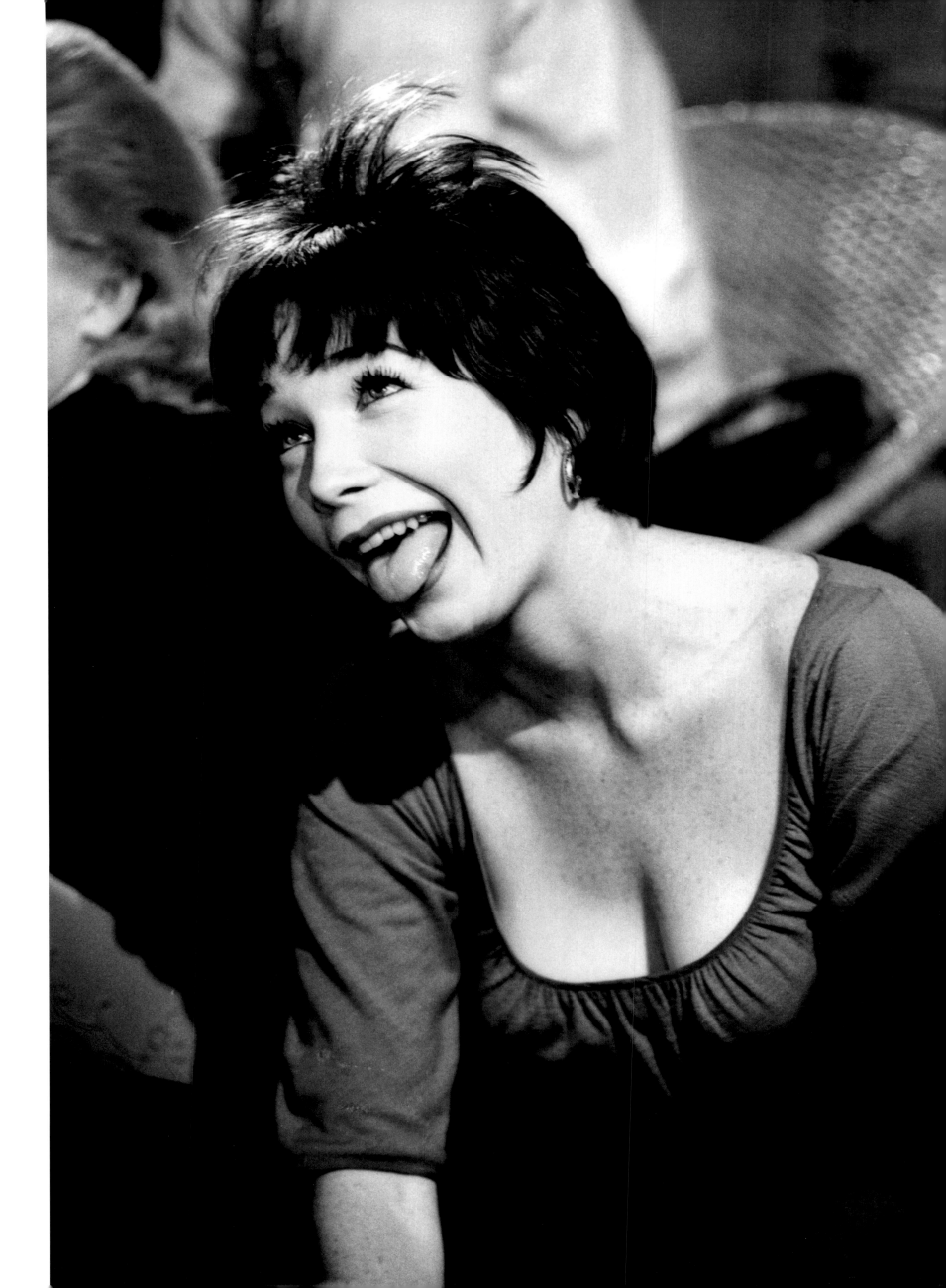

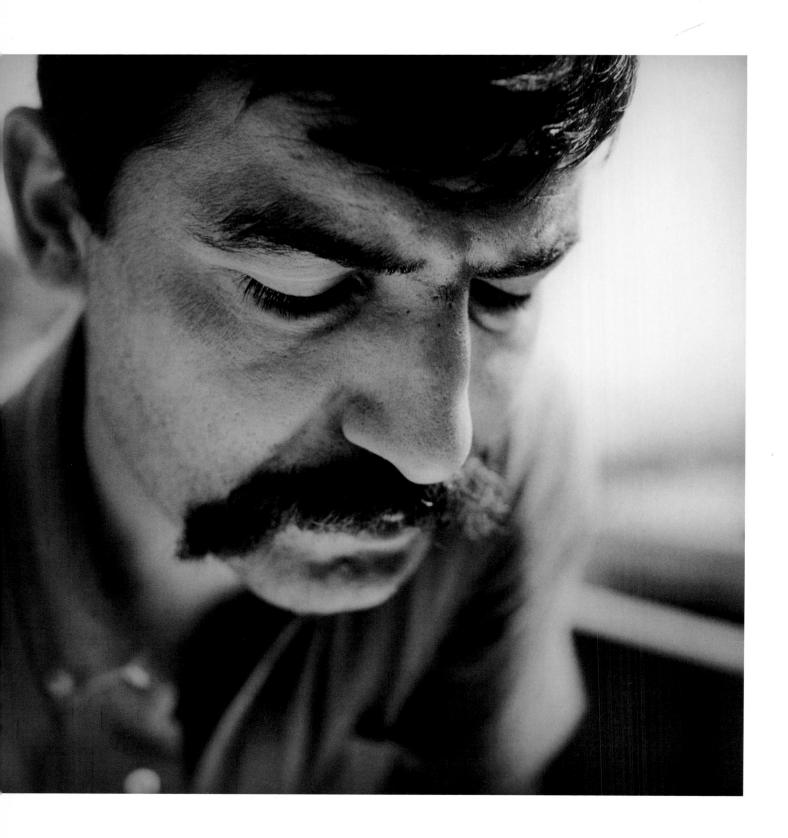

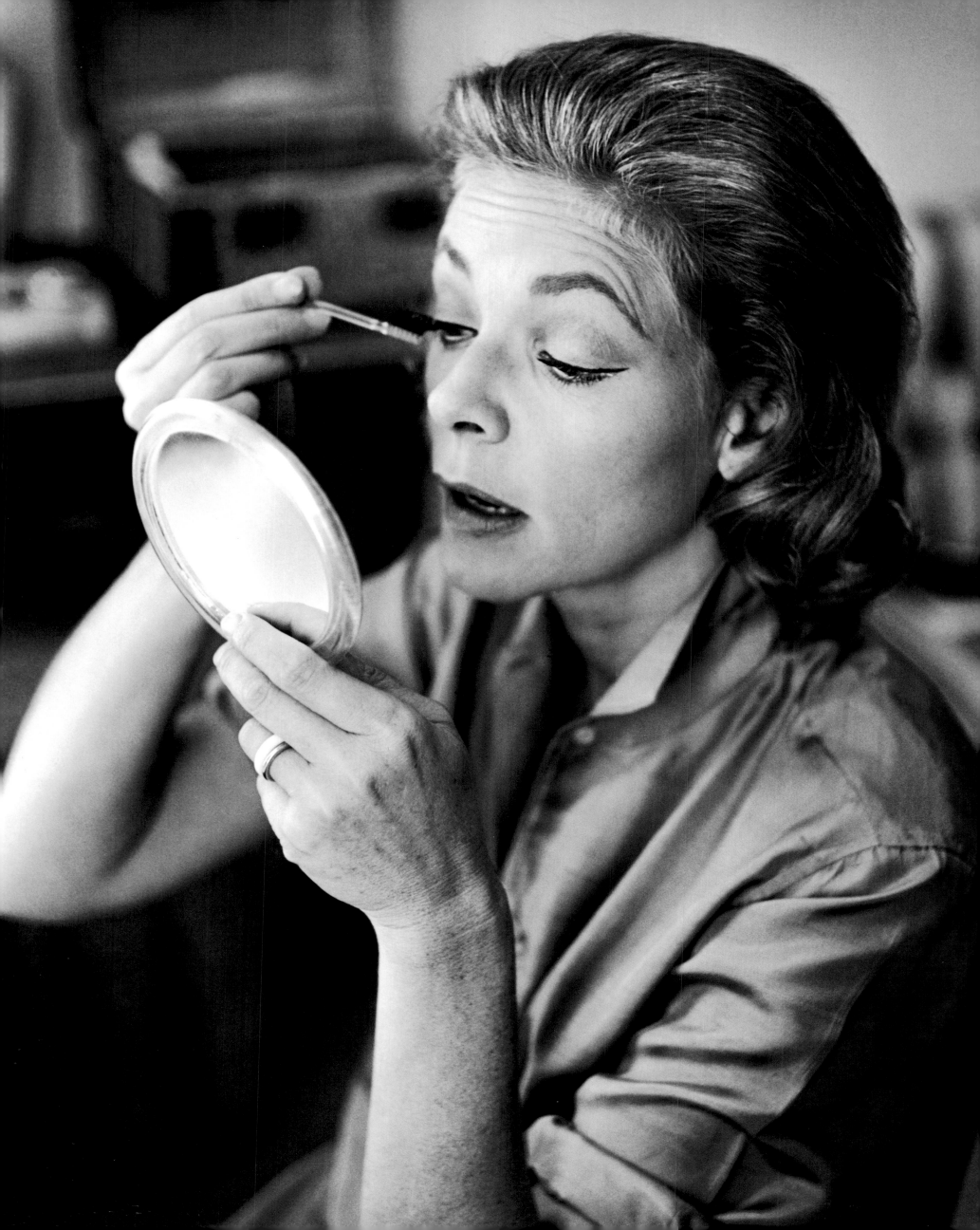

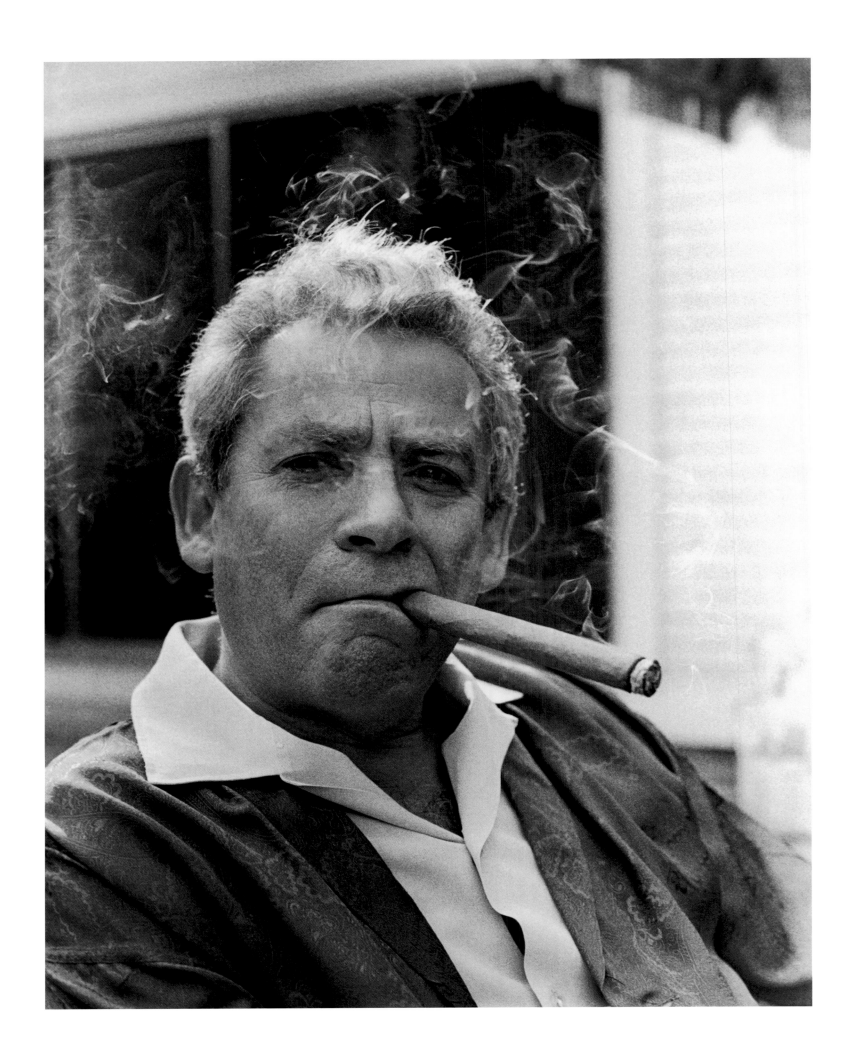

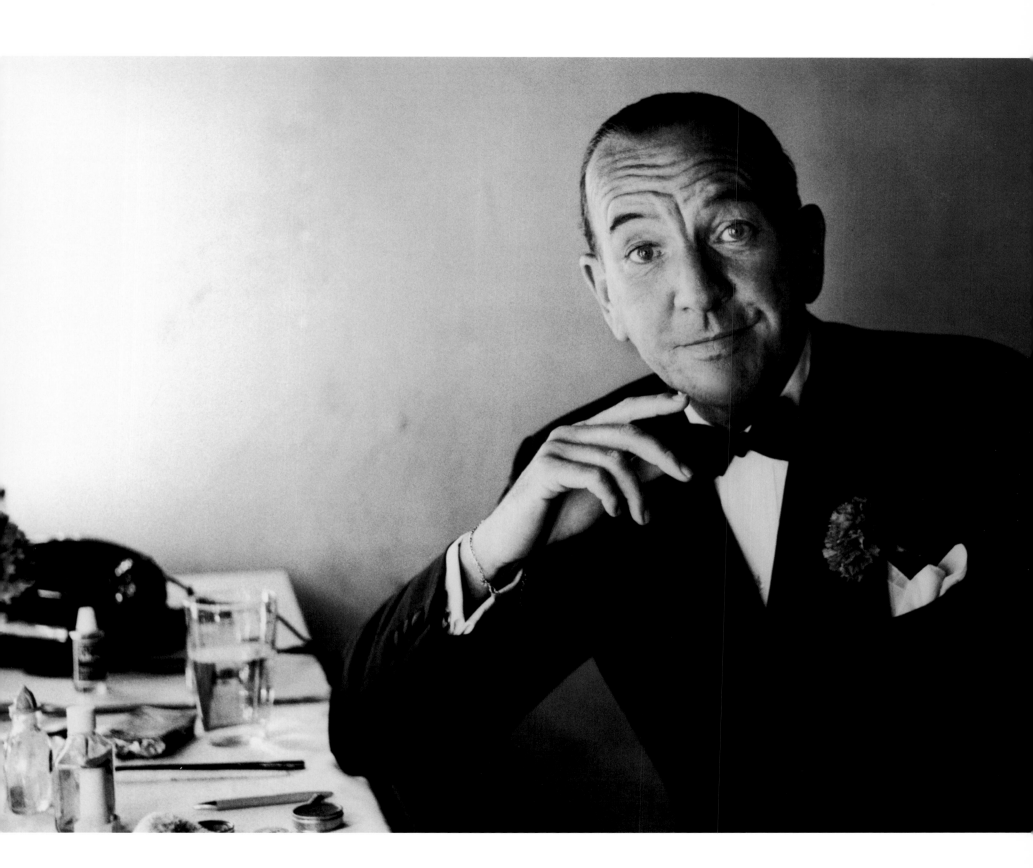

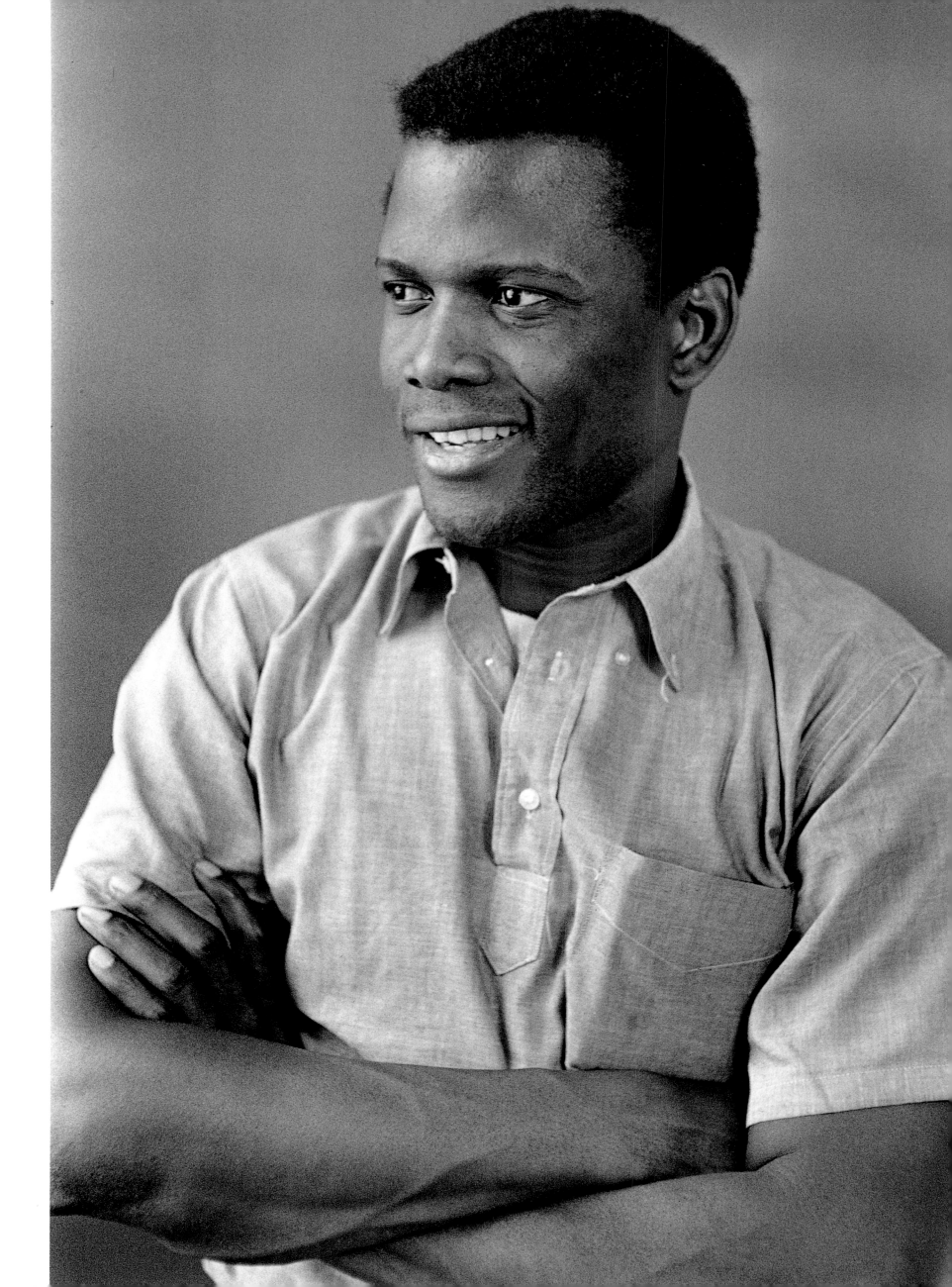

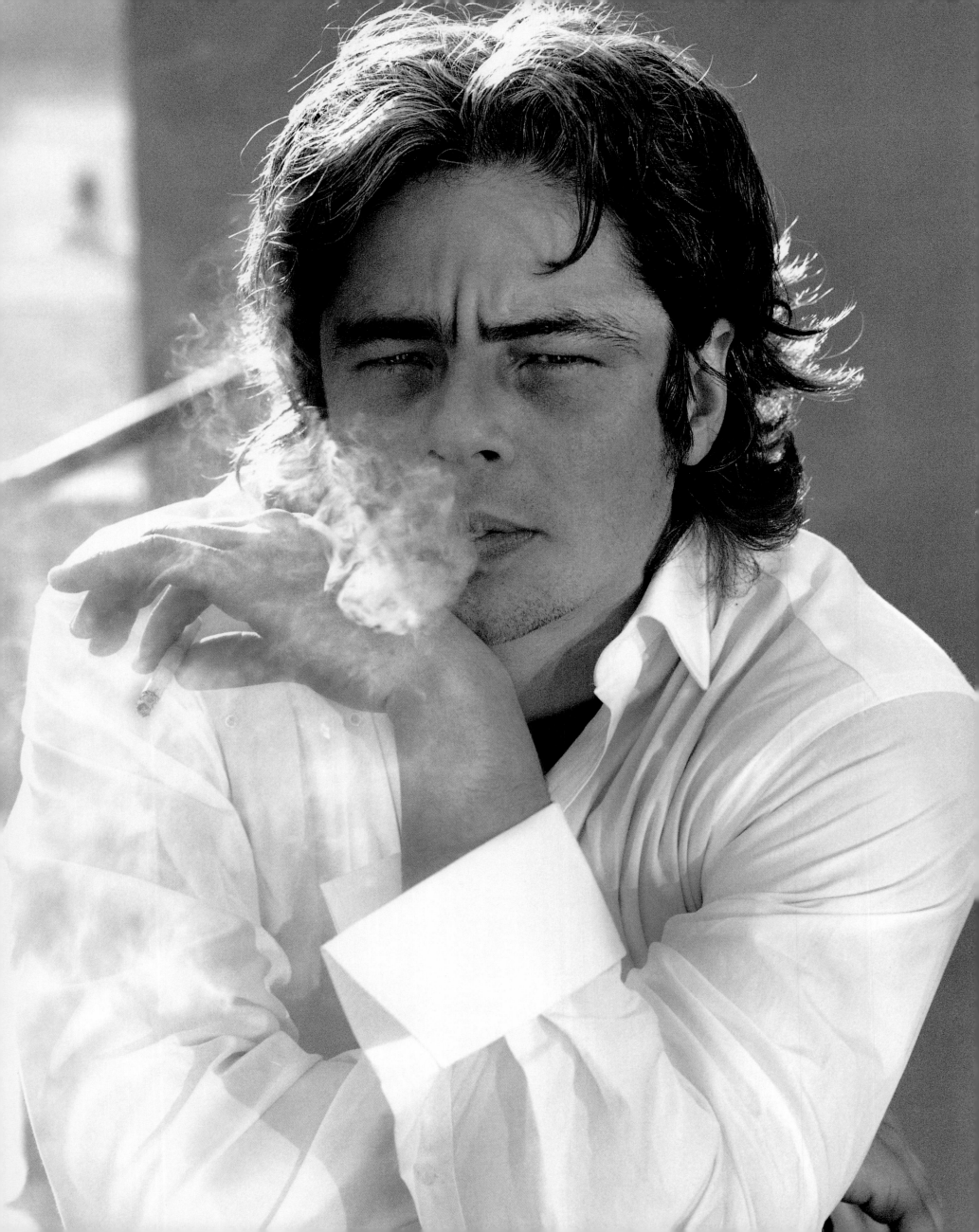

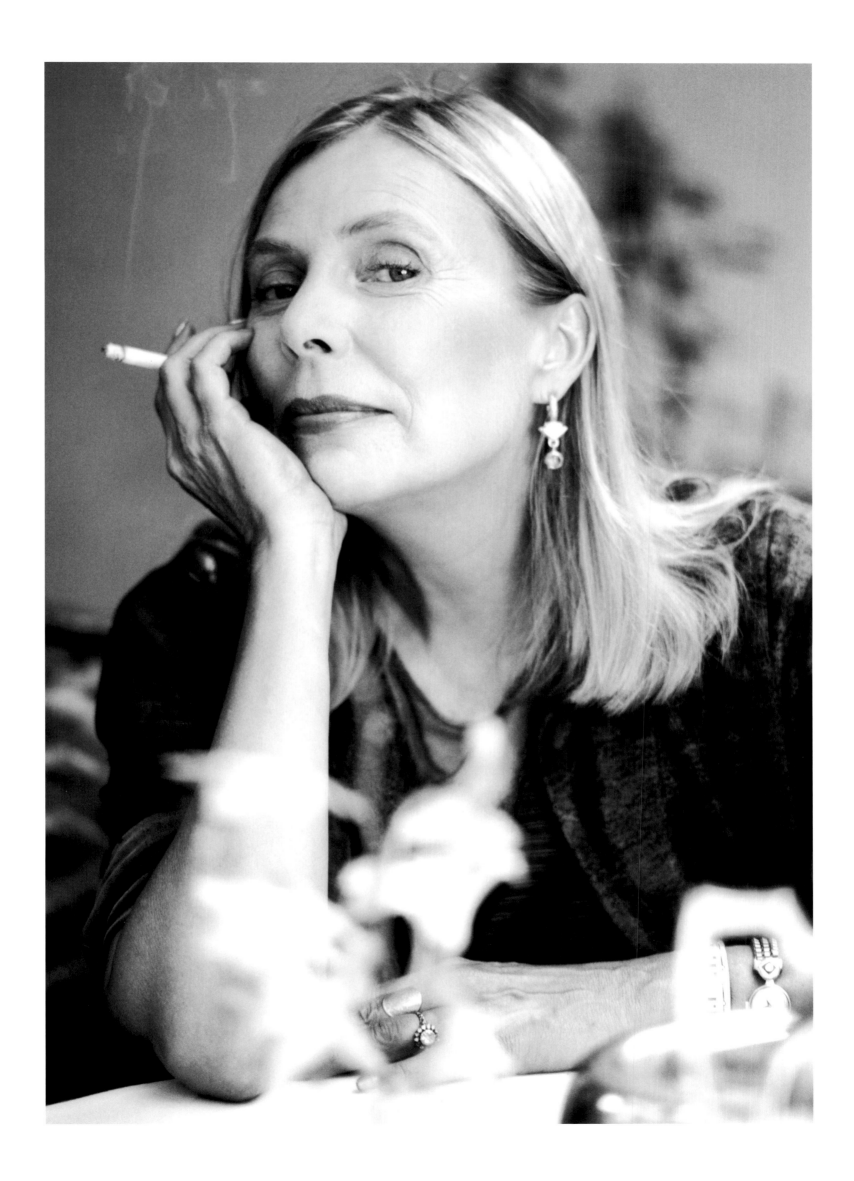

Cadaques, Spain, 1966. Peggy Ann Freeman from Detroit was known to the world as Donyale Luna, an extremely exotic fashion model. In the 1960s, during the swinging London period, Donyale, along with Twiggy, Jean Shrimpton, and Peggy Moffitt, was one of the "hottest" fashion models in the world. I had photographed Donyale in London and we had become good friends.

I had an assignment to go to Spain to photograph the extraordinary artist Salvador Dali. I asked Donyale to accompany me, thinking that Dali would enjoy her looks and her personality.

While she packed her bags for the trip in her Paris apartment, I made some suggestions as to what to include. I asked Donyale if she had a plain white dress in her closet. She pulled out a wonderful long, pure white crepe gown. "That would be perfect," I said with enthusiasm. "Perhaps I can persuade Salvador Dali to paint on that dress while it's on you. He'll probably love the idea." Donyale was aghast, responding, "Paint on my dress! Are you kidding? That's a Rudi Gernreich and it cost me eighty dollars!" I then tried to convince her that the dress could become a piece of art. She was not convinced. Then I told her that a Dali-painted

SALVADOR DALI and DONYALE LUNA

dress would most likely be a thousand times more valuable. That did it. She agreed to take the white dress with us. On our way to the airport she asked, "How much is a thousand times eighty?"

We had an incredible four days with Dali at the medieval fishing village that he had turned into a home and studio on the shores of the Mediterranean in Cadaques. Dali adored Donyale, and he particularly enjoyed "camping" with her for pictures. He loved the idea of painting on her while she donned the white gown.

Years later, sadly, Donyale hit rock bottom from the use of drugs. She was living in New York City and having a tough time surviving. She sold the Dali-decorated dress for less than a hundred dollars.

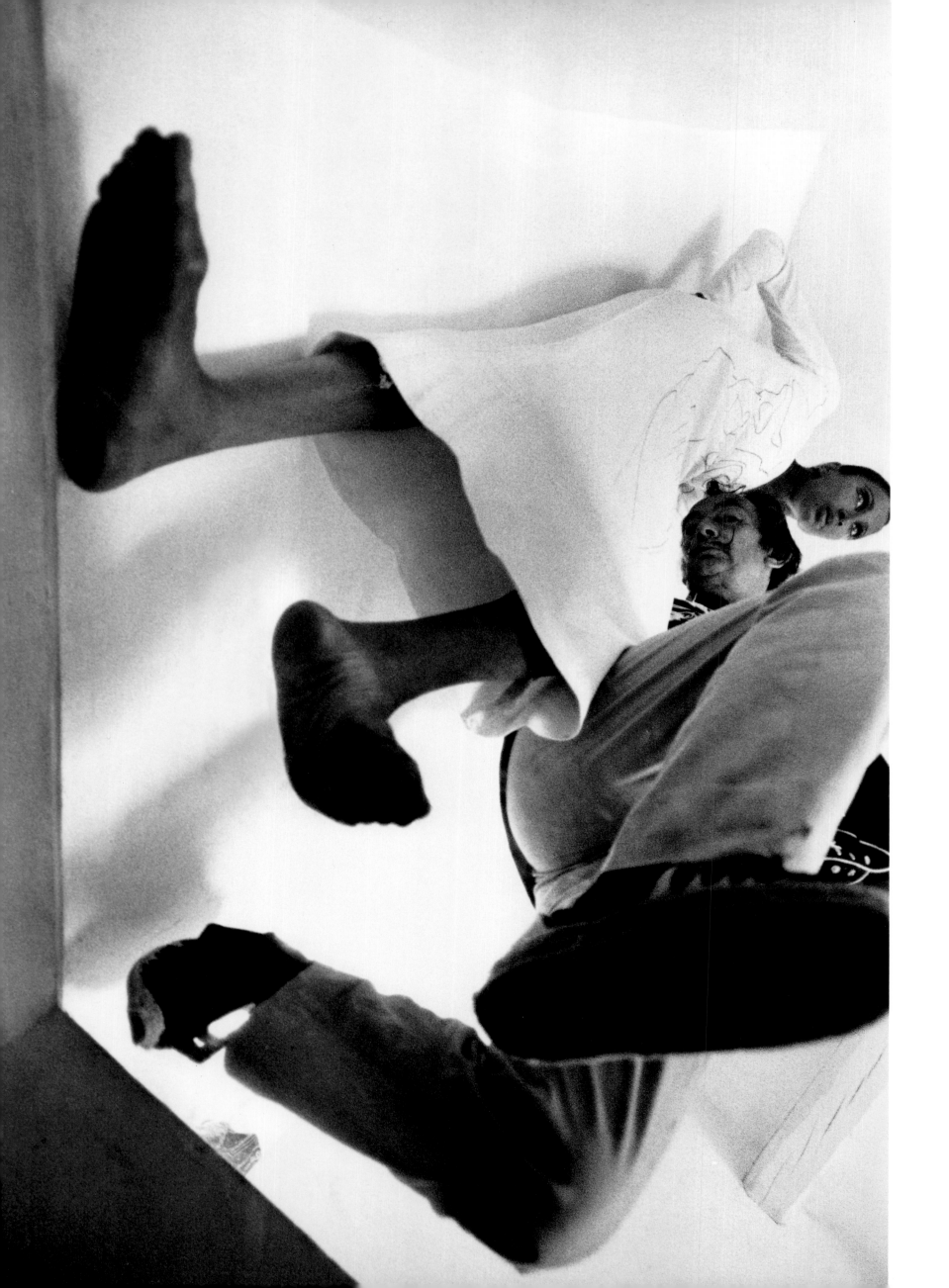

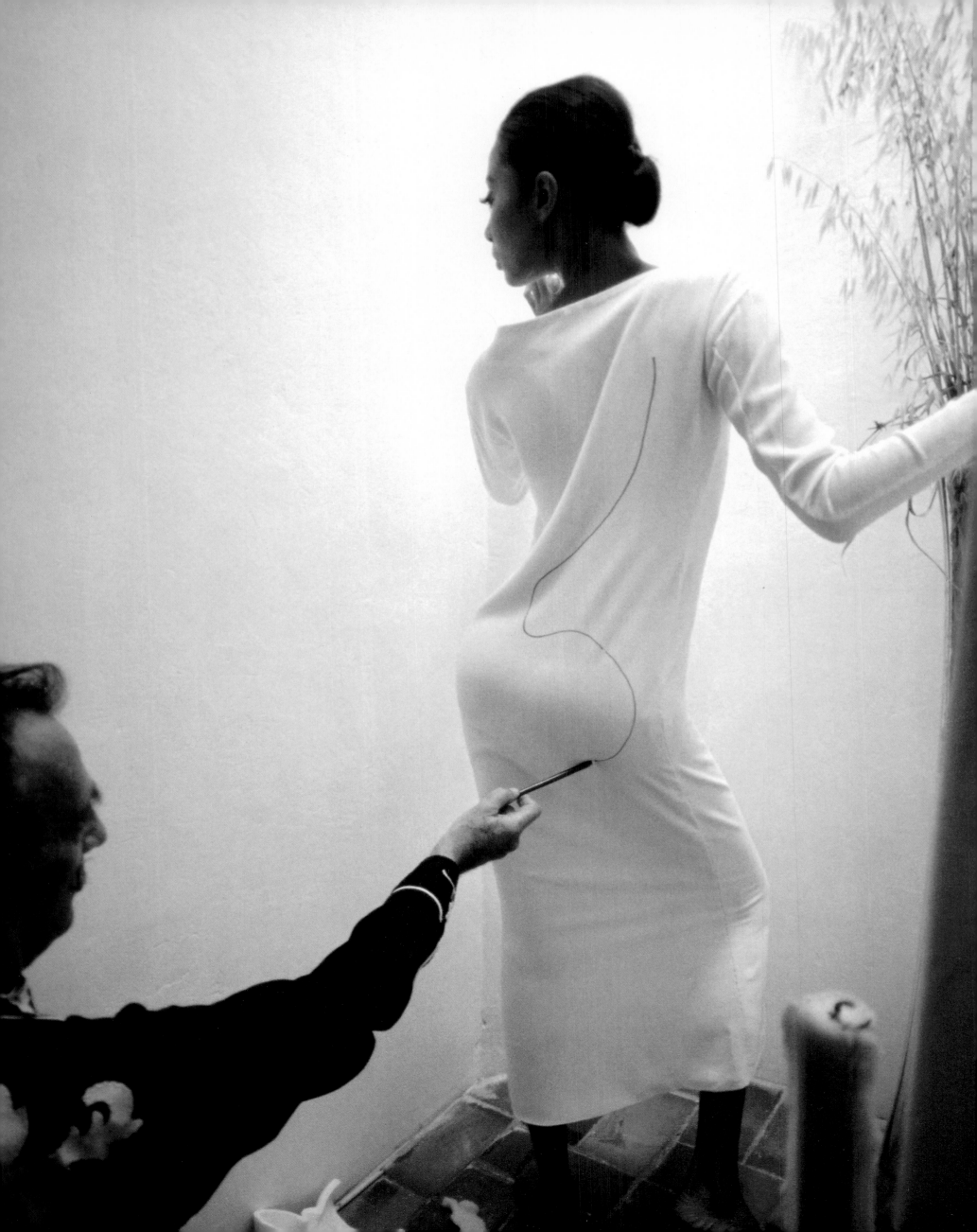

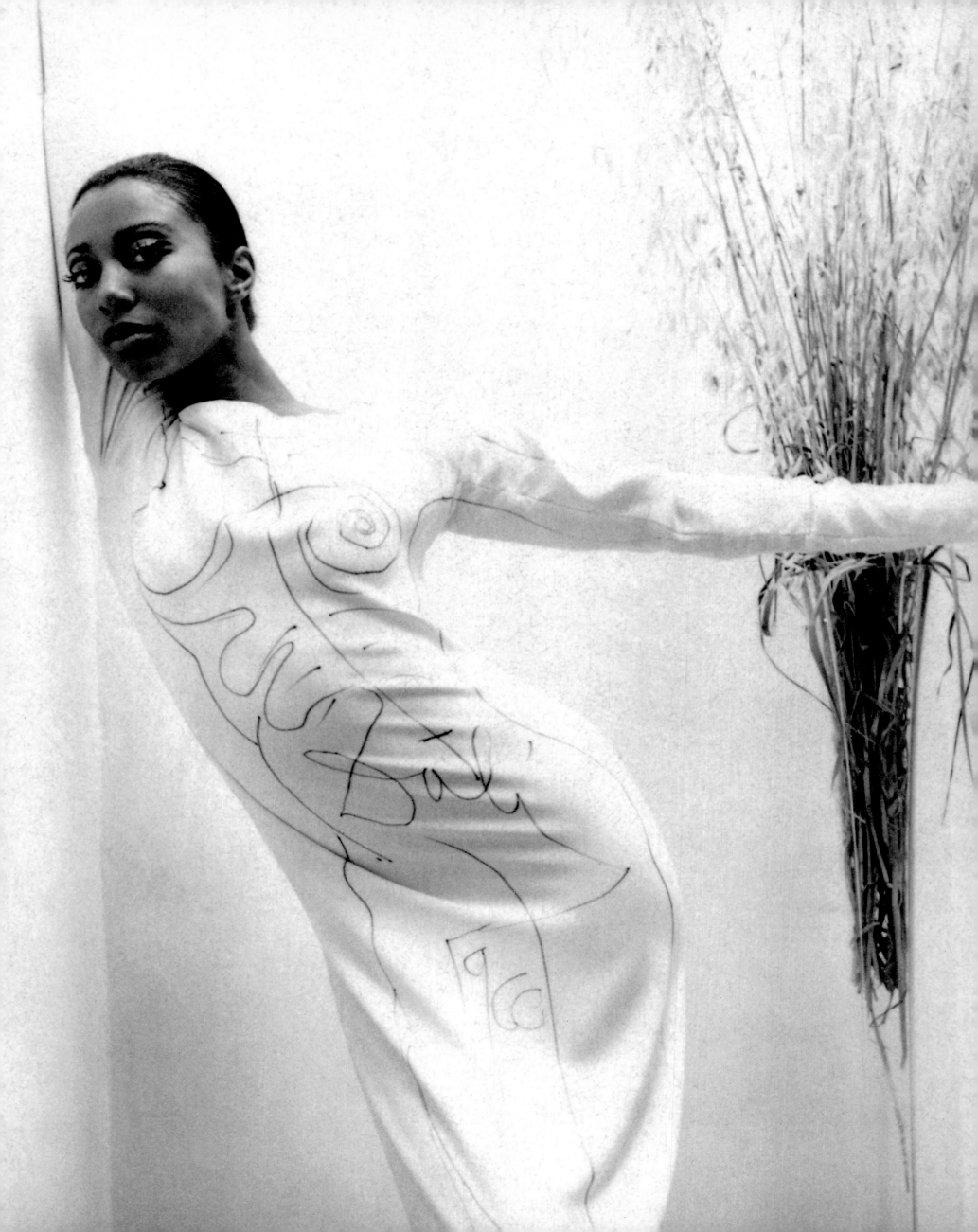

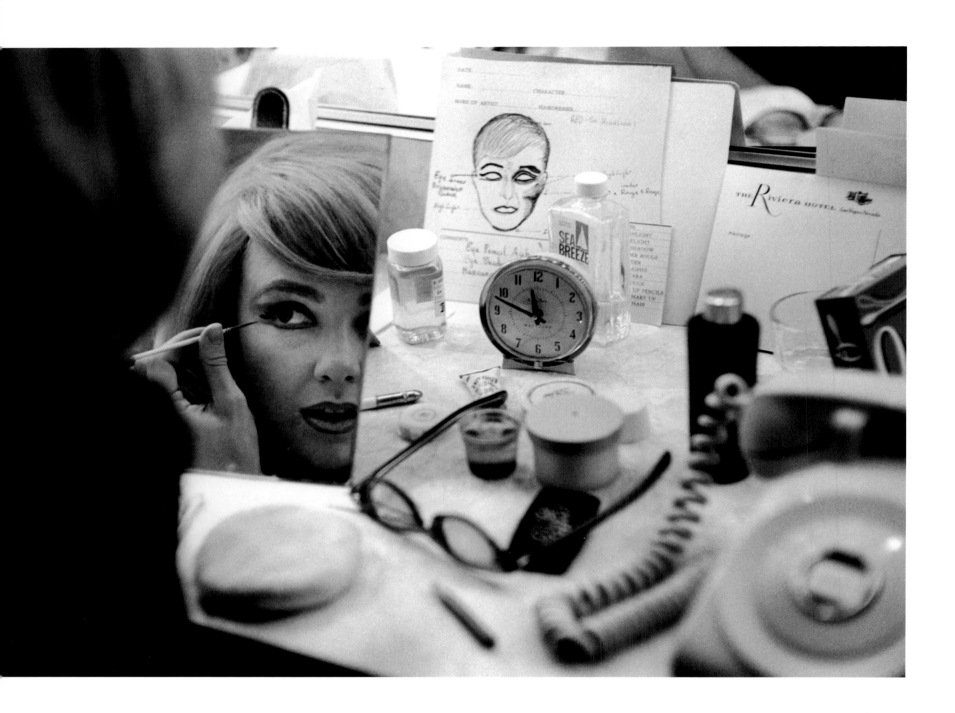

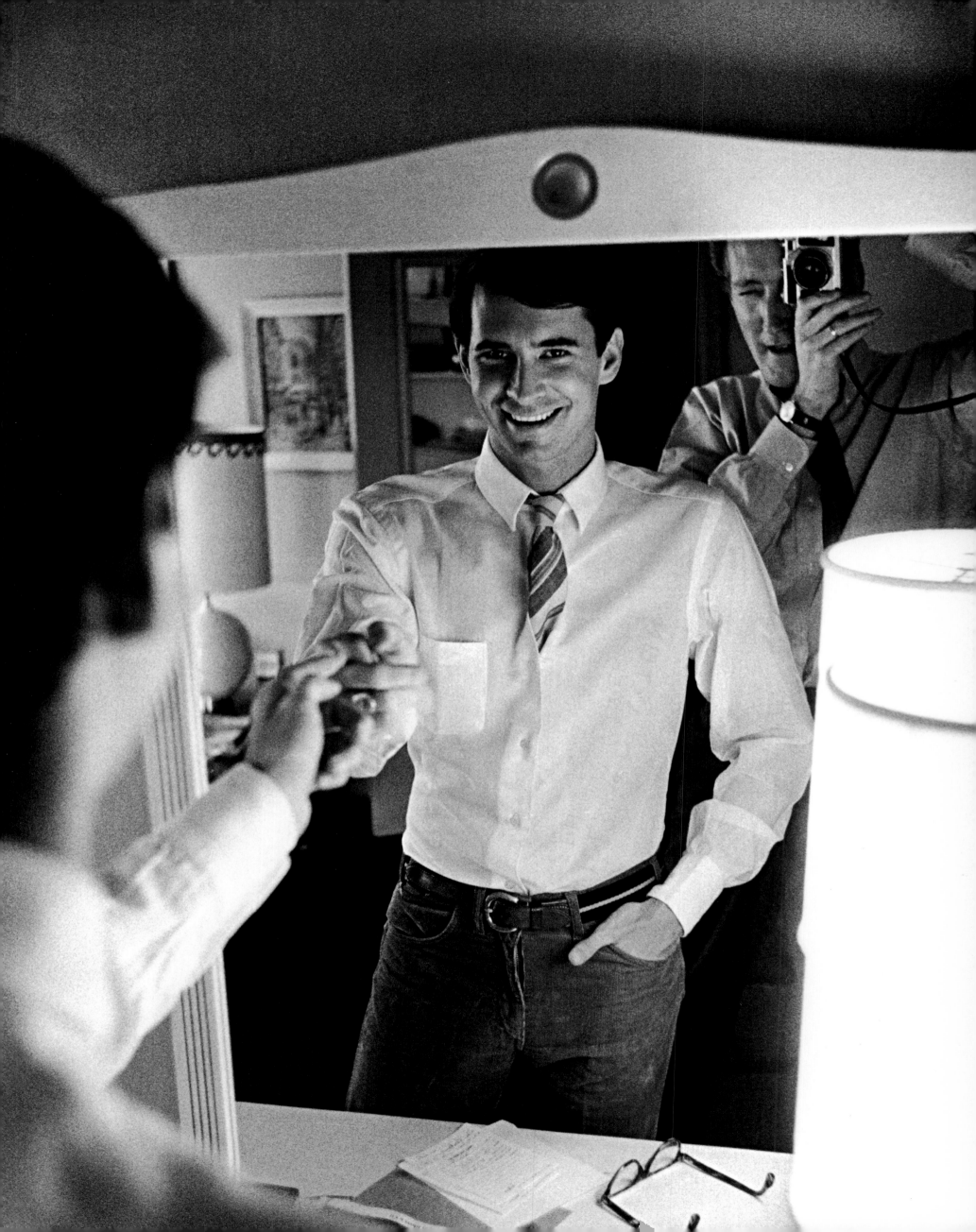

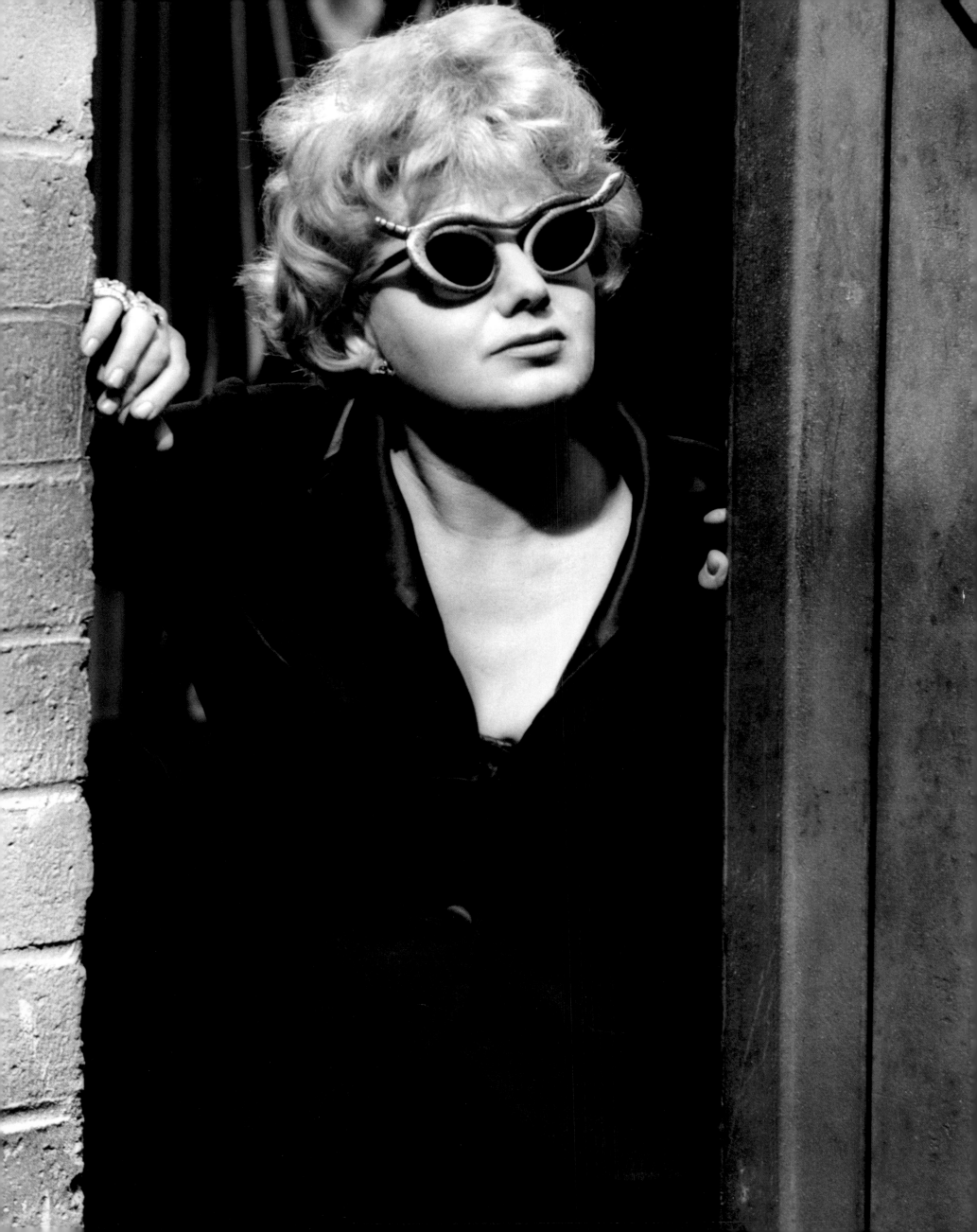

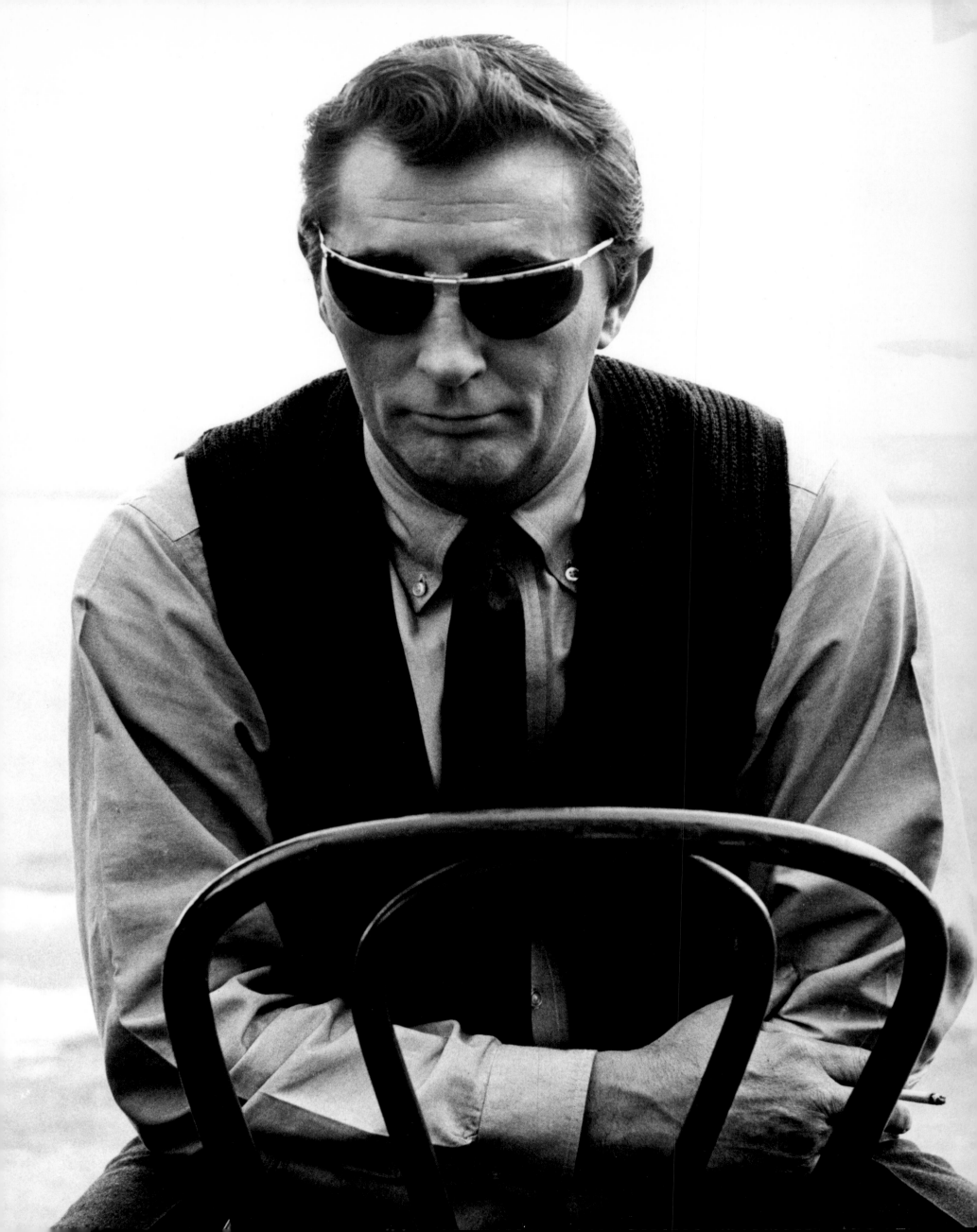

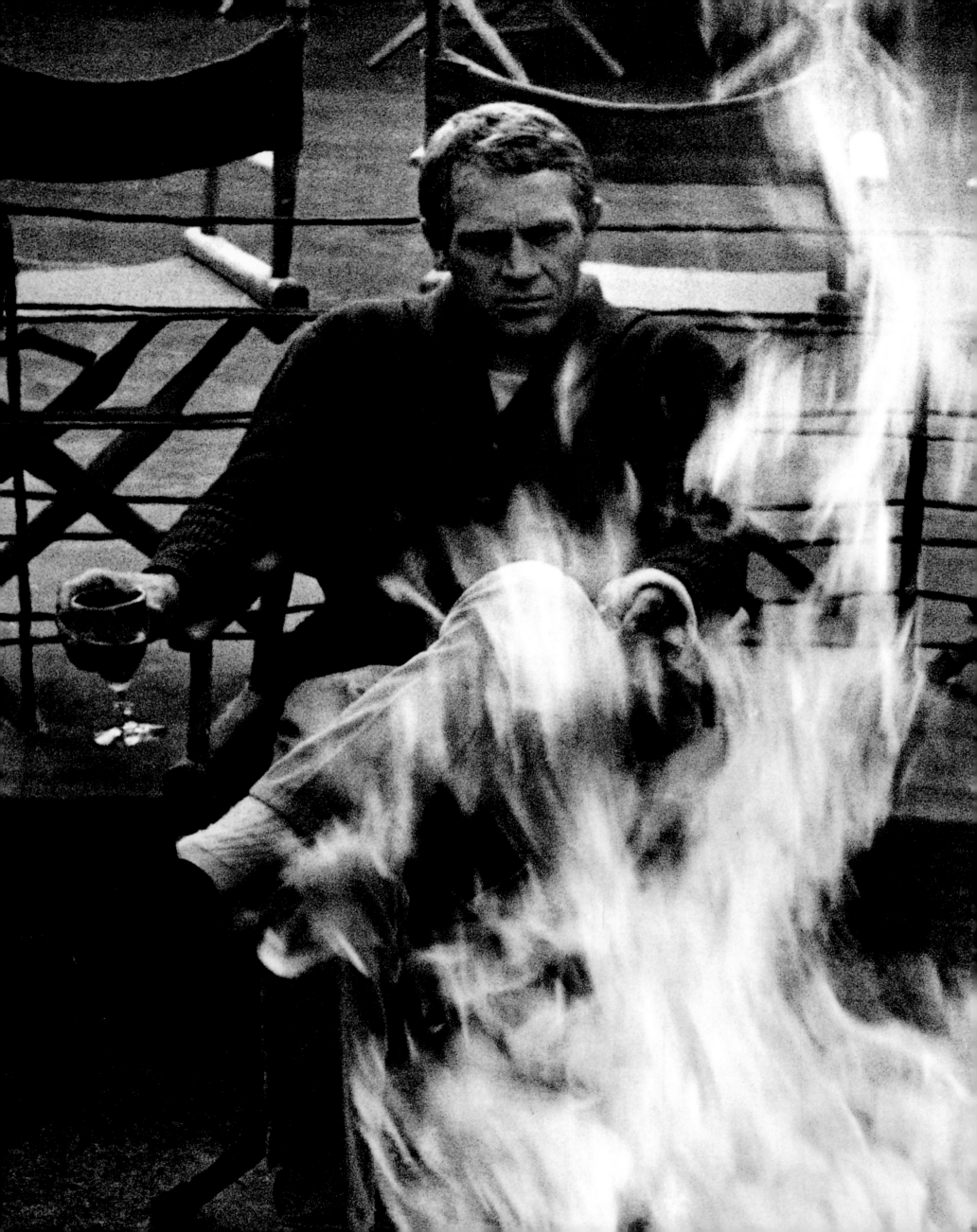

Big Sur, California, 1963. Like a lot of Americans, I discovered Steve McQueen when I saw him on the television series *Wanted: Dead or Alive* in 1958. He had made his film debut only two years before with a bit part in *Somebody Up There Likes Me*, but in this show his performances were unusual and provocative, especially in the close-ups. Like Spencer Tracy before him, Steve could register in a matter of seconds a vast number of moods, thoughts, and tensions with lightning-speed introspection.

STEVE McQUEEN

In 1962, when he was about to work in the feature *Love With the Proper Stranger*, I happened to get an assignment to photograph him and co-star, Natalie Wood. Over a number of years, and through several movie productions, Steve and I had become close friends. I had never met anyone quite like him. He was uneducated but intelligent, street-smart, mean, often funny, and hip—in fact, he was super-hip.

He was also very possessive of certain friends. While shooting a film, he wanted me to be on the set all the time, have lunch with him, hang out when he was not working, and, most of all, he did not want me to associate with any other stars. "And especially not Paul Newman," he always said. "I'll be bigger than Newman. You watch." Theirs was a good-humored competition, because they were friends, but he definitely measured himself against the other actor.

His possessiveness didn't bother me too much at first. I always had a camera when we were together, on road trips, at his home, and during rehearsals, and being so close to him gave me opportunities for taking photographs that I've had with few others. But after a while, it began to trouble me. I never knew where he'd turn up next.

One night I was driving down Sunset Boulevard with Peggy, when she turned around said, "I think that guy on the motorcycle is following us." There was a biker behind us with one of those black plastic "bubble" helmets that didn't reveal his face. "Yeah," I said, "that's Steve." "How do you know it's Steve?" she asked. "I just know. Watch." At the next stoplight, I rolled down my window, waved at the familiar silhouette, and shouted, "Hey! Steve!" whereupon the mysterious biker turned onto a side street and sped off into the night.

The next day, I saw the same motorcycle and helmet near Steve's dressing room at the studio. I chided him about his pursuit of us the night before. A sheepish look came over his face, and he said, "Hey, man, a movie star's gotta have some fun, doesn't he?"

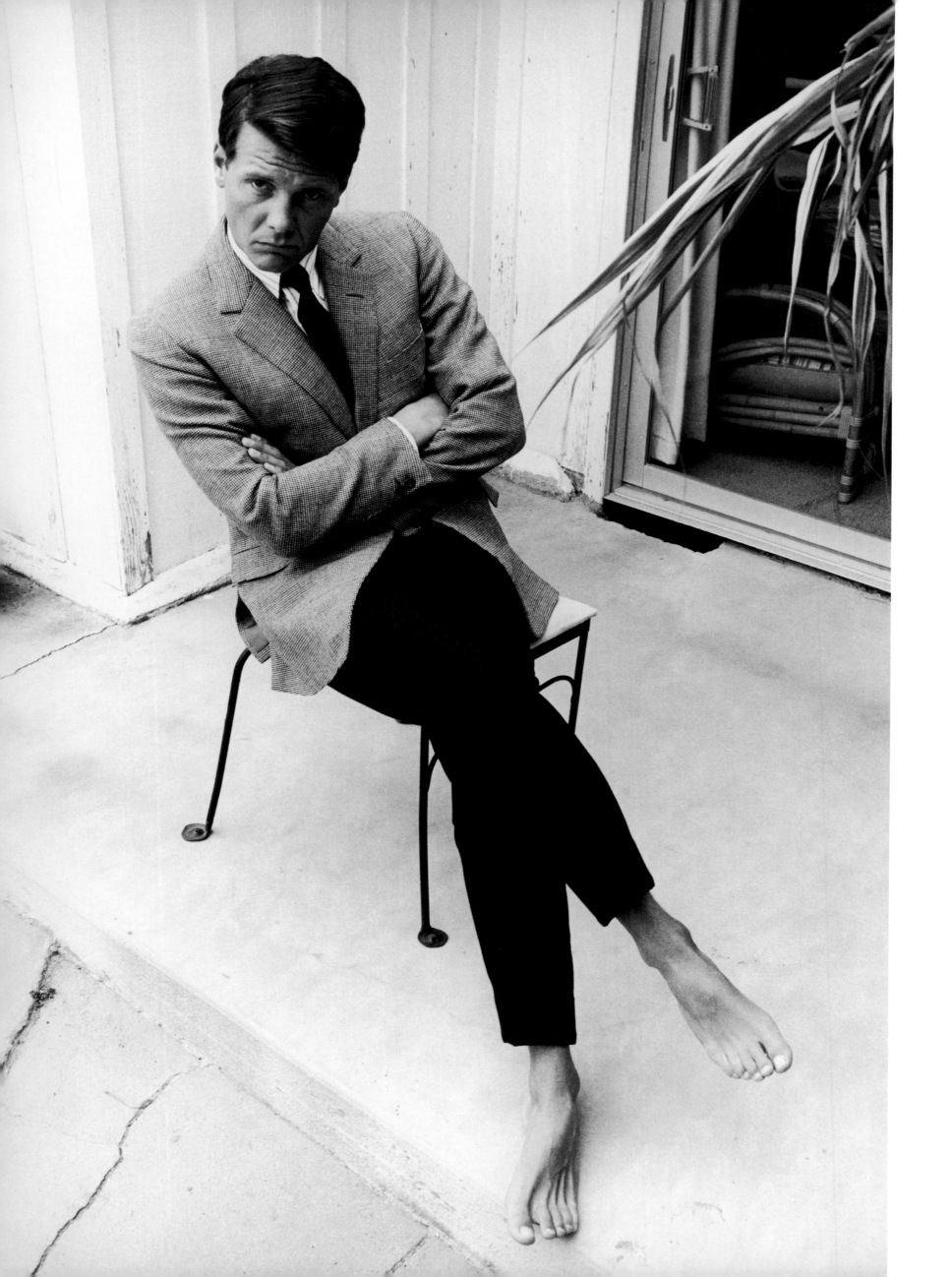

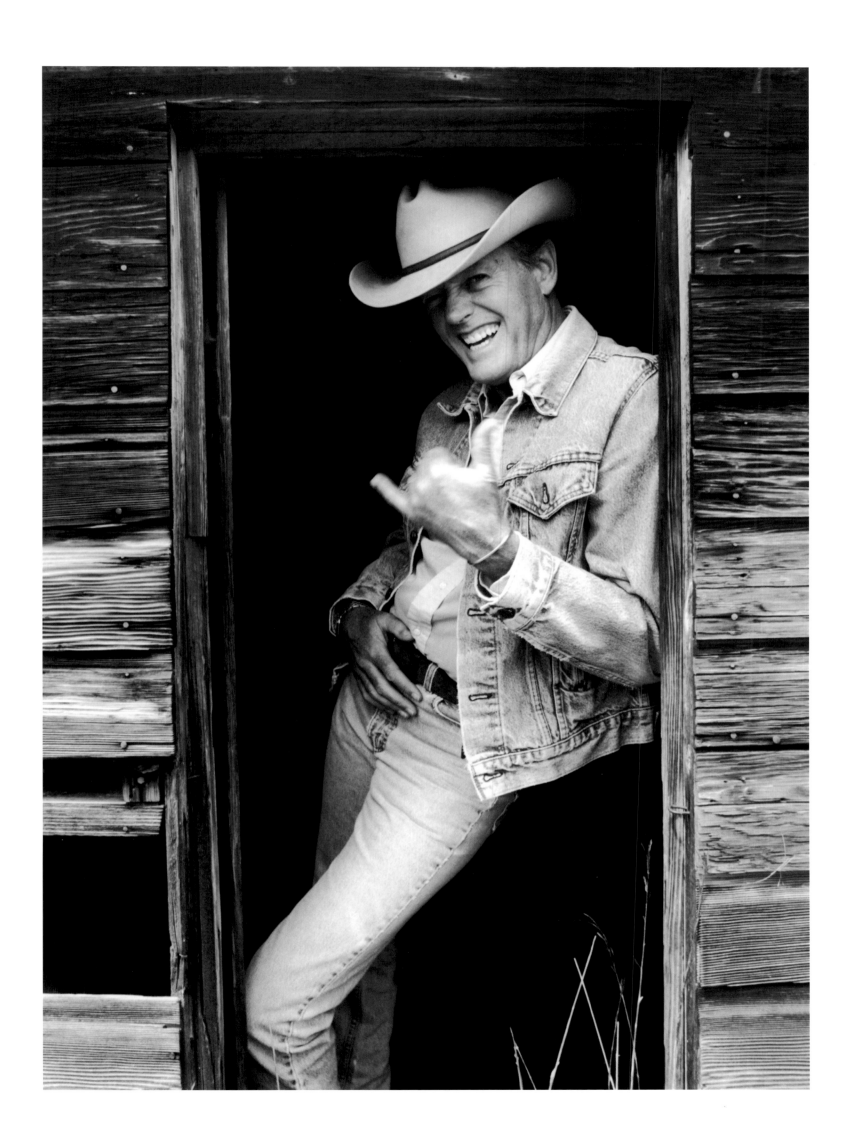

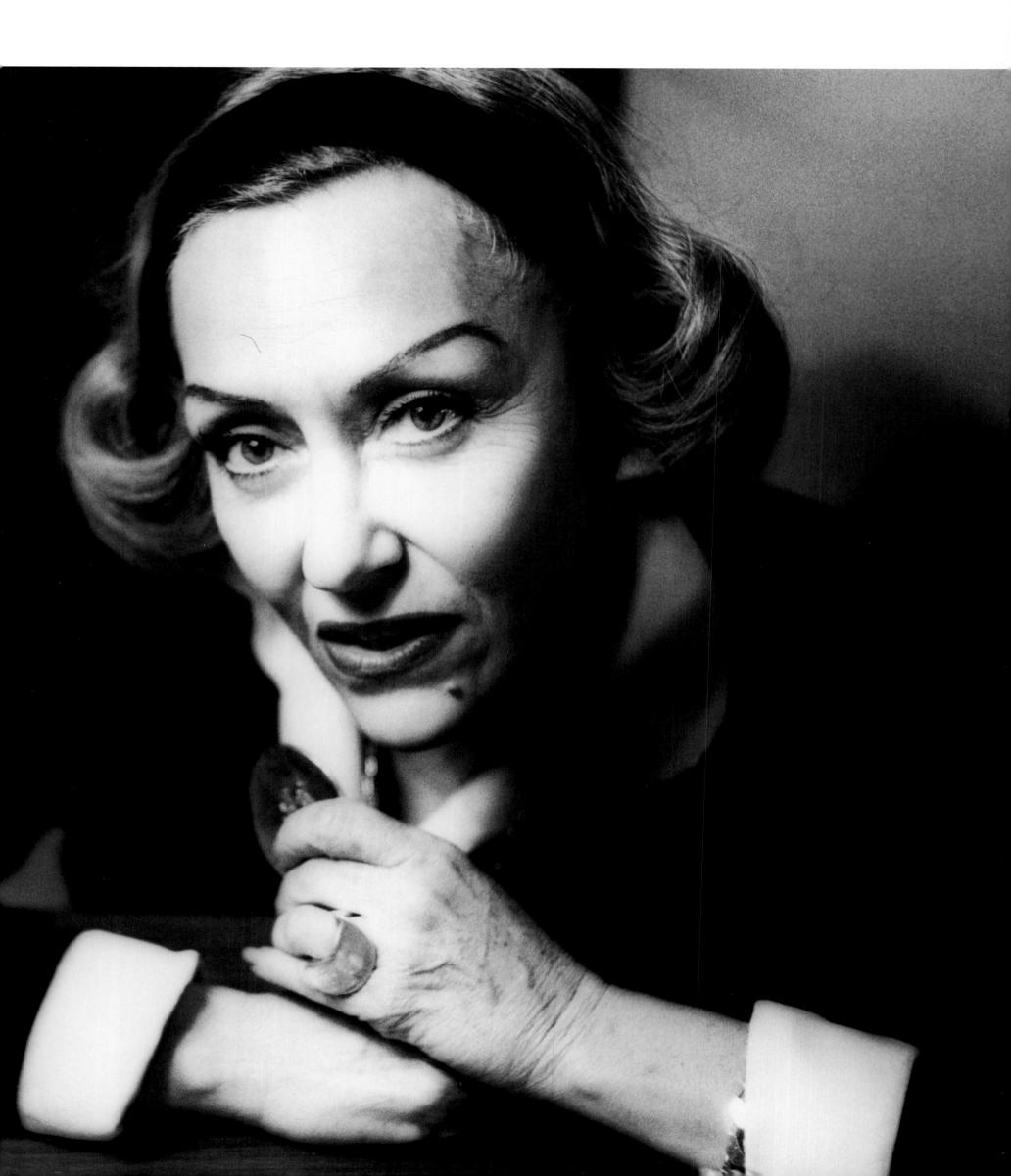

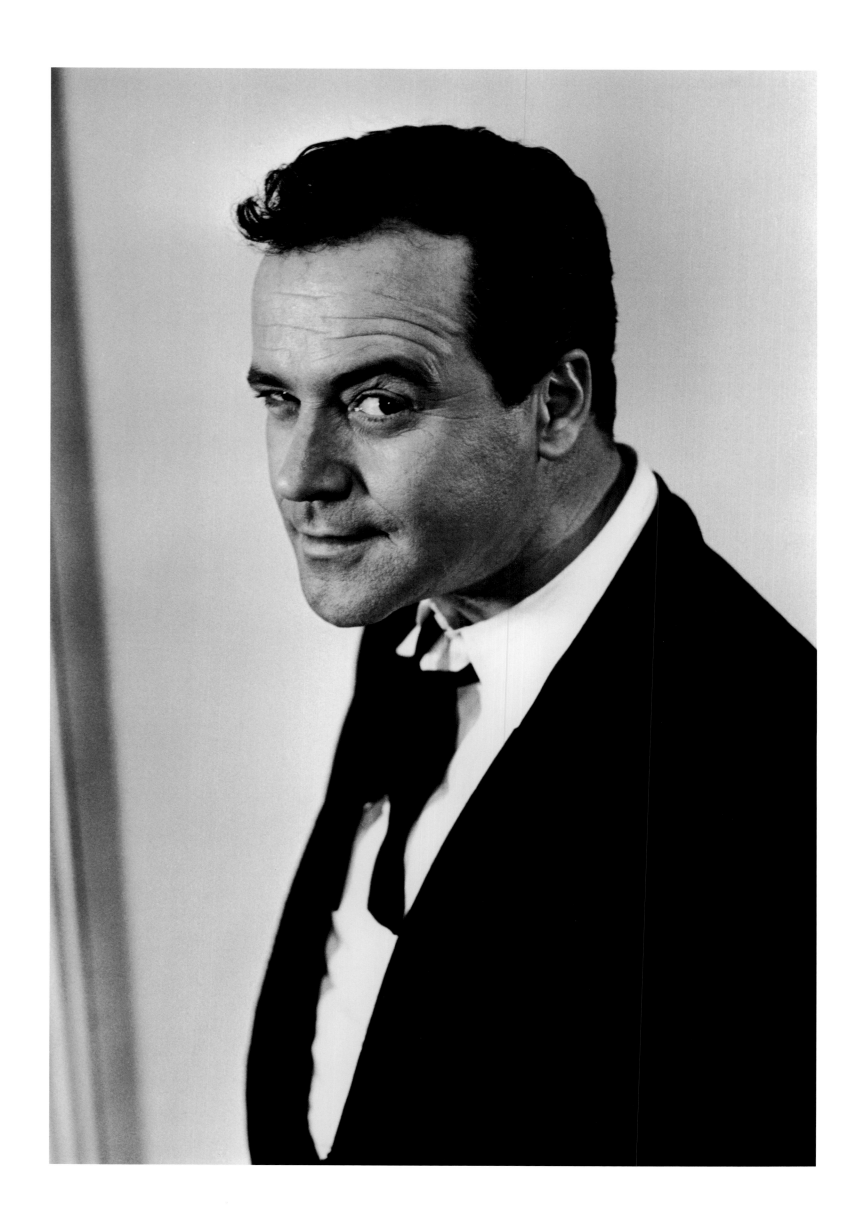

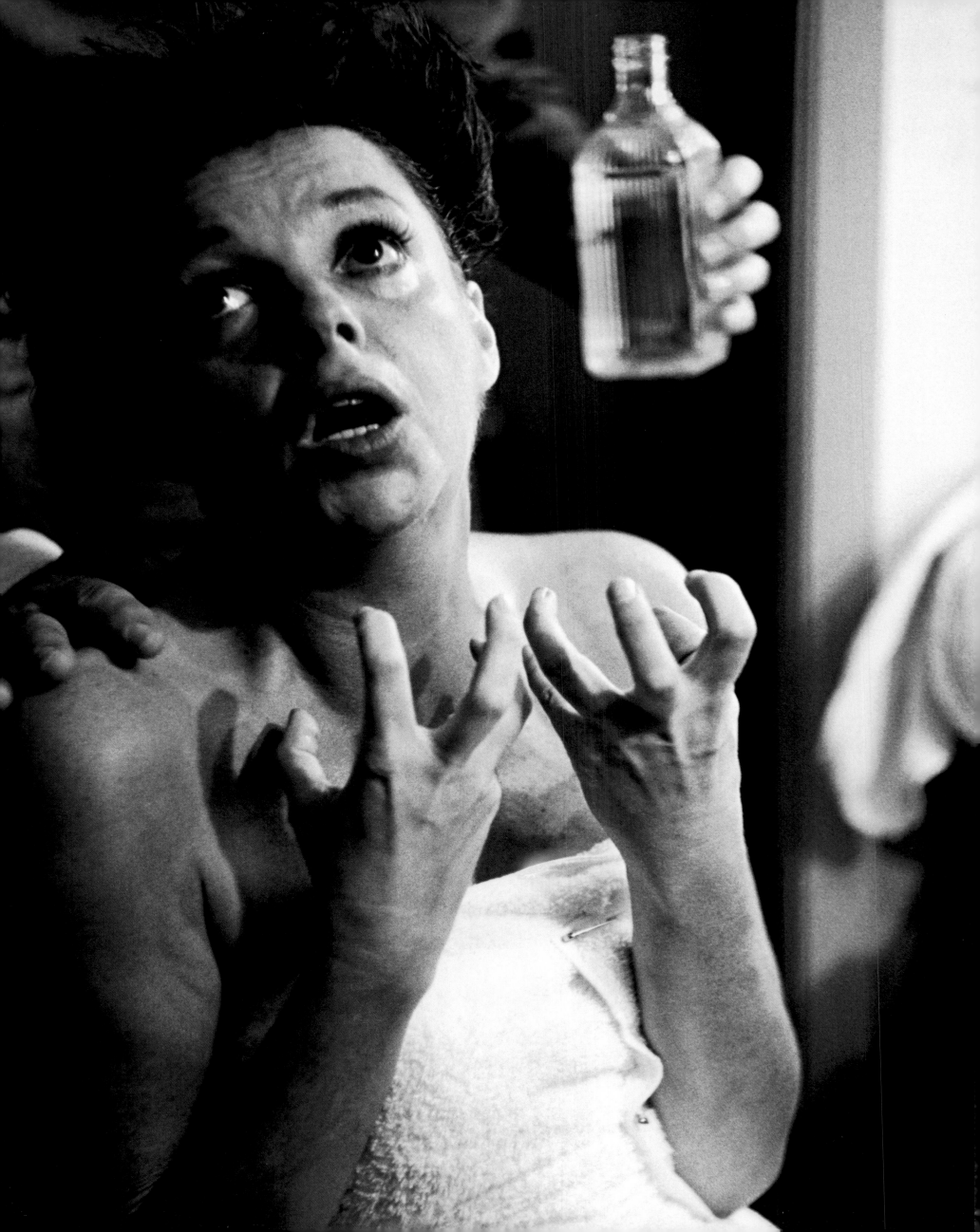

JUDY GARLAND

Las Vegas, 1961. The dressing room was filled with flowers and people—managers, publicists, a secretary, two agents, a hairdresser, a makeup person, and a hotel waiter taking orders for coffee or drinks. In the middle of all this was tiny Judy Garland. She was barefoot and wrapped in a large bath sheet, which covered her tiny figure like an oversized evening gown.

Her hair was wet and straggly. Judy did not look good, even though she knew that I would be taking pictures. I think that she was actually enjoying the commotion and, of course, the attention. The sad part was that she was drinking Liebfraumilch from one of two open bottles that stood on her makeup table along with many prescription drugs. She would drink the wine like it was water, and every now and then she would pop a pill. Her attendants did not seem to react to this behavior, or perhaps they chose not to notice. However, at one point Judy grabbed a bottle of rubbing alcohol and one of those around her quickly took it from her, saying, "No! Judy dear…"

She displayed such angst and fear. I felt for her, but most of the people in the room seemed used to it. I felt she was miserable, but she seemed to be enjoying it to some extent.

After two hours, she was fully made-up and beautifully dressed. She was helped to one of the stage wings by hanging on to the arms of two strong men.

The fanfare played and a big booming voice announced to the audience, "Ladies and gentlemen, Miss Judy Garland!" Judy waited about thirty or forty seconds before she walked out on the stage. The applause, whistling, and shouting were thunderous.

It seemed to me that Judy gave a very professional, yet desperate performance. While she sang and spoke, she seemed to be crying out for help, using her performance brilliantly to express her need and her condition. I wondered how many people in audience felt this too.

I must confess that much of her performance was shtick not unlike Jerry Lewis' "love me, love me" performances, with songs like "Swanee—how I love ya, how I love ya…" But when she sang "Come Rain or Come Shine," I was very much moved, as was the entire audience.

Her show that evening was an enormous success. She left the stage only after several encores. She literally raced to her dressing room. Her face expressed both hysteria and happiness as she reacted to the applause of everyone backstage. She was triumphant and looked ecstatically happy.

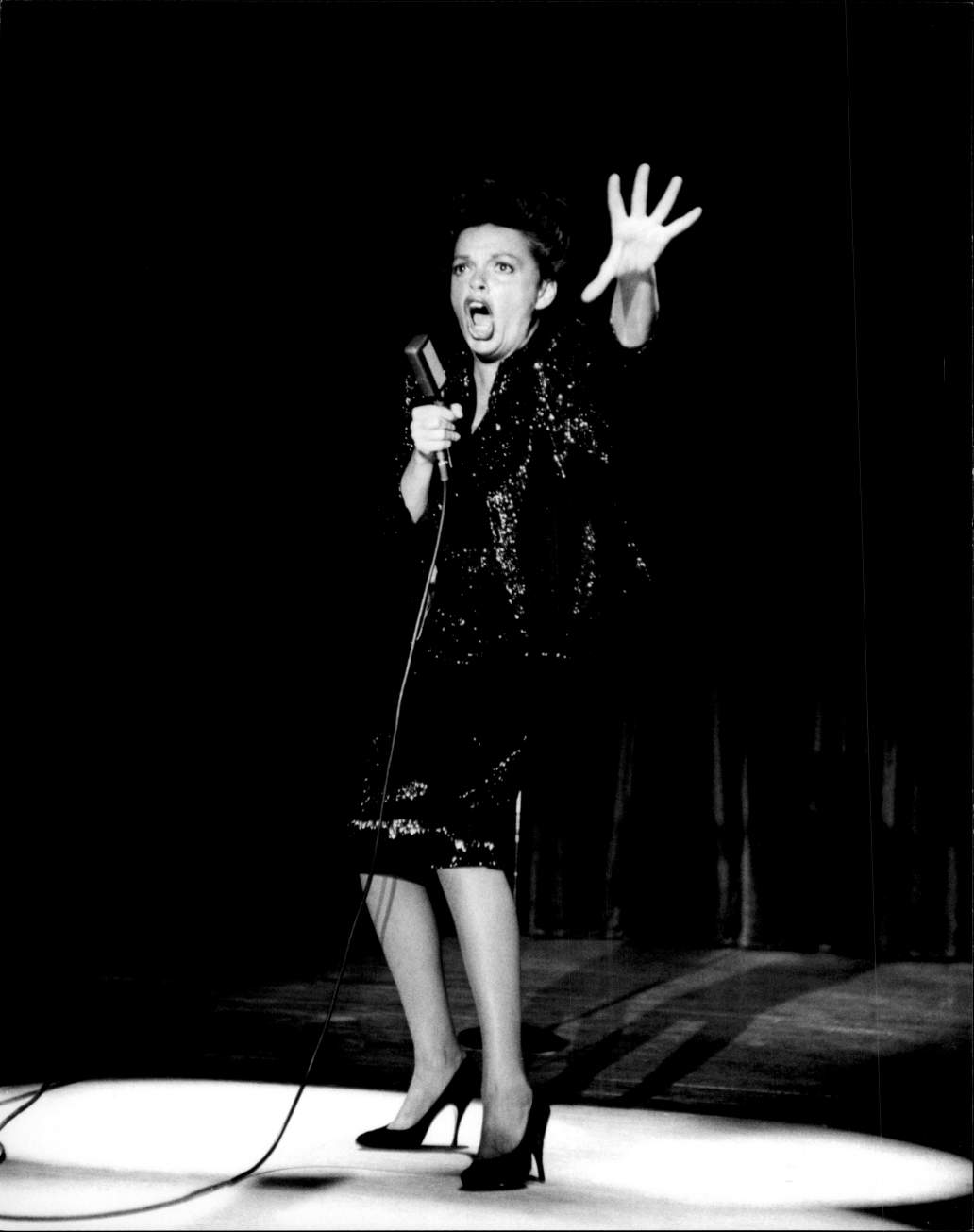

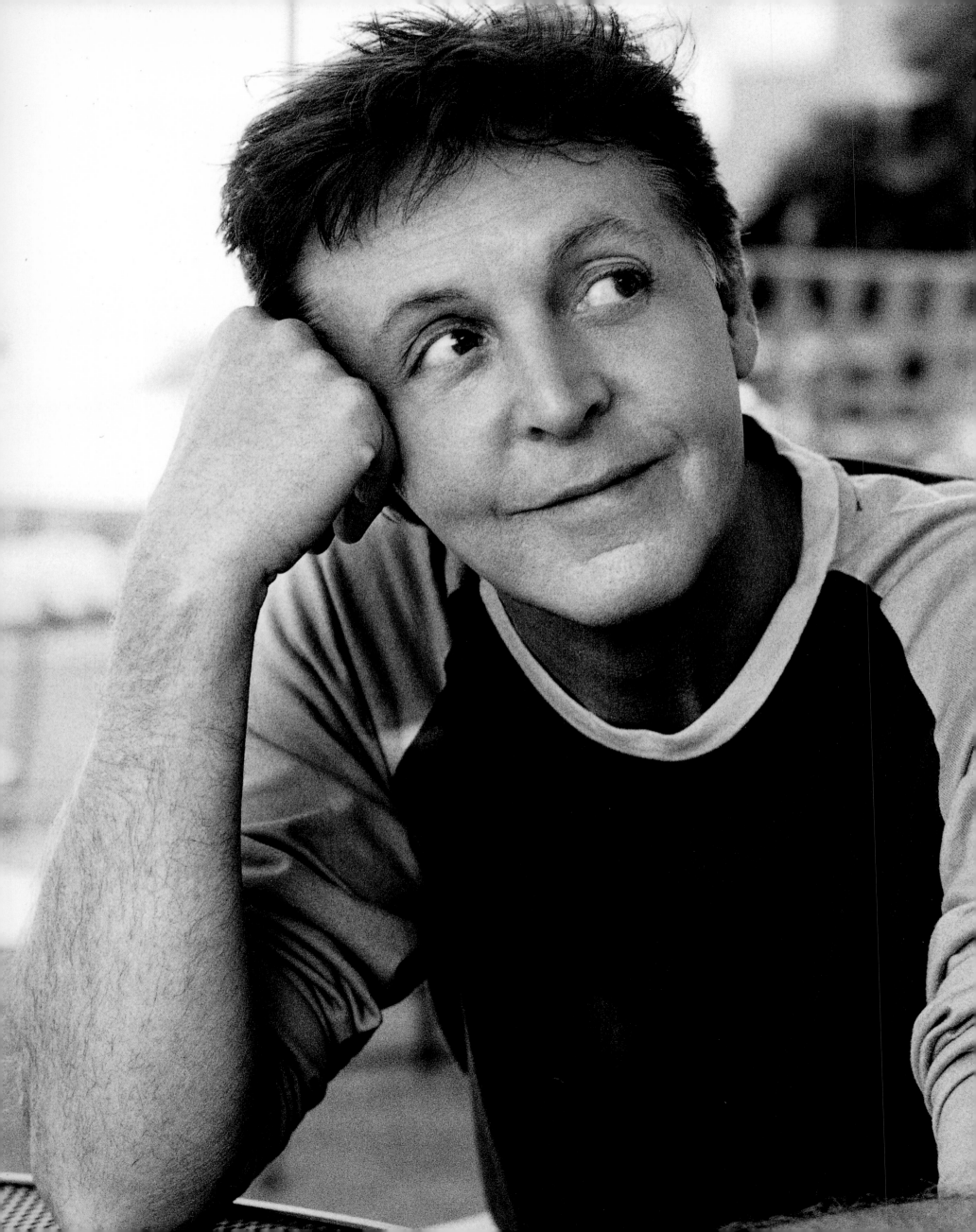

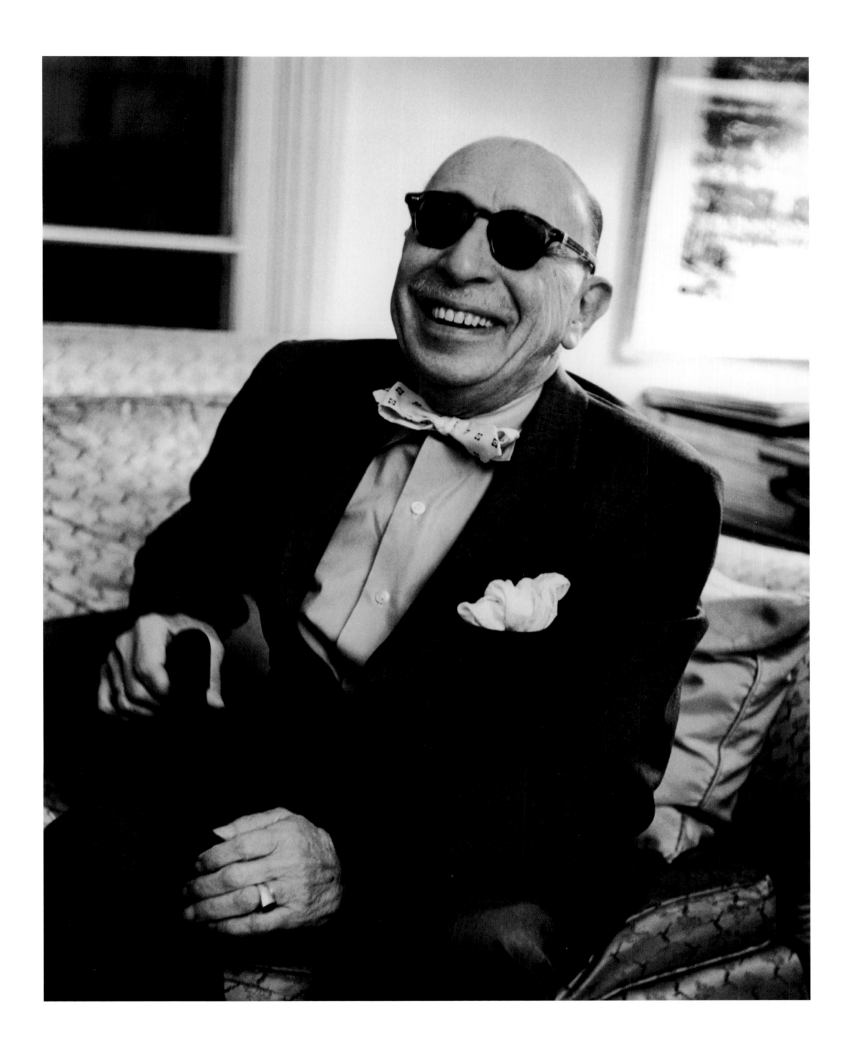

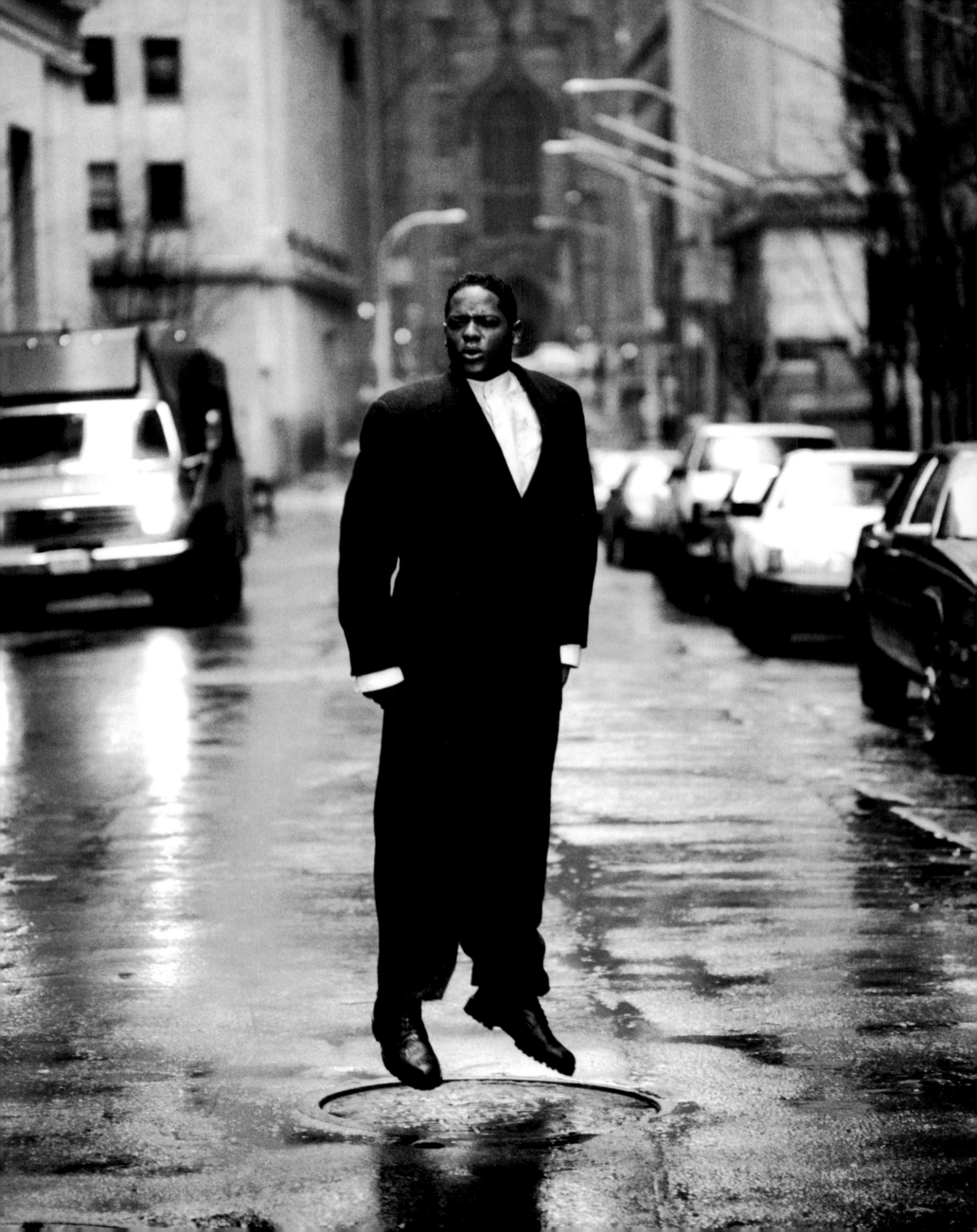

Los Angeles, 1961. It was not long after Rudolf Nureyev's stunning defection from the Soviet Union that he made his first appearance in Los Angeles where Peggy and I were living at the time. Peggy was and is a serious balletomane, and was anxious to see Nureyev perform, especially with Margot Fonteyn. We had seen them in *Le Corsaire*, and he was astonishing. Peggy was very excited, and suggested that I try to photograph Nureyev while he was in Los Angeles. I agreed. I thought it would be great to photograph such a fascinating and audacious artist.

I began by calling the hotel where I knew the Royal Ballet was staying. I spoke with the management, the publicist, and everyone that I could find connected with the company. I left messages for Nureyev at his hotel but to no avail. I got nowhere in my quest.

Finally, Peggy, knowing the ballet world, suggested that I send him flowers. At that time in America, no one would ever send a man flowers, but Peggy pointed out that in the Soviet Union flowers were sent not only to a ballerina, but also to male dancers and even to cosmonauts. So I sent him two dozen roses with a note of thanks for his great artistry, and a request to photograph him, even during a rehearsal.

He responded almost instantly with his heavy Russian accent on the telephone. He invited me to his rehearsal that very evening. Peggy and I met him on the stage of the Shrine Auditorium just minutes before the Los Angeles premiere of *Marguerite and Armand*. He was handsome and hard-working, charming but stern. He was rehearsing the Black Swan pas de deux. None of the pictures were posed; I had to shoot him in action with no interruptions or requests. Of course, I agreed to his rules.

It turned out to be a memorable twenty minutes; he was dancing just for us.

The moral of this story is: If you want to photograph a ballet dancer, send that artist a large bouquet accompanied by a note of sincere praise.

RUDOLF NUREYEV

124

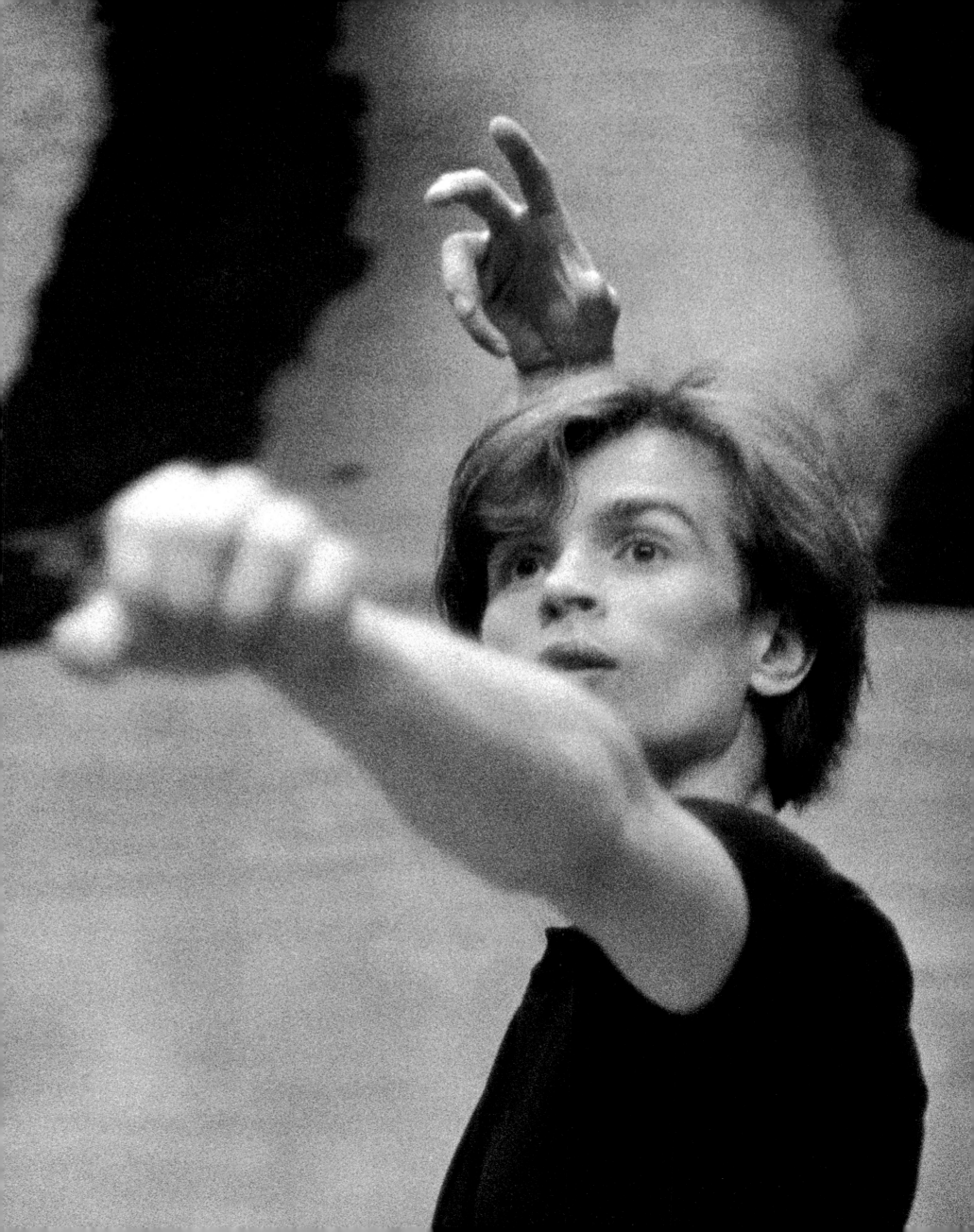

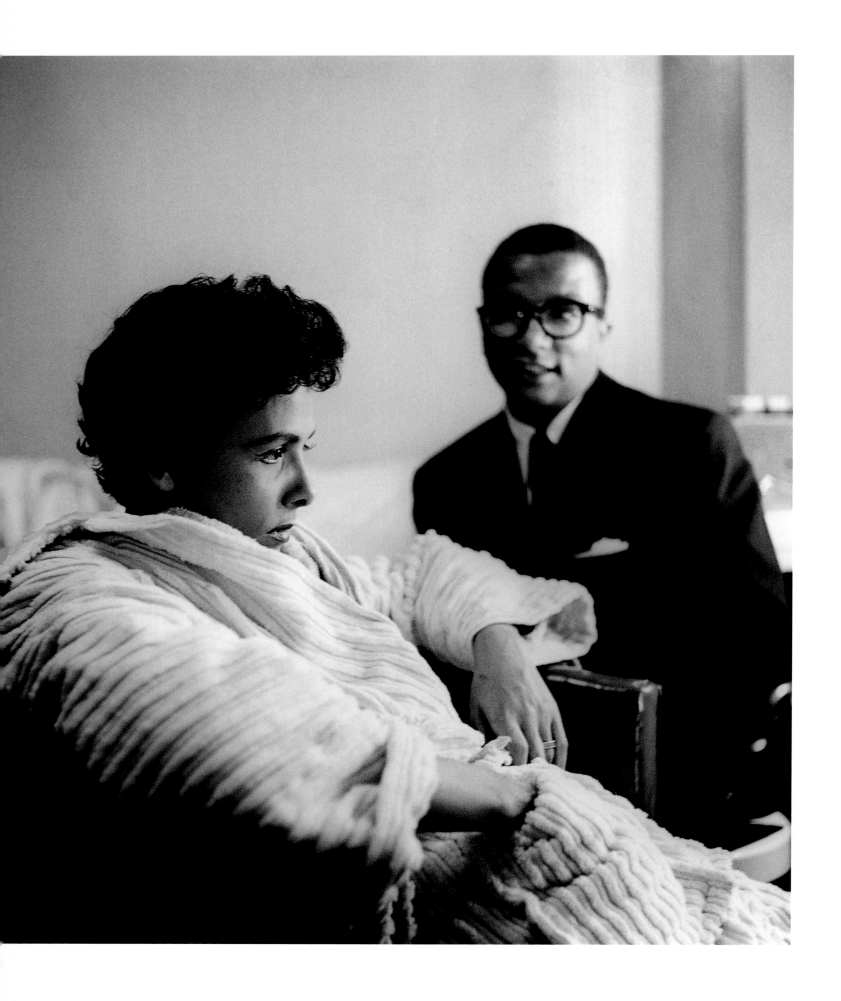

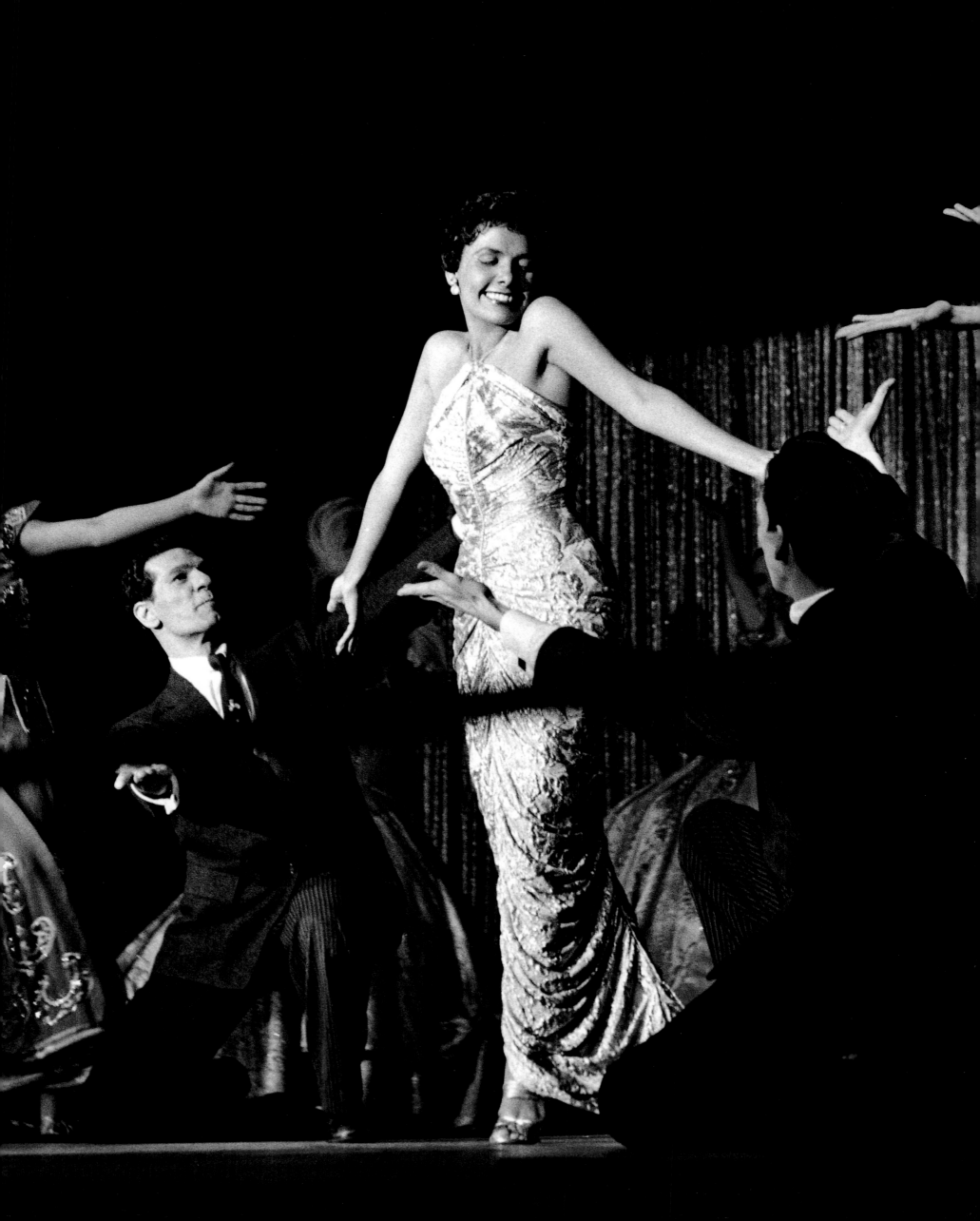

Hollywood, 1966. I was working in New York City in July, 1966 when my friend, writer Terry Southern, called to say that the first thing we must do when we arrive in Los Angeles was see comic Lenny Bruce. He had had a terrible accident. After a performance in San Francisco, Lenny had stepped through a plate glass window and fell to the street from the second floor. He had broken both ankles and his legs were in casts. Terry went on, "I talked to him, and he sounded pretty strung out. Hitting the ol' 'H' again."

When we arrived in Los Angeles, we went directly to Lenny's house in the Hollywood Hills. It was a beautiful California day. As his male nurse let us through the gate, we could see Lenny in his wheelchair sunning himself while studying an enormous law book resting on his lap.

LENNY BRUCE

He greeted us warmly, but there was no small talk. Instead, he immediately started reciting from the law book while putting down his attorneys, the system, the cops, the "monsters" who ran the entertainment industry, and on and on. "Those fuckers have labeled me the 'sick comic,' the 'dirty comic.' It's our *society* that is sick, man!" His ranting and raving went on for the entire visit, sprinkled occasionally with a funny joke—the only time he sounded like the old Lenny.

Lenny was in many ways a victim of his own choosing. His so-called obscenities, his "dirty" talk and jokes were important for the point he was making. Until recently, he had been unable to perform in any major city. However, his use of narcotics didn't help his cause. He spent his last days pouring over legal books and papers, trying to beat the cases against him.

Upon leaving his house Terry remarked, "Lenny is one of the most original voices of the century." The last thing Lenny shouted was, "If you see Sally"—Sally Marr was his mother and a former stripper—"tell her not to bury me as a Jew. I'm not a Jew anymore!"

Lenny died a few days later on August 3, 1966, allegedly from a drug overdose. Contrary to his wishes, he was buried with an orthodox Jewish service.

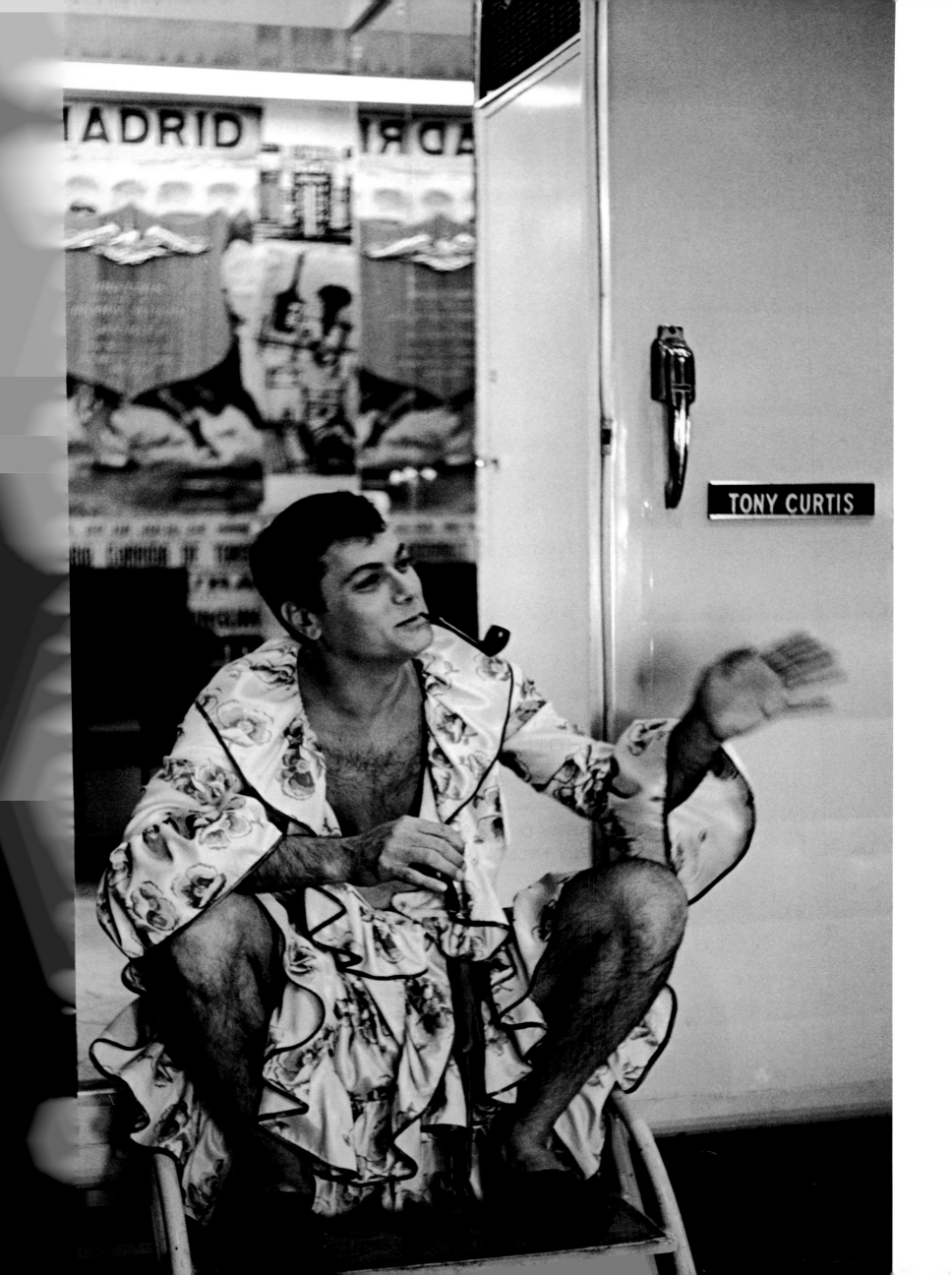

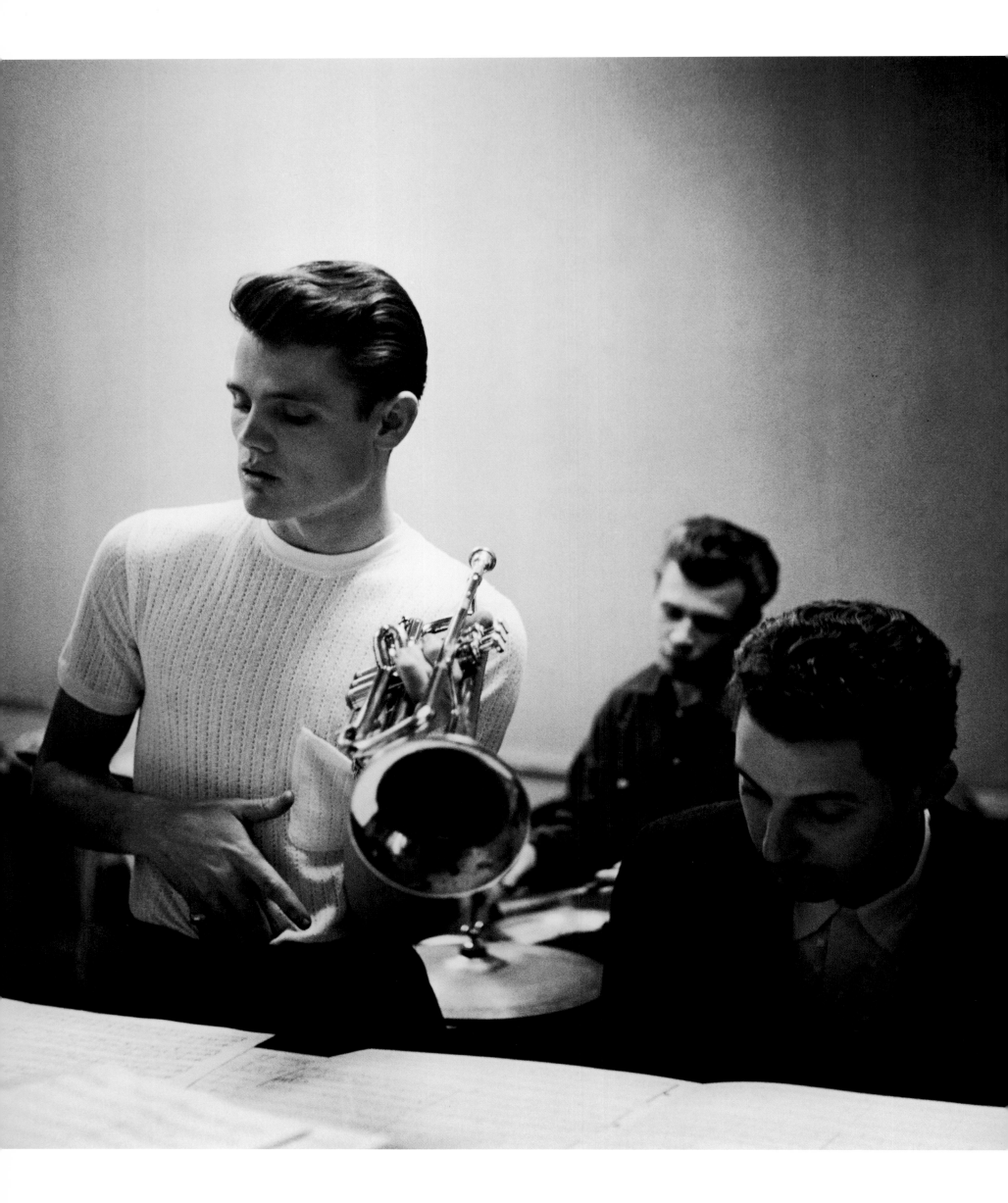

Hollywood, 1954. Jazz trumpeter Chet Baker taught me the true meaning of the term "photogenic." When I first started out, I met many beautiful girls and handsome guys, and photographed them with unsatisfying results. Being pretty seemed to have little to do with it; I learned that attractive people do not necessarily record well on film.

I first met Chet in 1952. He was on a small bandstand at the Tiffany Club in Los Angeles with Charlie Parker and a group of mostly black musicians. Chet was pale white and had an athletic stance. He looked like an angelic boxer, a tough guy with a pretty face topped with a slick '50s pompadour. The truly odd

CHET BAKER

thing about him was a missing front tooth which he tried to conceal. Later, when I got to know him better, he told me he did not want to have the tooth replaced because he was afraid that might change the sound of his trumpet playing.

When I began printing the pictures of these jazzmen in my darkroom, it was Chet's image that came through in the developing tray as a spectacular young face. What a great-looking guy! He's better looking in the photograph than he is in person, I thought. A light bulb turned on above my head: So that's what being "photogenic" means.

During this period, my friend Richard Bock formed Pacific Jazz Records, and Gerry Mulligan and Chet Baker became the label's big stars. Chet then formed his own enormously successful quartet. I was very fortunate to get to know him well (as well as anyone could, as he was enigmatic). I photographed him during his rehearsals, recording sessions, and live performances, and at early morning parties and jam sessions.

After five or six years, Chet and I grew apart, partly because of his increasing use of drugs and frequent incarcerations. He had to spend more and more time in Europe to avoid arrests in this country.

One cold, wintery night in 1970 at the Da Vinci Airport in Rome, I was reading a book while waiting for my delayed flight back to my home in London. Suddenly, I looked up from my book to see a figure coming toward me. In spite of the cold weather, he was dressed in blue jeans, a T-shirt, and sandals. He was carrying a trumpet case. "I don't believe it!" I thought to myself, "It's Chet." He looked dreadful and old beyond his years. As he approached me, he said casually and softly, "Hi, Clax, can you loan me some 'bread' to get back to Amsterdam?" He was quite direct, no small talk, just his request. It was as though we had just seen each other the day before rather than some thirteen-odd years earlier. I tried to talk with him a little, but it was evident that he just wanted the money, not conversation.

I did, of course, give him some money, and since it was cold, I gave him a sweater from my bag, which he accepted courteously. He promptly put the sweater on over his head and pulled it down. The funny thing was that I am very tall, and Chet was not. He looked hilarious in that big sweater hanging on him as he continued down the hall to the ticket counter.

I didn't see Chet again until Bruce Weber brought us together when he was filming *Let's Get Lost*. We both had aged, but Chet looked exceedingly old, with heavy lines on his face, thinned hair, and no teeth. I was shocked.

Just before Bruce's documentary about Chet was released in 1983, Chet died in Amsterdam after a fall from the second-story window of a hotel. The police concluded that it was an accident, but mystery still surrounds the circumstances of his death.

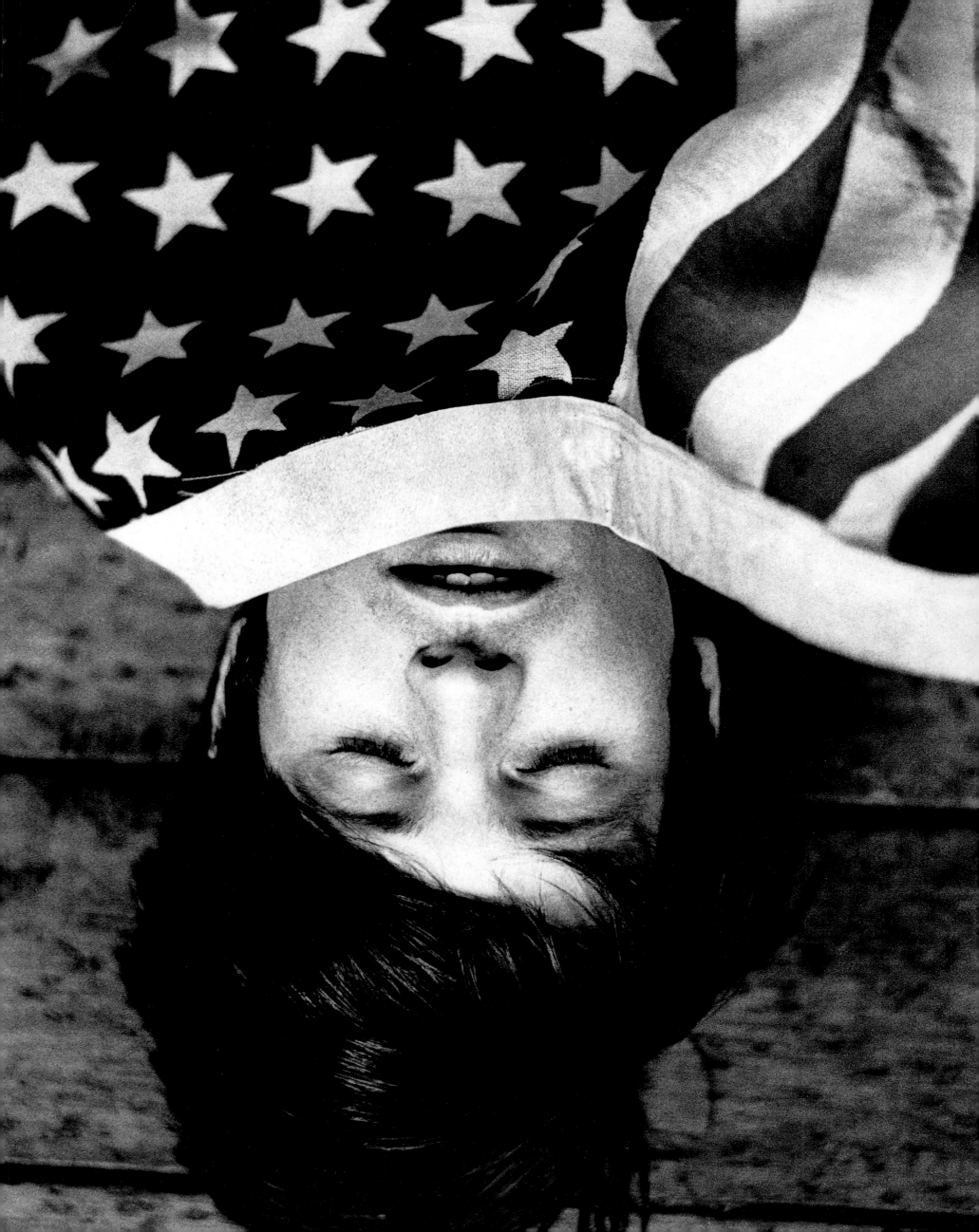

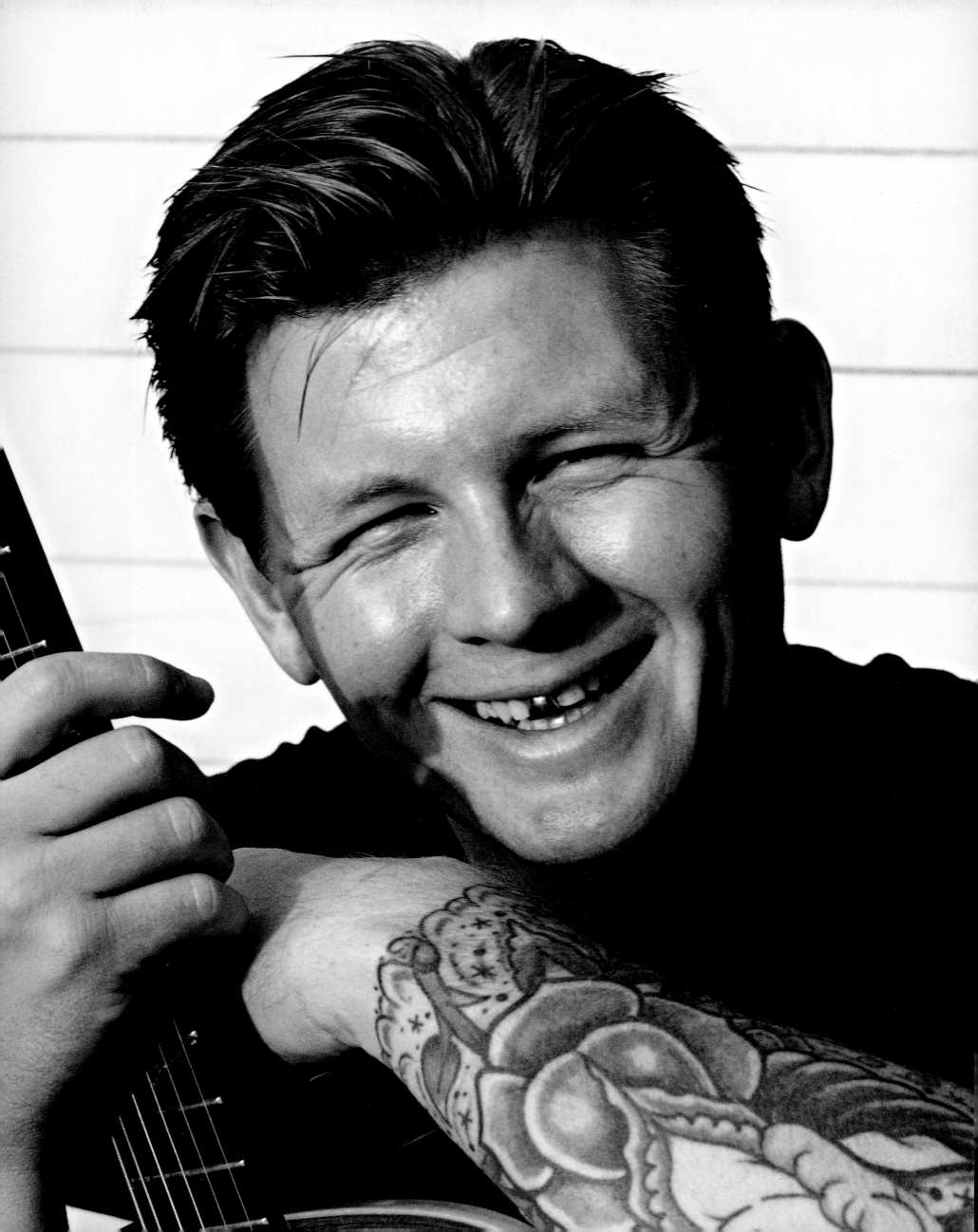

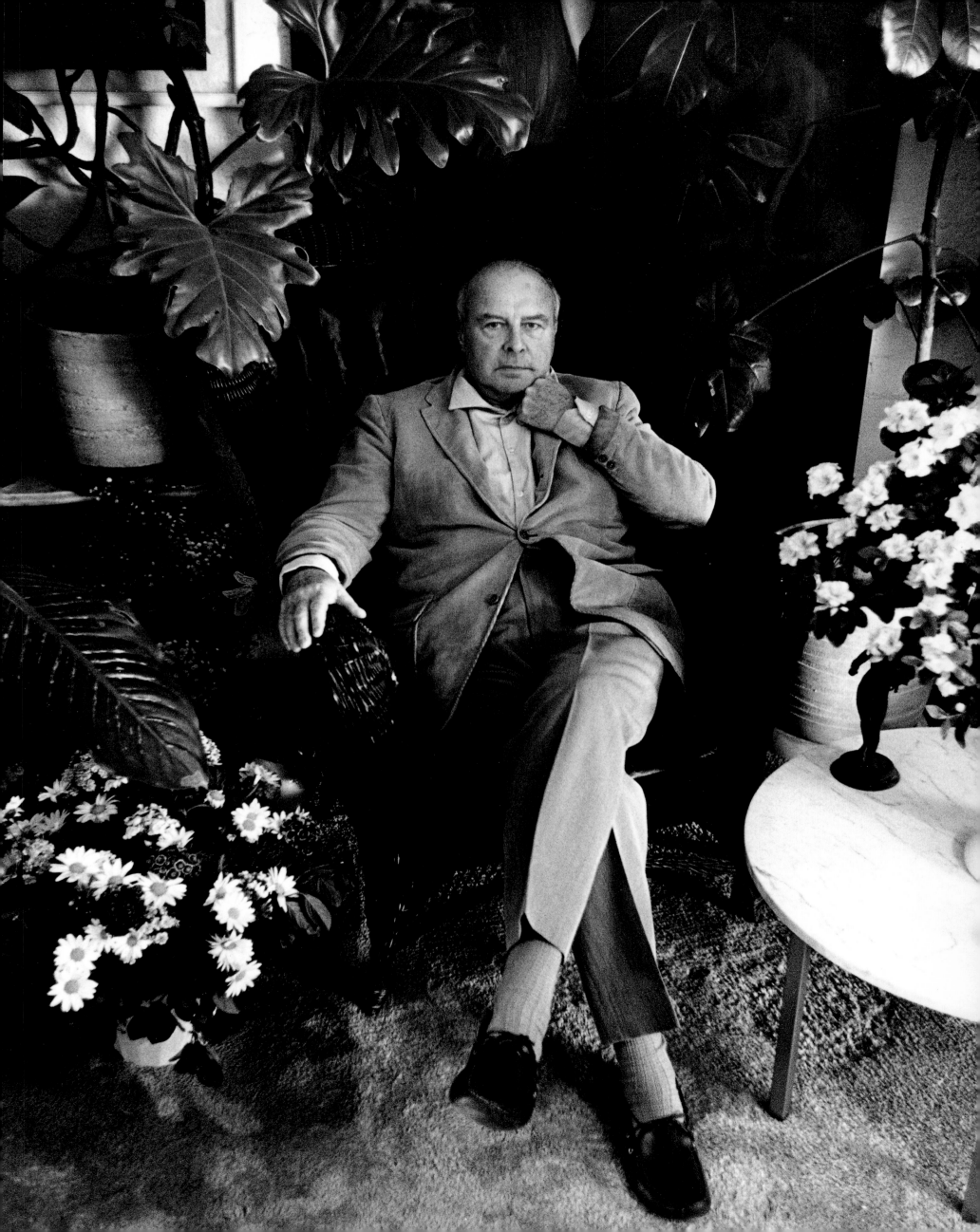

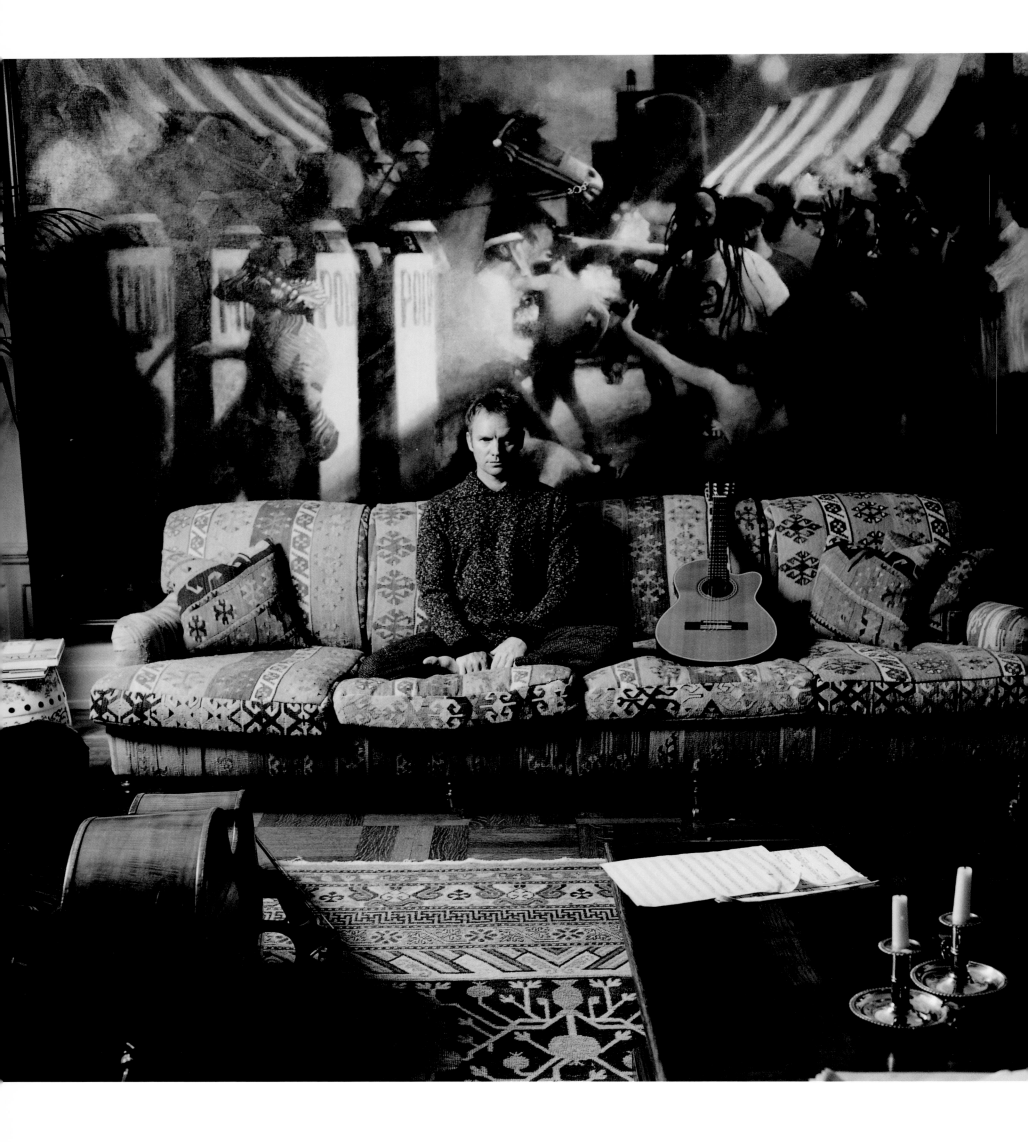

STING

New York City, 1996. On a cool spring day in 1996, I arrived at a very impressive building on Manhattan's Central Park West. The doorman directed me to the third-floor apartment belonging to the former schoolteacher from England who had become the wonderful musician and pop icon, Sting. A friendly houseman led me straight to the kitchen for a cup of coffee, then to a large circular dining table surrounded by a crowd of people, all of whom seemed to belong to Sting: publicists, agents, lawyers, a makeup artist a stylist, a personal hairdresser. Everyone was kind, and very much involved with their business, namely Sting.

I had gone there to photograph Sting for the cover and booklet of his latest CD, *Mercury Falling*. Those assembled wanted to know what I had planned for the shoot. It got to be a bit confusing, with everyone talking at once, so I wandered off to a large, beautiful sitting room to think and enjoy my coffee. Suddenly Sting walked in barefoot, visibly naked under an open silk kimono. He extended his hand and greeted me with a hearty handshake and a very warm welcome. He sat down next to me and finished eating his bowl of fruit, talking the whole time. A short time later, Trudie Styler (Mrs. Sting) entered the room, also barefoot and wearing nothing under her open silk kimono. Making matters even more visually interesting, this very pretty woman was nine months pregnant and looked it. We had a pleasant chat about the imminent photo session, whereupon they excused themselves.

Sting returned dressed impeccably in a trendy wool sweater and black pants. I had my photo equipment ready to go. I asked if the art director or any of the room full of people would be with us while shooting. "Definitely not!" he said. "I'm much too shy to have anyone around while I'm being photographed."

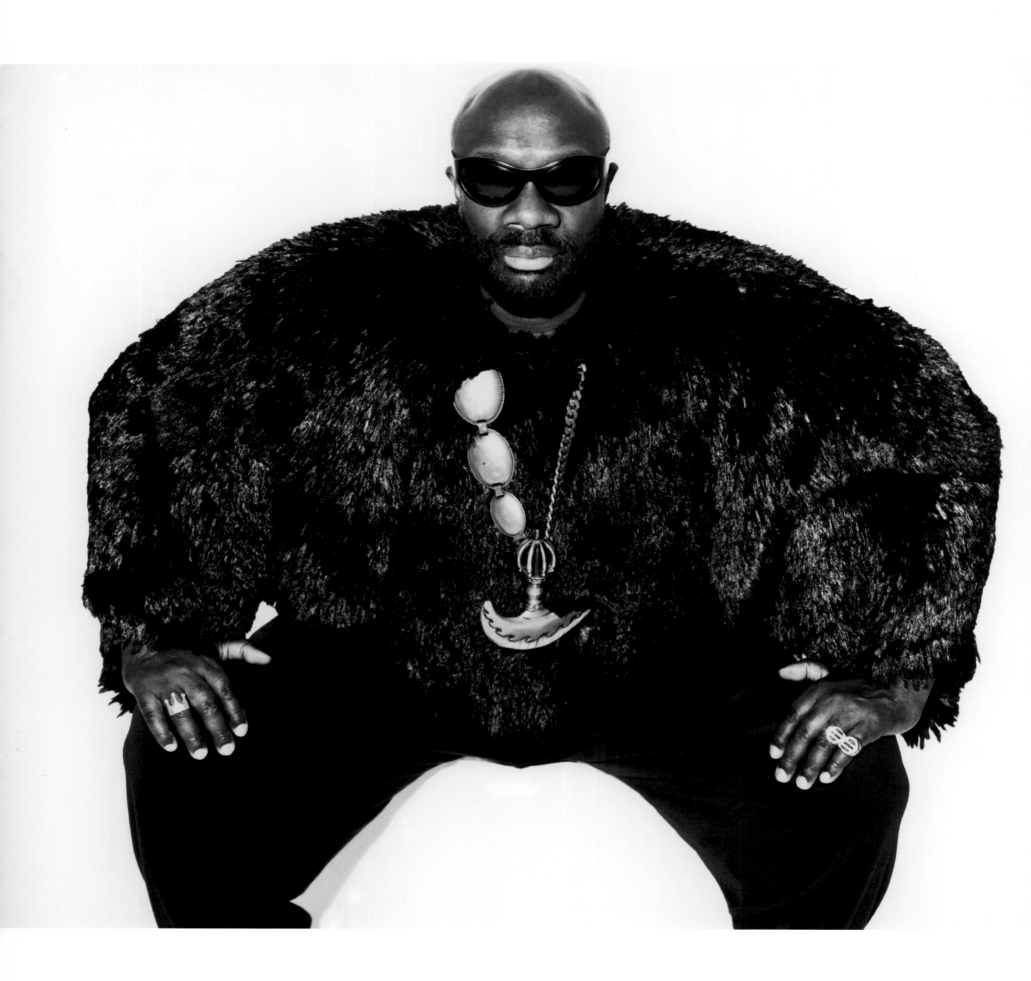

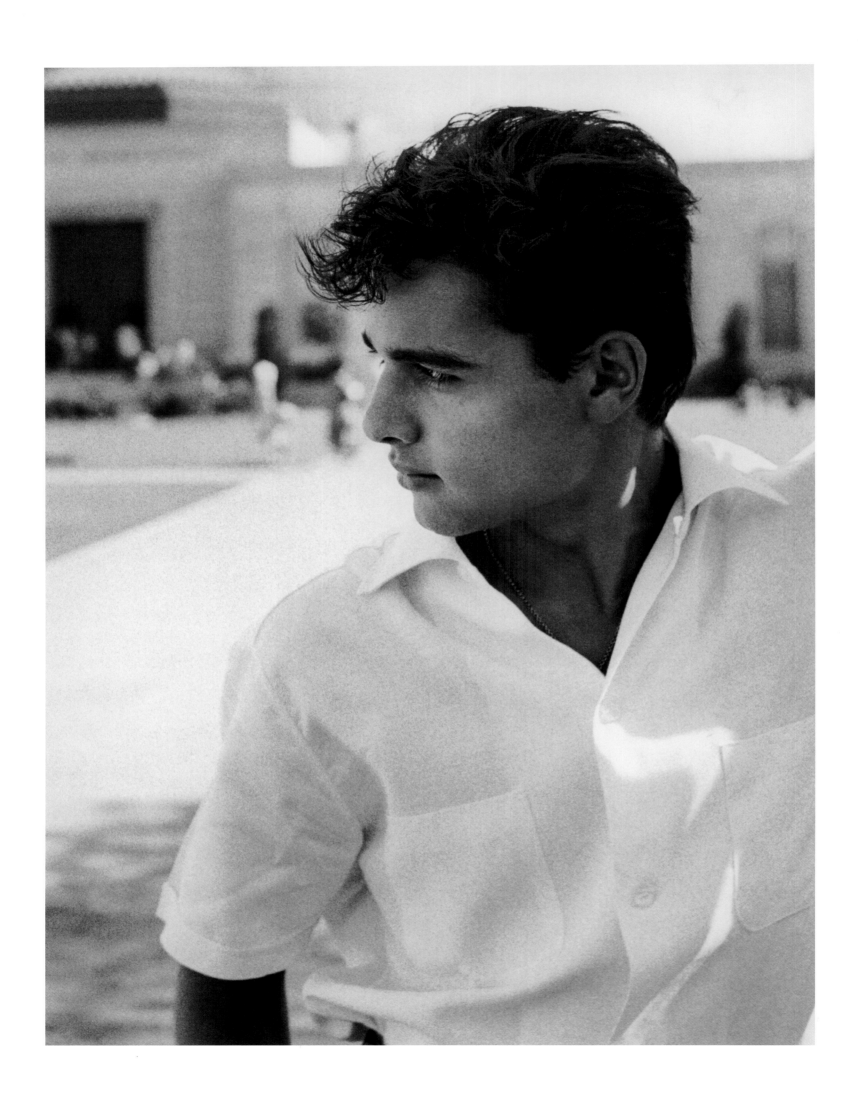

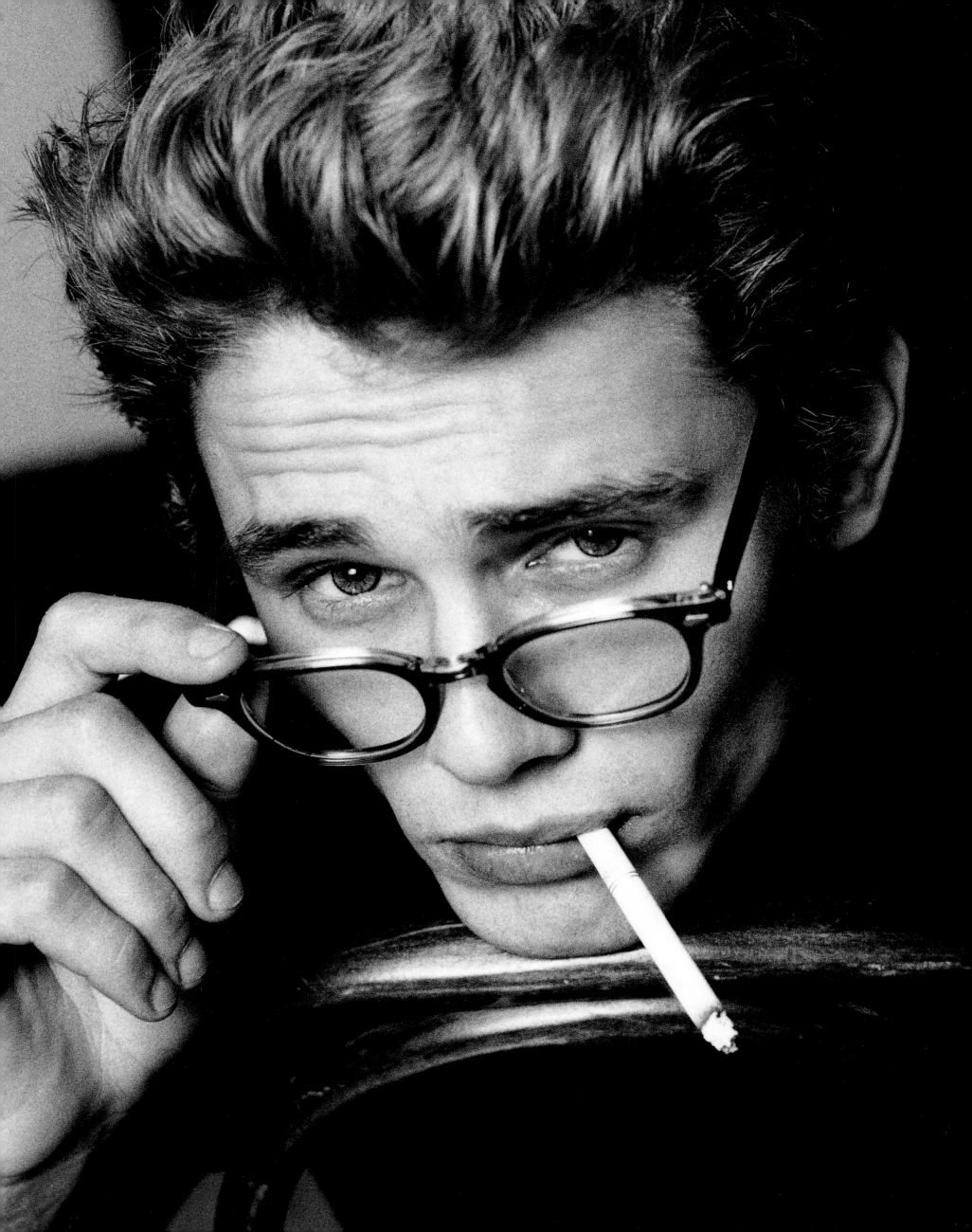

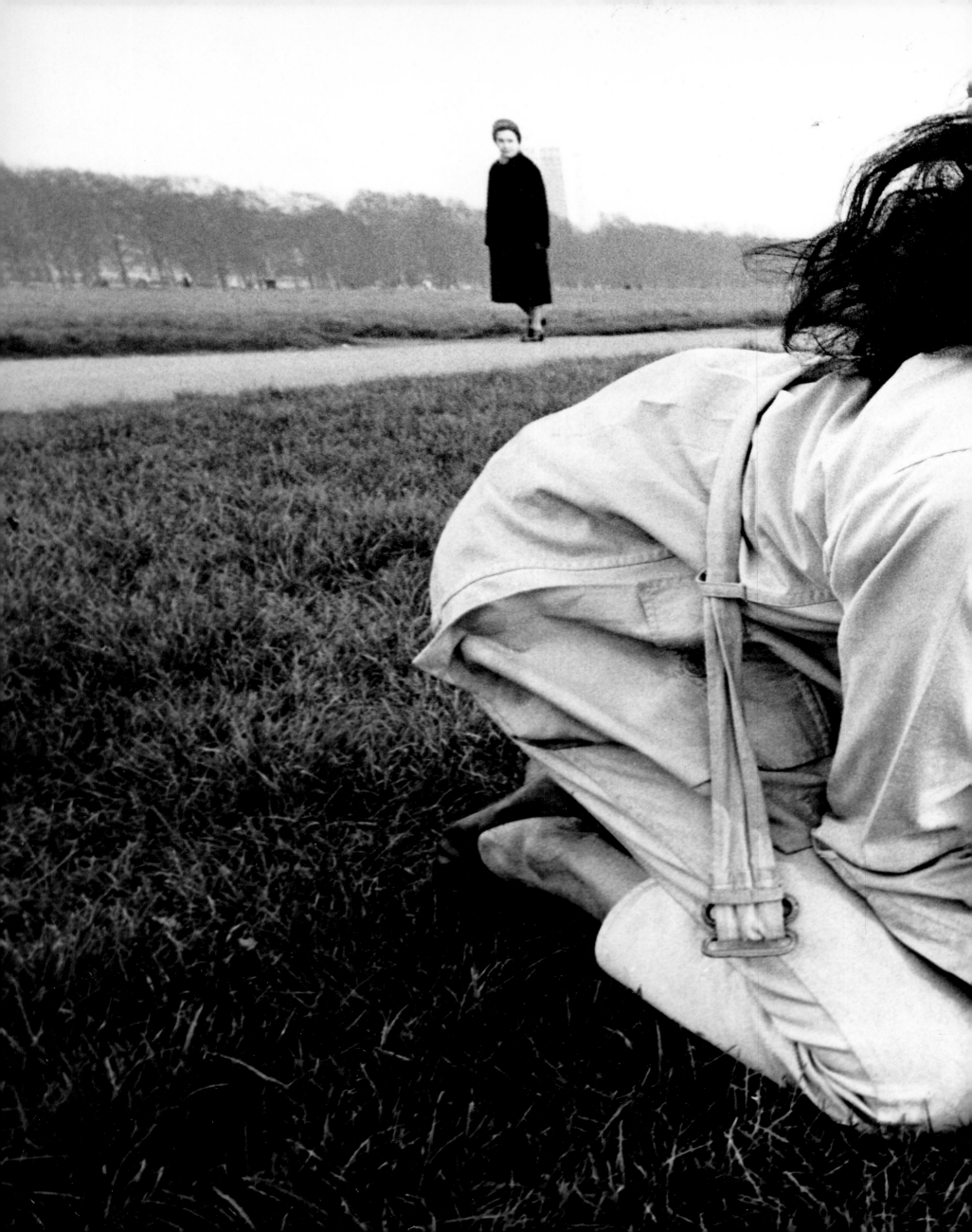

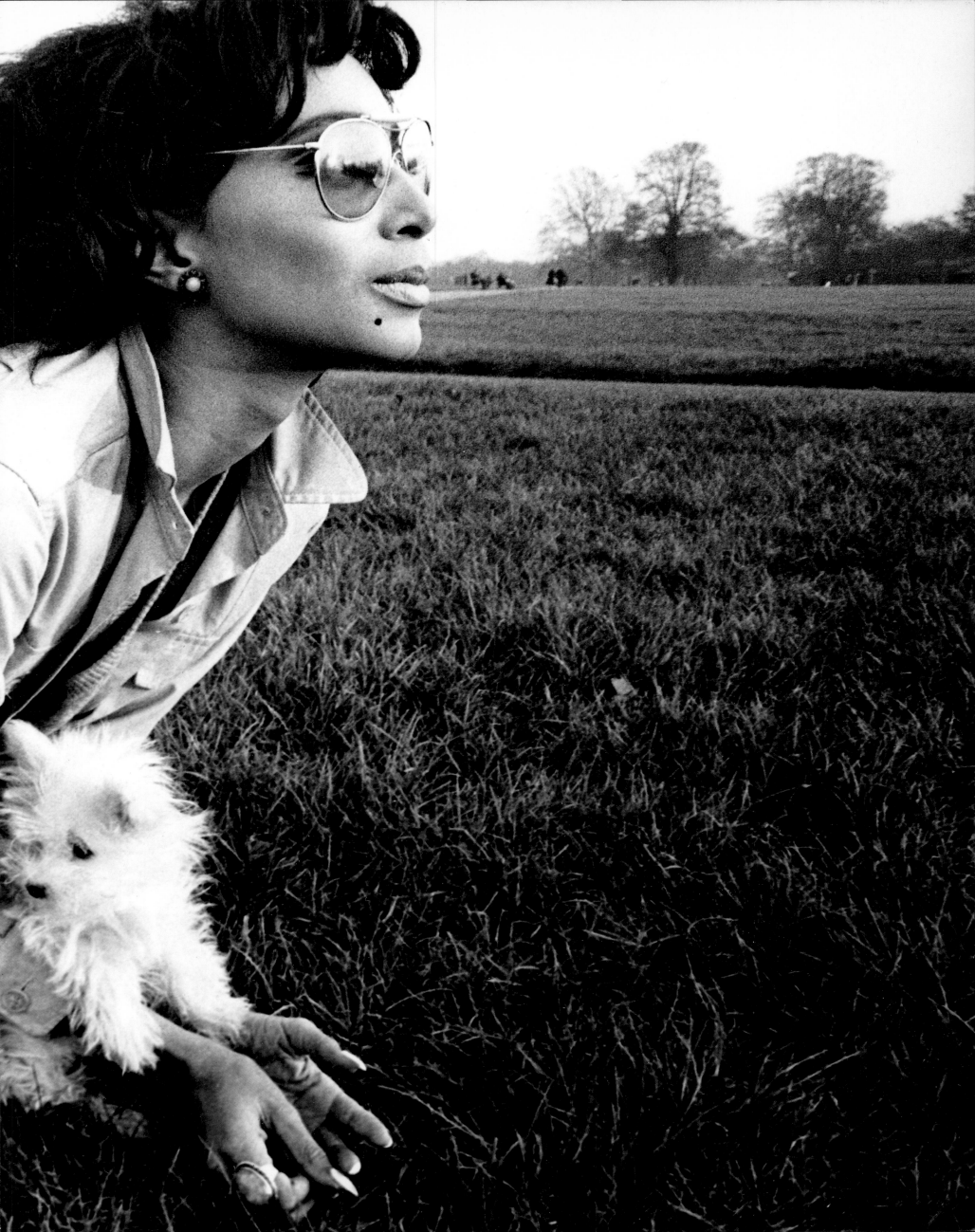

CHRISTOPHER MICHAEL CLAXTON

Beverly Hills, 1981. I consider myself blessed to have photographed so many wonderful, talented, crazy, brilliant, maddening, and amusing people. They were all important to me in some way. They are all a part of my collective photographic memory. But I end with a person very special to me: my son Christopher at age eight. He is now twenty-eight, and not so innocent anymore—nor is our country. For me, in this picture, he is a metaphor for America: its goodness, its strength, and, I hope, its future.

September 11, 2001

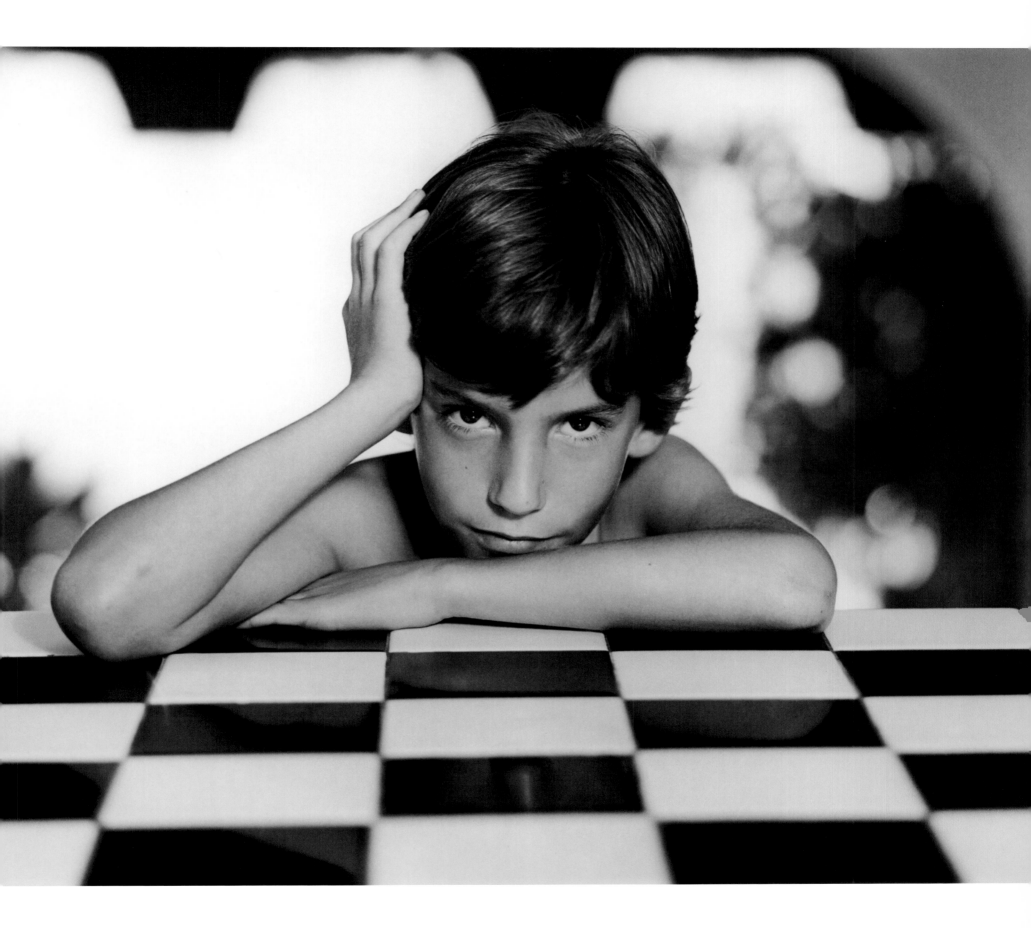

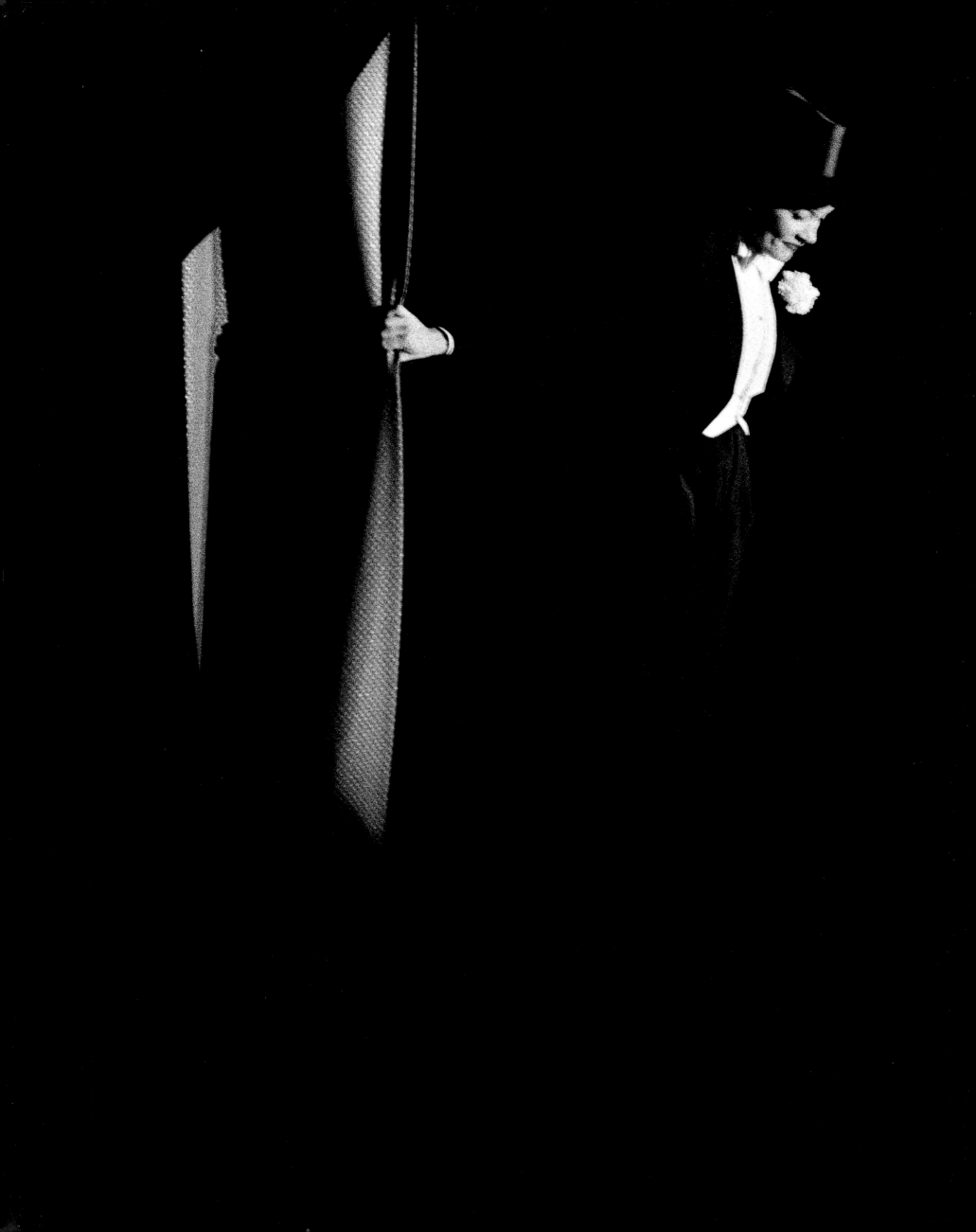

PUBLISHER'S NOTE

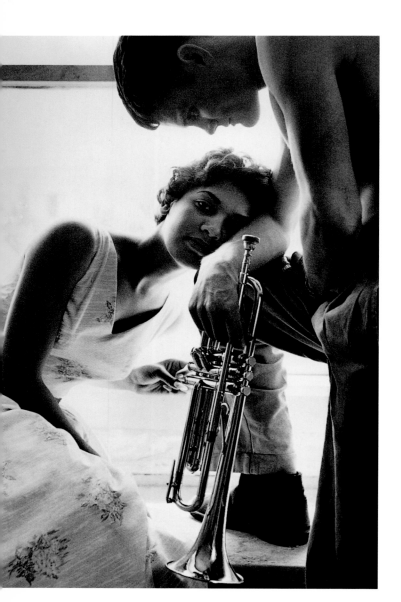

Photography is a form of memory. A century ago, the French novelist Emile Zola wrote, "You cannot claim to have really seen anything until you have photographed it." He might have said you can't claim to have really remembered anything until you've seen a photograph. The photographic image, both a work of art and a record of a moment in time, is the way we remember our world. Memory, of course, is also a work of art. And what we see in a photograph is always a mix of what we bring to it—how we feel about the subject, how we respond to what we see—and what the photographer has created out of light, movement, and place. Something essential about a life can be captured in that art. We know this instinctively, even in the memory of an image, especially of someone we love: a familiar gesture; a certain glance; a well-wrought pose; a moment, gone forever, of expressive will and human emotion.

The life expressed in *Photographic Memory* is also William Claxton's. In the early 1950s, while still in school at UCLA, Claxton began photographing musicians on the flourishing Los Angeles jazz scene. His subsequent history with jazz is well known. While still a student, he founded the record company Pacific Jazz with producer Richard Bock, and went on to shoot (and often design) hundreds of album covers. His quintessential images of jazz musicians have appeared in scores of magazines, and have been shown in galleries and museums around the world. The body of work he created chronicles a whole trajectory of postwar American jazz, from its early years to bebop, West Coast cool, and the flowering of free-form improvisation. When shooting in Los Angeles and San Francisco, Claxton often photographed his subjects outside, bringing an intimacy to his images that said as much about his friendships with these artists as it did about the California light. He did this intentionally, almost as a counterpoint to the stereotypical image of sweaty jazz musicians in dark, smoke-filled clubs. He brought this same fresh approach to his images of musicians in New York, Chicago, New Orleans, and other cities around the country.

Less well known is the fact that, throughout his career, Claxton just as diligently photographed people from all walks of life, both the famous—writers, actors, directors, composers, artists, and fashion designers—and the family and friends to whom he has been closest. A Pasadena kid who went to high school in Glendale, Claxton has been an insider in the world of L.A. art and entertainment for most of his adult life. He has always moved easily between jazz clubs, recording studios, the art scene, film sets, and the homes of the artists who became his friends. Above all, this book is about those friendships.

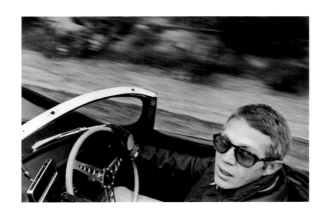

As a young man Claxton gravitated toward jazz musicians because of his love of jazz. That passion was enough to earn him lifelong friendships with many of those he photographed. (While still living with his parents, he brought Charlie Parker home after a gig on Central Avenue for an early-morning breakfast—as good an example as any of the reconciliation of life and art.) Claxton continued to be drawn to jazz musicians because, as he sees it, they possess a rare a combination of ingenuousness and discipline, which makes for interesting personalities. Whether they've made it or not, they tend to develop a style all their own as individuals. And if this book is first about friendship, it is next about style. Although genuinely too modest to admit it, Claxton is universally considered as gracious, funny, elegant, and stylish a man as you are likely to meet, and with enough charm and wit to have been at home in any Noel Coward play. He has always admired these qualities in others, especially in those who seem to have them effortlessly and in abundance, and it shows in the photographs—in the beauty of Gloria Swanson shopping with Claxton in an antique store, speeding in a race car with the *über* hip Steve McQueen, or in the image of a learned, elegant Vincent Price at home with his renowned collection of art.

A keynote in the life in these pages is Peggy Moffitt, Claxton's wife of more than forty years, who has been a pivotal influence in his life and art. Their work together began with photo sessions for album covers, and continued with the fashion designer Rudi Gernreich—Claxton as photographer, Moffitt as model and muse. Her reputation as a groundbreaking model who contributed to the crafting of the images in which she appeared does only partial justice to the depth of the lifelong collaboration between the two. Their bond and collaborative spirit is evident here in abundance, and the memories offered in these informal portraits are shared between them. More often than not, they are our memories too.

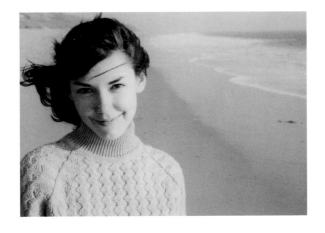

Although he is best known for his jazz photographs, *Photographic Memory* reveals Claxton as a versatile artist whose subject is the human face, the human psyche, and the human form. "The international languages of jazz and photography need no special education or sophistication to be enjoyed," he has said. "All I ask is that you listen with your eyes." It's a request that can be applied to all of his work. And if we listen with our eyes—aware of the parallel between a photographer with his camera and a musician with his "ax"—what we see in *Photographic Memory* is the pattern of a life expressed, like that of any great musician, in pursuit of the truest notes.

—The Editors
New York City
June 2002

153

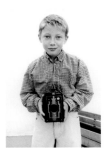 **3** Simon LeComte
Sherman Oaks, California, 2000

No, it's not William Claxton as a child. I photographed Simon holding a Box Brownie similar to my first camera. The picture appears in a film documentary about me and my work.

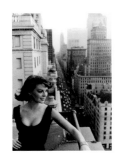 **7** Natalie Wood
New York City, 1961

We shot this high above Fifth Avenue on the balcony at the Sherry Netherlands Hotel. She had a day off from filming *Love with the Proper Stranger* with Steve McQueen.

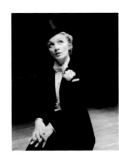 **11** Marlene Dietrich
Las Vegas, 1955

During a dress rehearsal, the legendary master of finding one's "key light" demonstrates that talent here.

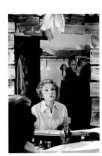 **13** Marlene Dietrich
Las Vegas, 1955

In the star's dressing room at the Sands Hotel; I could not help myself from shooting a double portrait.

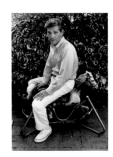 **14** George Segal
London, 1966

This was shot just before our departure for East Berlin to start filming *The Quiller Memorandum*, with Alec Guinness.

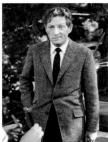 **15** Danny Kaye
MGM Studios, 1957

Danny was mugging for me during the filming of Michael Kidd's *Merry Andrew*.

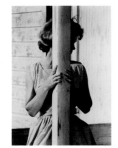 **16** Lee Remick
Wharton, Texas, 1963

This candid portrait was taken while Lee worked on the film *Baby, the Rain Must Fall* with Steve McQueen.

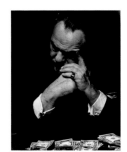 **17** Edward G. Robinson
Beverly Hills, 1964

I don't know which he revered more—his fine collection of Impressionist paintings or his Friday night poker games.

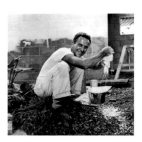 **18** Richard Lang
La Crescenta, California, 1952

Pals since we were teenagers, Rich taught me the basics of photography.

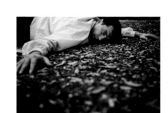 **20** John Cassavetes
Burbank, 1962

On the front lawn of Warner Bros. Studios during the filming of *A Child Is Waiting*, in which John directed Judy Garland and Burt Lancaster.

 22 Ali MacGraw
Beverly Hills, 1971

We took pictures on the patio after lunch when Ali was Mrs. Robert Evans.

 23 Robert Redford
Hollywood, 1960

After several Broadway and television shows, Redford was working in his first feature film, *War Hunt*, for producers Denis and Terry Sanders when I met and photographed him.

 25 Lelia Goldoni
Laguna Beach, 1956

We were running around the beach just having fun. Lelia had a talent for changing her looks in a flash.

 26 Don Bachardy
Hollywood, 1962

California artist and companion to writer Christopher Isherwood. Don sketched Isherwood during his life, and as he was dying.

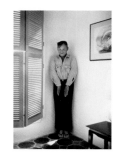 **27** Christopher Isherwood
Santa Monica, 1961

Christopher at his home in Santa Monica Canyon. I am his camera.

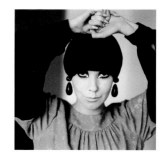 **29** Peggy Moffitt
New York City, 1969

Peggy needed a "head shot" for her modeling agency. We shot this one in the living room of our apartment.

 30 Tom Pittman
Hollywood, 1957

The young actor with his specially-built Porsche, which carried him to his death.

 31 Tom Pittman
Hollywood, 1957

Up to his untimely death, Tom had all the makings of a brilliant career and large following.

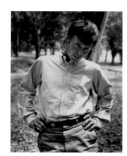 **32** George Hamilton
MGM Studios, 1961

George discovered Gene Kelly's polo coat from *Singing in the Rain* in the wardrobe department. When told that he now looked like a real actor, George replied, "I don't want to be an actor, I want to be a movie star."

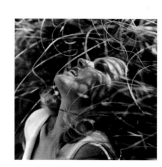 **33** Ursula Andress
Sherman Oaks, California, 1962

The ravishing beauty was married to John Derek at the time. We were just taking pictures for our own amusement.

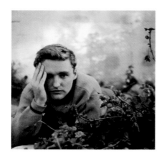

34 Dennis Hopper
Hollywood, 1955

The first of many shots that I was to take of Dennis through the years.

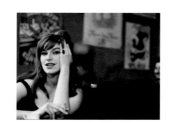

36 Maggie Ryan
San Francisco, 1954

At the height of the Beat scene, in one of the many coffee houses near Lawrence Ferlinghetti's City Lights bookshop in North Beach.

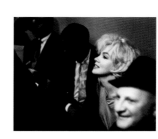

37 Billy Kidd
Venice Beach, 1961

A colorful young artist who was painting pictures of vintage cars when we met.

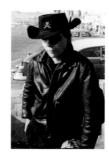

39 Ray Charles, Marilyn Monroe
Hollywood, 1961

Taken at a Frank Sinatra recording session; Ray is seated to Marilyn's right.

40 Geraldine Page
Hollywood, 1962

On the set of the film version of Lillian Hellman's play *Toys in the Attic*, Miss Page would sit alone and suck on a lollipop while preparing for her next scene.

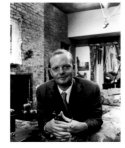

41 Truman Capote
Burbank, 1957

Photographed here on an abandoned set for a television show, Capote was both sober and fascinating.

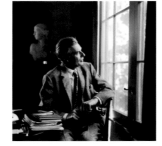

43 Aldous Huxley
West Hollywood, 1955

I caught Huxley in a moment of contemplation—perhaps through his "windows of perception"—in the library of his home on Kings Road.

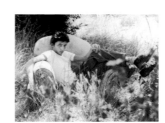

44 Richard Evans
Los Angeles, 1958

I photographed the young actor in a vacant lot near his home.

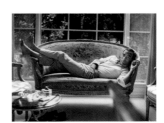

45 Peter Howard
Bel Air, 1961

His mother was a Vanderbilt, his father was actor John Howard. Peter died young of alcoholism after pursuing a brief career as an actor.

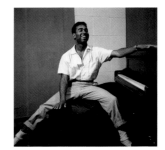

46 Bobby Short
Hollywood, 1955

I became a fan when I was barely out of high school. Our friendship has lasted many years. In fact, he played and sang at my wedding.

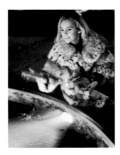

47 Tuesday Weld
New Orleans, 1964

While on location on the film *The Cincinnati Kid*, Tuesday discovered a wishing well. The glow from the fountain created perfect fill light for this picture.

49 Vincent Price
West Los Angeles, 1962

You can tell a lot about a man by what he rescues from a fire. Evacuating his art-filled mansion in the fire of '62, Vincent took only a small Rembrandt and two tins of caviar.

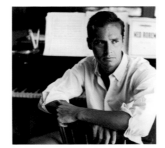

50 Ned Rorem
Brentwood, California, 1961

The young composer was on a fellowship at the Huntington Hartford Retreat.

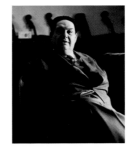

51 Darius Milhaud
Berkeley, 1956

Dave Brubeck introduced me to this composer who was his mentor.

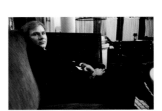

52 Andy Warhol
New York City, 1962

Photographed in Johnny Nicholson's café on East 58th Street, Warhol had just finished sketching Peggy's bare feet and mine before heading out to dinner.

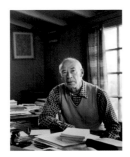

55 Henry Miller
Big Sur, California, 1955

His huge oak table served as a dining table, work desk, and stage for his intriguing conversations.

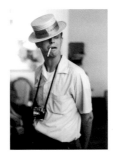

56 Lee Friedlander
Hollywood, 1960

Photographer Lee Friedlander was best man at my wedding. Here he is partying at our studio apartment.

57 Joan Baez
Carmel, California, 1962

After shooting pictures for two of her album covers, she drove me around the beautiful area in her new Jaguar.

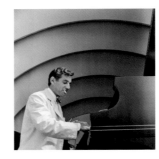

58 Leonard Bernstein
Hollywood, 1956

He confessed to me that he loved being photographed; here he is at a rehearsal at the Hollywood Bowl.

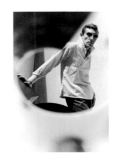

59 John Weitz
London, 1966

We were to shoot a fashion layout of Weitz's menswear for the glossy *Town* magazine, but the male model who was booked didn't show up, so John modeled his own designs brilliantly.

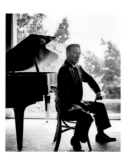

60 Hoagy Carmichael
Hollywood, 1956

Hoagy was gracious enough to give me private performances over a couple of drinks rather often. Here we were shooting the cover of his LP *Hoagy Sings Carmichael.*

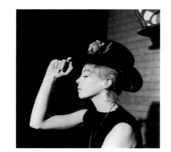

61 Leslie Caron
MGM Studios, 1960

This portrait was taken during a break in the filming of *The Subterraneans*, based on Jack Kerouac's novel.

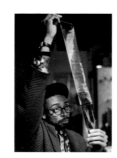

62 Spike Lee
New York City, 1989

Spike is scrutinizing my color shots of Denzel Washington, which would be used as the advertising art for his film *Mo' Better Blues.*

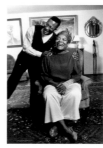

63 John Singleton, Maya Angelou
Winston-Salem, 1993

This was shot during a photo session for *Harper's Bazaar.* I first knew Dr. Angelou when she was a sexy exotic dancer in North Beach in the early 1950s.

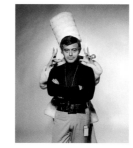

64 Rudi Gernreich
New York City, 1968

We set up a temporary photo studio in Rudi's New York showroom every season to photograph his lines. Here Peggy stands behind him.

66 George Balanchine
Los Angeles, 1961

The famous choreographer is demonstrating a step for dancers Patricia Wilde and Jonathan Watts during a rehearsal at the Greek Theatre.

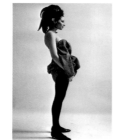

69 Barbra Streisand
New York City, 1964

In between fashion poses, I shot this funny picture of Barbra showing us how the rest of her looked while modeling a Rudi Gernreich hat.

70 Alan Bates
London, 1966

Playboy had me photograph him for a special feature on the "new and important people" in British theater.

71 Peggy Moffitt
Paris, 1966

When my bride and I first lived in Paris, we could only afford a small, cheap but amusing hotel just off the rue de Rivoli.

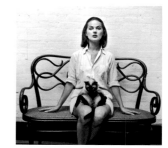

73 Carol McCallson
New York City, 1955

By this time Carol was a famous fashion model and divorced from Scavullo. This picture was shot while having drinks with artist Joe Eula one hot afternoon in the city.

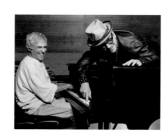

74 Burt Bacharach, Elvis Costello
Hollywood, 1998

During the recording session for their collaborative CD *Painted From Memory*, we were under pressure to shoot two magazine layouts and the cover for the disc in 45 minutes.

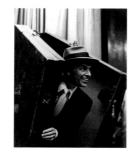

75 Frank Sinatra
Hollywood, 1954

Sinatra clowning as he springs from a harp case during the recording of his *In the Wee Small Hours* album.

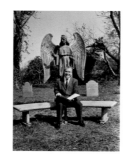

76 Horton Foote
Wharton, Texas, 1963

The playwright was working on some rewrites for director Robert Mulligan during the filming of Foote's *Baby, the Rain Must Fall.*

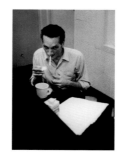

77 Joe Albany
Hollywood, 1954

Although he looks maniacal here, Joe was a sweet, dedicated, and innovative jazz pianist.

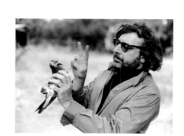

79 Terry Southern
Ojai, California, 1971

The hardcore iconoclast-author giving the peace sign to a seemingly belligerent dove.

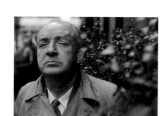

80 Vladimir Nabokov
New York City, 1963

While on an assignment for *Harper's Bazaar*, we walked toward an omelette shop on East 53rd Street for a bite of lunch when it started to rain.

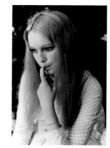

83 Mia Farrow
Beverly Hills, 1961

The young actress was appearing in the TV hit *Peyton Place* at the time I photographed her in a beautiful flower garden at the Beverly Hills Hotel. She liked the blossoms so much she ate them.

84 John Lithgow
Studio City, 1999

We met in Prague in '94 during the shooting of *WWII: Then There Were Giants*, in which John portrayed Roosevelt and Michael Cain, Stalin, and Bob Hoskins, Churchill. During the slow periods, John would amuse all with his brilliant wit and uproarious shenanigans.

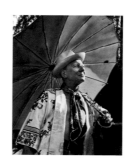

85 Sir John Gielgud
Beverly Hills, 1961

The famous actor was in Hollywood to work in the film version of Evelyn Waugh's *The Loved One.* As I photographed him, he expressed a particular concern: "Oh, I hope I don't look like a poof."

86 Mark Isham
Los Angeles, 1994

We were shooting a CD cover for this composer and trumpet man. I was taken by the way the horizontal rays of light cut across his pinstripe suit.

87 Anjanette Comer
Beverly Hills, 1964

I shot this actress, who played a funeral home cosmetician in *The Loved One,* for the cover of a book I did with Terry Southern, *The Journal of the Loved One.* The publisher rejected it.

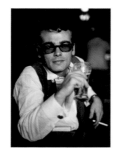

88 Dean Stockwell
West Hollywood, 1962

Dean would snap his fingers to the music of Mozart and harpsichordist Wanda Landowska, exclaiming, "Man, do they swing!"

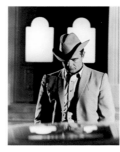

89 Marlon Brando
Columbia Ranch, 1965

The "sheriff" gives me the evil eye during a rehearsal while appearing in Arthur Penn's film *The Chase.*

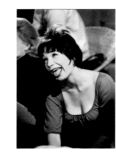

91 Shirley MacLaine
Hollywood, 1961

Funny and brilliant, Shirley clowns for Robert Mitchum, her co-star in the film *Two for the Seesaw.*

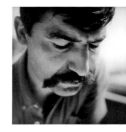

92 John Altoon
Los Angeles, 1958

Painter Altoon's personality and style were so original and unique that he influenced many of the young artists in the L.A. art scene in the late '50s and early '60s.

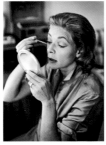

93 Lauren Bacall
Hollywood, 1963

We met over lunch at Fox Studios, and she let me do some casual portraits in her dressing room. I was thrilled; I had had a crush on her ever since *To Have and Have Not.*

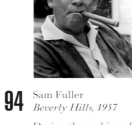

94 Sam Fuller
Beverly Hills, 1957

During the making of his war film *Verboten!,* rather than say "Action!" director Sam Fuller would fire his Colt .45 revolver into the air.

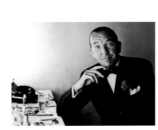

95 Noel Coward
Las Vegas, 1955

Mr. Coward loved to be photographed. The more I shot, the campier he would become, and the more we would both laugh.

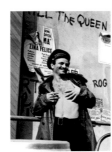

96 Peter Falk
Hollywood, 1962

Long before television's *Columbo,* Mr. Falk worked in a bizarre film version of Jean Genet's *The Balcony.*

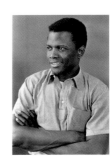

97 Sidney Poitier
Hollywood, 1963

I was so sure that Mr. Poitier was going to win the Oscar for his performance in *Lilies of the Field* that I wanted to shoot him for the cover of a movie magazine called *Cinema.* I shot the picture, and he won his Oscar.

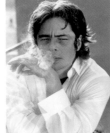

98 Benicio Del Toro
Los Angeles, 2001

Mr. Del Toro was modeling a group of men's white summer suits for a *GQ* fashion layout. He amused me by becoming a different character with each outfit that he donned.

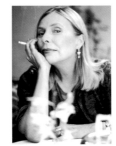

99 Joni Mitchell
Bel Air, 1997

I liked the way the light filtered through the sycamore trees onto her face. That and the fact she makes cigarette smoking a most sensual act for a beautiful lady.

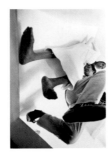

101 Donyale Luna, Salvador Dali
Cadaques, Spain, 1966

Dali loved performing for the camera, as did Donyale. It made my job easy.

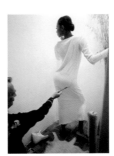

102 Salvador Dali, Donyale Luna
Cadaques, Spain, 1966

The famous surrealist begins to "ruin" Donyale's gown.

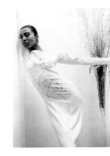

103 Donyale Luna
Cadaques, Spain, 1966

Suddenly, Donyale's $80 gown is now worth "a thousand times as much."

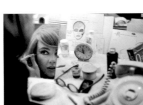

104 Edie Adams
Las Vegas, 1958

She had been widowed when Ernie Kovacs was killed in an automobile accident. Getting back to work on the stage in Las Vegas was a wonderful boost for her spirit.

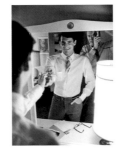

105 Anthony Perkins
New York City, 1957

We shot this in Tony's digs next door to the City Center Theatre on West 58th Street.

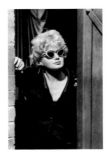

106 Shelley Winters
Hollywood, 1962

The versatile actress played a madame in Joseph Strick's far-out film adaptation of Jean Genet's *The Balcony.*

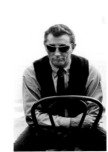

107 Robert Mitchum
Hollywood, 1961

Mitchum was the most relaxed actor I have ever worked with. He often sang or told stories to the film crew during the long waits while filming a movie.

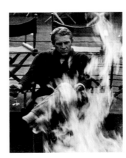

108 Steve McQueen
Big Sur, California, 1964

His star was on the rise in a big way. God only knows what he was thinking about as he stared into the flames.

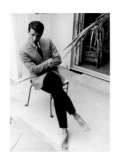

110 James Fox
Malibu, 1965

Relaxing at his cottage on the beach, the British actor was working on *The Chase* with Marlon Brando, Jane Fonda, and Robert Redford.

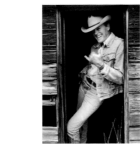

111 Peter Fonda
Montana, 1998

This picture was taken for *The New Yorker* at Peter's ranch in the hinterlands of The Big Sky State.

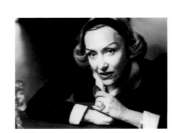

113 Gloria Swanson
Los Angeles, 1962

We met in an antique shop in what is now West Hollywood. When she spotted my camera, it was instant rapport. I couldn't help remarking about her beauty. She smiled and said, "Thank you, my dear. But one's hands tell the truth, I fear."

114 Billy Wilder
Los Angeles, 1998

Wilder, in his 90s, was the guest of honor at one of publisher Benedikt Taschen's parties at his famous Chemosphere house.

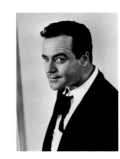

115 Jack Lemmon
Hollywood, 1964

This was shot during the shooting of a film called *How to Murder Your Wife,* at Paramount Studios.

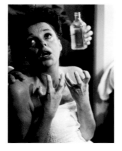

116 Judy Garland
Las Vegas, 1961

These photographs reveal the magical transition from a sad, depressed artist to one who was vivacious and magnetic the moment she stepped onstage.

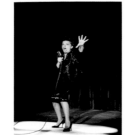

118 Judy Garland
Las Vegas, 1961

She seemed to be crying-singing "Love me, love me, please love me!"

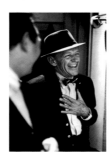

119 Fred Astaire
Hollywood, 1962

Mr. Astaire had just started his own record company, which he named Ava Records after his daughter. Here he is with the producer-drummer Jackie Mills.

120 Sir Paul McCartney
Hollywood, 2001

The famous Beatle requested me to shoot his first recording session in many years. I was very honored.

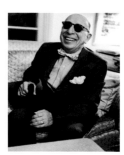

121 Igor Stravinsky
Hollywood, 1956

The composer and his wife Vera had many intimate cocktail parties in their Hollywood Hills home. He enjoyed both his bourbon and an occasional groping of the lady nearest him.

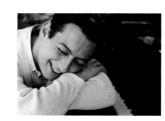

122 Andre Previn
Hollywood, 1955

We worked together many times when the young Previn led a double life as musical director for MGM Studios and as a jazz pianist.

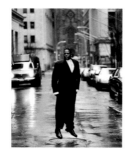

123 Blair Underwood
New York City, 1995

During a fashion shoot for *GQ*, my only direction for Blair was, "Remember, you're on Wall Street."

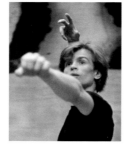

125 Rudolf Nureyev
Los Angeles, 1961

During the rehearsal the great dancer managed to concentrate on his dancing and "pose" for my camera. The problem for me was keeping up with his incredible speed.

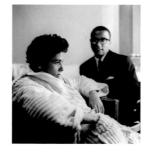

126 Lena Horne, Billy Strayhorn
Las Vegas, 1956

A rather sad Lena in her dressing room backstage being comforted by her composer friend, who she referred to as "Sweet Pea."

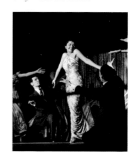

127 Lena Horne
Las Vegas, 1956

Fifteen minutes later, Ms. Horne turns on the megawatt force of her talent onstage at the Sands Hotel.

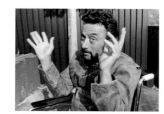

128 Lenny Bruce
Hollywood, 1966

Even in his wheelchair and in great pain, Lenny never stopped defending himself and his beliefs with outrageous humor.

130 Tony Curtis
Hollywood, 1963

Tony carries on the tradition of actors dressing in drag; it must be fun, for every famous actor has tried it on and off the stage.

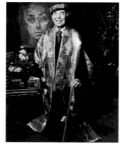

131 Tony Duquette
Beverly Hills, 1998

This multi-talented artist designed utterly fantastic stage sets, interiors, and jewelry. He was almost child-like in his delight of beauty.

132 Chet Baker
Hollywood, 1954

Chet was rehearsing for his first vocal album. With him are Russ Freeman, piano, and Bob Neel, drums.

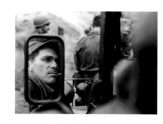

134 Sydney Pollack
Topanga Canyon, 1961

Here he is performing as an actor along with Robert Redford in the low-budget film *War Hunt* before he became a famous director and producer.

135 Kaffe Fassett
London, 1966

We were shooting this anti-war poster during the Vietnam conflict. My model Kaffe, an American, became a successful textile designer famous for his knitting and needlepoint in England.

136 Jake Labotz
Los Angeles, 1999

Here's a great musician who overcame drug addiction to help other victims of abuse through his art.

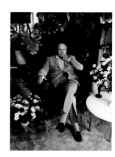

137 John Houseman
Malibu, 1962

The Housemans, John and Joan, were brilliant hosts to many artists on Sunday afternoons. We were fortunate to be included often.

138 Sting
New York City, 1996

I felt that this elegant and eclectically-styled room matched his subtle artistry with great style.

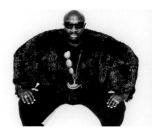

140 Isaac Hayes
Hollywood, 1995

He was every bit as formidable as a fashion model as he was as a musician. We shot this for *Detour* magazine.

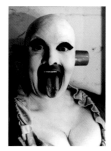

141 Leigh Bowery
Hollywood, 1986

Performer with the outrageous Michael Clark dance company, Bowery was a model for many of Lucian Freud's famous paintings.

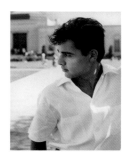

142 Sal Mineo
Burbank, 1954

A close friend of and fellow actor with James Dean, Sal was murdered in 1976 in West Hollywood.

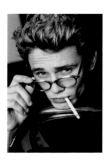

143 James Franco
Los Angeles, 2000

This young actor won an Emmy for his portrayal of the legendary James Dean in the TNT television movie directed by Mark Rydell.

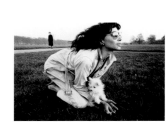

144 Donyale Luna
Hyde Park, London, 1966

No matter where we were or what she was wearing, Donyale would stop for a picture and always prove to be unbelievably photogenic.

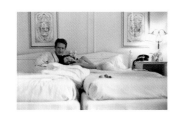

146 Mr. & Mrs. William Claxton
New York City, June 14, 1959

I set the self-timer on my camera, placed it on the chest of drawers across the room, then ran and leapt into bed as the camera captured us in our Savoy Plaza Hotel suite the morning after our wedding.

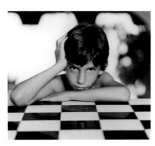

149 Christopher Michael Claxton
Beverly Hills, 1981

This was shot in our kitchen after school, but before milk, cookies, and conversation.

150 Marlene Dietrich
Las Vegas, 1955

The star takes her final bow for the closing act onstage at the Sands Hotel.

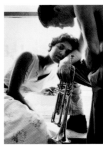

152 Halema and Chet Baker
Redondo Beach, 1955

I had gone to Chet's house to photograph him for a record cover, but the moment this beautiful girl opened the door, I knew that she had to be in the picture.

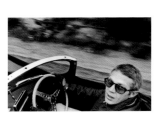

153 Steve McQueen
Hollywood Hills, 1963

Steve was driving his Jaguar XKSS on Mulholland Drive. I'm the foolish young photographer standing in the passenger's seat shooting him at breakneck speed.

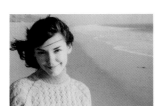

153 Peggy Moffitt
Malibu, 1958

We had only known each other a short time, but our love for each other shows in this photograph.

Photographic Memory

Published in the United States by powerHouse Books,
a division of powerHouse Cultural Entertainment, Inc.
180 Varick Street, Suite 1302, New York, NY 10014-4606
telephone 212 604 9074, fax 212 366 5247
e-mail: clax@powerHouseBooks.com
web site: www.powerHouseBooks.com

First edition, 2002

Library of Congress Cataloging-in-Publication Data:
Claxton, William.
 Photographic Memory / by William Claxton.
 p. cm.
 ISBN 1-57687-085-5
 1. Celebrities--Portraits. 2. Portrait photography. 3. Claxton, William. I. Title.

 TR681.F3 C53 2000
 779'.2'092--dc21

 00-058463

Hardcover ISBN 1-57687-085-5

Separations, printing, and binding by Artegrafica, Verona
Photo editing by Peggy Moffitt
Design by Simon Johnston

A complete catalog of powerHouse Books and Limited Editions is available upon request;
please call, write, or visit our web site.

Other books by William Claxton:

Jazz West Coast, Linear Productions, 1955
Jazzlife, with Joachim Ernst Berendt, Burda Verlag, 1962
Journal of the Loved One, with Terry Southern, Random House, 1965
Jazz, Twelvetrees Press, 1987
The Rudi Gernreich Book, with Peggy Moffitt, Rizzoli International, 1991
California Cool, with Graham Marsh/Glynn Callingham, Chronicle Books, 1992
Jazz West Coast: Artwork of Pacific Jazz Records, with Hidetoshi Namekata, Bijutsu Shuppan-Sha, 1992
Young Chet, Schirmer/Mosel, 1993
Claxography: The Art of Jazz Photography, Nieswand Verlag, 1995
Jazz Seen, Benedikt Taschen Verlag, 1999
Laugh: Portraits of the Greatest Comedians, William Morrow and Company, 1999
Steve McQueen, Arena Editions, 2000

Acknowledgments:
Thank you Simon Johnston, Praxis Design; Thierry Demont, David Fahey, The Fahey Klein Gallery; Peggy Moffitt Claxton; and Craig Cohen and Daniel Power of powerHouse Books, who made this book possible.

10 9 8 7 6 5 4 3 2 1

Printed and bound in Italy